MUNDOS
ALTERNOS

ART AND SCIENCE FICTION
IN THE AMERICAS

MUNDOS ALTERNOS

ART AND SCIENCE FICTION IN THE AMERICAS

Robb Hernández
Tyler Stallings
Joanna Szupinska-Myers

WITH CONTRIBUTIONS BY
Kency Cornejo
Rudi Kraeher
Kathryn Poindexter
Itala Schmelz
Alfredo Suppia
Sherryl Vint

UCR ARTSBLOCK
University of California, Riverside

Hernández & Stallings, eds.

Published with the
assistance of
the Getty Foundation

CONTENTS

More than mere escapism, science fiction can prompt us to recognize and rethink the status quo by depicting an alternate world, be it a parallel universe, distant future, or revised past.

—Catherine S. Ramírez, "Afrofuturism/Chicanafuturism: Fictive Kin," 2008

Mundos Alternos: Art and Science Fiction in the Americas is a groundbreaking exhibition that explores the intersections of science fiction, technoculture, and the visual arts. In a wide-ranging survey, UCR ARTSblock brings together Chicano, Latino, and Latin American artists from across the Americas who have tapped into the science fiction genre to imagine new realities, both utopian and dystopian visions.

Science fiction provides a unique artistic launching point to explore the colonial enterprise that shaped the Americas and to present alternative perspectives speculating on the past and the future. The approach for the exhibition and accompanying book was to look at cross-cultural relationships, without foreclosing the specificity of Latin America, Central America, the Caribbean, and "Latinidades," broadly defined. The rich histories of science fiction literature, art, and film, especially those of Mexico, Cuba, Argentina, Brazil, and the United States, inspired this effort. The exhibition installations within the UCR ARTSblock galleries represent those movements and provide context for the artworks that make up *Mundos Alternos*.

The research phase for *Mundos Alternos* included eighteen months of travel throughout Argentina, Brazil, Chile, Cuba, Mexico, Puerto Rico, and the United States, visiting more than four hundred artists, curators, scholars, and gallerists. In the end, the curatorial team selected more than thirty Chicano, Latino, and Latin American artists and collectives who demonstrate science-fictional characteristics in their works. The curators of *Mundos Alternos* are Robb Hernández, assistant professor in UCR's English Department; Tyler Stallings, artistic director of the Barbara and Art Culver Center of the Arts; and Joanna Szupinska-Myers, California Museum of Photography's curator of exhibitions. The depth and breadth of the curators' inquiries into the subject matter make *Mundos Alternos* a noteworthy addition to a growing body of scholarly research in the field of science fiction.

Mundos Alternos: Art and Science Fiction in the Americas is part of Pacific Standard Time: LA/LA, a series of thematically linked exhibitions presenting a far-reaching and ambitious exploration of Latin American and Latino art in dialogue with Los Angeles. Supported by grants from the Getty Foundation, Pacific Standard Time: LA/LA takes place from September 2017 through January 2018 at more than seventy cultural institutions across Southern California.

A special thank you goes to the Getty Foundation for its generous support of *Mundos Alternos* and University of California, Riverside Chancellor Kim A. Wilcox and Milagros Peña, Dean of the College of Humanities, Arts, and Social Sciences. Their unwavering commitment to UCR ARTSblock enriches our Southern California communities through the arts and scholarship.

Sheila Bergman
Executive Director, UCR ARTSblock

Science fiction's two cores are speculations on future technologies and the subsequent building of imaginary worlds that bring them alive. Two unique facets of the University of California, Riverside (UCR) embody these nuclei, which were inspirations for *Mundos Alternos: Art and Science Fiction in the Americas*. The first was UCR's Eaton Collection of Science Fiction & Fantasy, housed at the UCR Library's Special Collections & University Archives—one of the world's largest collections of its kind. The second was UCR's designation as a Hispanic-serving institution; defined as a nonprofit, degree-granting institution with full-time Hispanic undergraduate students representing twenty-five percent or more of the students. UCR was the first in the UC system to receive the honor in 2008. In both cases, UCR has been forward thinking both in its science fiction collections and also in how it equips students to envision building their futures, especially, in the case of UCR, when they are often from immigrant families and the first in their families to attend college.

We are indebted to Deborah Marrow, director, and Joan Weinstein, deputy director at the Getty Foundation; Heather MacDonald, program officer at the Getty Foundation; Selene Preciado, program assistant at the Getty Foundation; Gloria Gerace, managing director for Pacific Standard Time: LA/LA. It has been a privilege for ARTSblock to work with the book's four invited essayists—Kency Cornejo, Alfredo Suppia, Itala Schmelz, and Sherryl Vint—who have contributed, along with essays by the curators, substantial new scholarship on the themes of science fiction, film, art history, and Chicano, Latino, and Latin American studies. Kathryn Poindexter, CMP curatorial assistant, *Mundos Alternos* project coordinator, and this book's managing editor, was the invaluable glue that kept both the exhibition and publication afloat and on parallel tracks. Contributing author Rudi Kraeher, a PhD student at UCR in the English Department contributed valuable artist descriptions. It was also a pleasure working on the book with Lucia|Marquand—thank you to Ed Marquand and Adrian Lucia.

We are greatly indebted to the members of the extended research team: Miguel Ángel Fernández Delgado, Mexican science fiction scholar and researcher at the Escuela Libre de Derecho (Mexico City) and associate researcher at the University of South Florida; Rocío Aranda-Alvarado, curator at El Museo del Barrio in New York, who has explored the history and making of art in the Caribbean; Alfredo Suppia, professor in film studies at the University of Campinas, who focuses on Brazilian and Latin American science fiction film; Rebeca Noriega Costas, an independent curator in Puerto Rico; Sherryl Vint, professor in the Media and Cultural Studies Department at UCR, whose research specializes in science fiction, biopolitics, and technoculture; and Melissa Conway, former head of special collections at the UCR Libraries, who was instrumental in building the Eaton Collection. We are also appreciative of the enthusiastic support of ARTSblock's new Executive Director, Sheila Bergman.

While there are rich histories of Latin American science fiction in literature and film, as in Mexico, Cuba, Argentina, and Brazil, *Mundos Alternos* is the first exhibition to explore these themes with Latin American, Chicano and Latino art histories presented together.

Tyler Stallings
Artistic Director, Barbara and Art Culver Center of the Arts, UCR ARTSblock

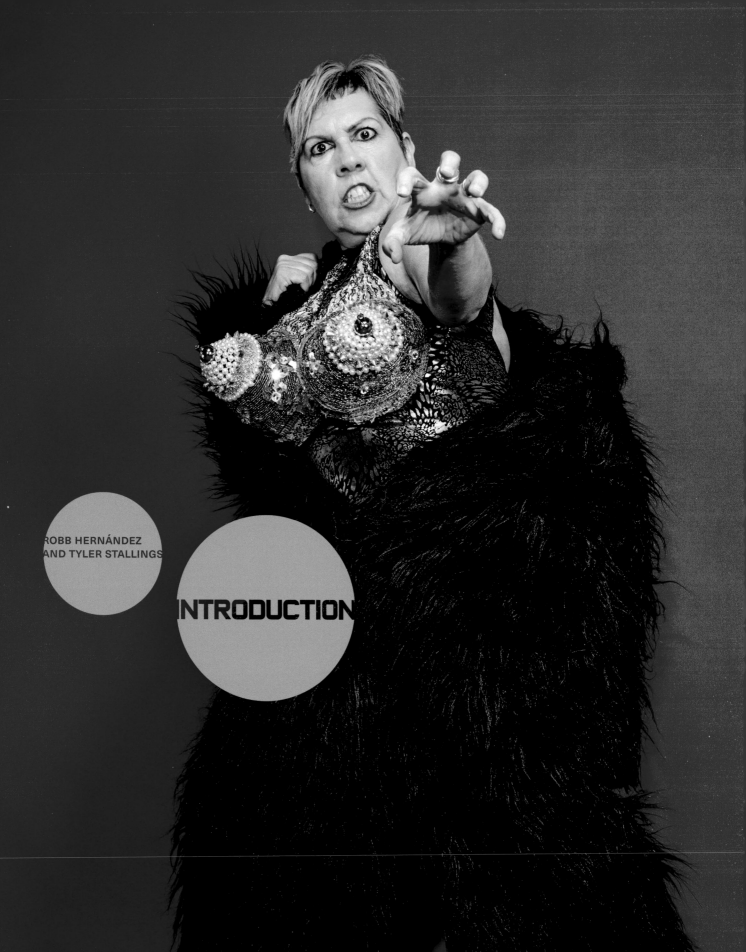

ROBB HERNÁNDEZ
AND TYLER STALLINGS

INTRODUCTION

uite possibly one of the most significant texts of Latin American science fiction is not "México en el ano 1970" (1844), published by Fosforos-Cerillos in the short-lived literary periodical *El Liceo Mexicano,* which pontificated national progress. It is not the broadsheets of Mexican printmaker José Guadalupe Posada and his astronomic imagining of Halley's Comet as an ominous sight of disaster and sign of the impending Mexican Revolution in 1910. And it is probably not *El Eternauta* (1957/1969), the Argentine serialized comic by Héctor Germán Oesterheld that uses alien invasion to comment on dictatorship, U.S. imperialism, and militant uprising in Buenos Aires.[1] Rather, it is Jacqueline Barnitz's *Twentieth Century Latin American Art* (2001), a text more restrained in its historical gravitas and stature in science fiction studies.[2]

A foundational textbook used and reused in university surveys on the trends, currents, and aesthetic genealogies in modern and contemporary Latin American art, the book's back matter presents one of the most unusual and strange manifestations of art geography. A map of the Americas is generously provided, which follows a timeline that designates art movements, national periods, and timely events. Mexico, Argentina, Brazil, Peru, and Chile are among those charted in Barnitz's rendering. And yet, Puerto Rico is absent. Central America appears as a darkened empty landmass, unmapped like a black hole to a nameless elsewhere. It remains as a negative space, an inverse of Latin America's artistic sophistication attuned to Mexico and the Southern Cone. Despite being an isthmus of profound consequence in the colonial project of the Americas and agribusiness expansionism in labor and trade, Central America is there and not there—a region with no past.

Barnitz's circumscription of Central America echoes Joaquín Torres-García's drawing *América Invertida* (1943),[3] in which the Uruguayan artist subverted national hierarchies by inverting the map of the Southern Cone, placing the south north. His vision of South America from the perspective of the "upside down" is a telling reminder to students in his School of the South workshop that art training need not happen elsewhere. Of course,

his conceptual intervention does not reverse Central America's positionality.[4] Even in the "upside down," it is still central to the Americas' axis. For these reasons, *Mundos Alternos: Art and Science Fiction in the Americas* foregrounds the otherworldly existence of sites/sights like Central America—a place with no past; a place whose dual proximity to Los Angeles and Latin America is quite present and yet speculative; a place left with only its future. This alien(ating) existence is but one "mundo alterno" from which we challenge the blind spots undergirding the "LA/LA" dyad. Science fiction's visual potentiality grows. As an analytic, it makes this vision clearer.

Mundos Alternos brings together contemporary artists from across the Americas who have tapped into science fiction's capacity to imagine new realities, both utopian and dystopian. As a mode of analysis and image creation, science fiction offers a unique artistic landscape in which to explore the colonial enterprise that shaped the Americas as well as contemporary perspectives that speculate on the present and past via a viewpoint from the future. More than thirty artists and collaborative groups participated in the show, with most of the works created over the last three decades. All employ science fiction imagery to suggest alternative modes of being "alien" and "alienated" in the global flows of transnationalism, trade expansionism, and post-industrial capitalism. Given the current political climate, increased surveillance, and militarized borders, Latino and Latin American artists intimately know the violent consequence of "alien" discourse in a U.S. ocular regime. In this way, science fiction in the visual and performing arts of the Americas permits a powerful perspective and alternative vision on histories of colonialism, military occupation, political dictatorship, and immigration in the United States, Mexico, Central America, South America, and the Hispanophone Caribbean.

The organizing principle for the exhibition and accompanying book is a constellation inspired by Latin American curator Mari Carmen Ramírez's call to organize works through a synecdochical approach based on "luminous points."[5] *Mundos Alternos* draws from a range of media and genres, including paintings, graphite drawings, mixed-media sculptures, video projections, site-specific installations, costume design, and a smaller exhibition within the exhibition. By engineering "alternate worlds," it creates immersive media environments and experiences that challenge the Earth-bound sites from which citizenship, borders, and national bodies are traditionally viewed and understood in Latino, Latin American, and American studies.

After visiting six nations in Latin America (Argentina, Brazil, Chile, Cuba, Mexico, and Puerto Rico), as well as numerous U.S. cities (Austin, Chicago, Houston, Los Angeles, Miami, New York, Phoenix, San Antonio, San Diego, San Francisco, and Santa Fe), the curatorial team and transnational specialists in art and science fiction confronted challenging lines of inquiry from the outset. What constitutes a Latino and Latin American "science fiction" art practice? Is it based on a recognizable set of generic

science fiction tropes like time travel, space exploration, or cyberpunk? Is it a question of figurative icons like UFOs, cosmic representations, or rocket semiotics? Is it a regional art formation drawing on local folklore, paranormal encounters, or the influence of extraterrestrial sightings? Our task was to organize an exhibition that elucidates national boundaries and subjectivities through the visual vocabulary of alternative world-making and speculative models.

For the curatorial team,[6] there were few exhibitions that could serve as precedents, especially on this size and scale. The most notable was *Past Futures: Science Fiction, Space Travel, and Postwar Art of the Americas* (2015), presented at Bowdoin College Museum of Art and curated by Sarah J. Montross. *Past Futures* featured artists working in Latin America and the United States who witnessed the achievements of the space age and the influence that actually going into outer space had on the science fiction genre. Examining "expressions of anxiety about nuclear annihilation, government surveillance, and threats of dehumanization,"[7] Montross explored these conjoined states of space travel, science fiction, and domestic and international politics, focusing on post–World War II relationships in the Americas, such as after the 1959 Cuban Revolution.[8]

In contrast to that exhibition's emphasis on the interaction of nations during the Cold War, we decided explicitly not to organize the exhibition around the fraught nature of national boundaries. Identities, borders, and histories are important; however, we were mindful of area studies that have been the subject of intellectual and political fodder in Latin American studies as extensions of U.S. State Department policy, Cold War militarism, and geopolitical isolationism. In art history, nation-period rubrics in Latin American art parlay curatorial approaches that generate rigid definitions of national patrimony, oftentimes circumventing alternative or hemispheric connections that Latino art, especially art practices situated in a science fiction idiom, can more clearly unsettle and redefine.

Some of the earliest science fiction shows in the realm of Chicano art emphasized a cunning social satire. In San Diego, artist Perry Vasquez curated *Plan 9 from Aztlán* (1995) at Centro Cultural de la Raza and *Alien Attack: Outer Visions in Popular Art* (1996) at Virus Gallery. These shows were among cultural responses to the racist and xenophobic discourse surrounding California's Proposition 187, a ballot initiative championed by Republican governor Pete Wilson in 1994.[9] The campaign to pass the measure, which tried to deny public services to undocumented immigrants, played into nativist fears by warning of "illegal aliens" invading California. Vasquez's exhibitions exemplify science fiction's capacity for biting political critique.[10] Of course, these are happening in and sheltered by Chicano cultural institutions and not necessarily fine art museums, suggesting the false divisions between science fiction as a genre of commercial and "low brow" popular culture and not necessarily contemporary art writ large.

This dynamic persists under the creative lens of Tejano or Texan Mexican border artists. San Antonio's Luis Valderas is heir apparent to

Vazquez's mantle. In 2005, he formed Project MASA, or the "MeChicano Alliance of Space Artists," spurred by the ways in which Chicano artists were using speculative technologies, celestial motifs, and pre-Columbian cosmologies to reframe the future and rethink Latino perceptions of outer space. Valderas's main curatorial guideline to artists was "establish an awareness of outer space as an integral part of the Chicano(a) Modern Mythos / Reality / Iconography,"[11] implicitly asking, with some defensive satire with regard to terminology and political rhetoric, "Who is an alien?" MASA became an ongoing venture of three thematic shows between 2005 and 2007.

The second exhibition held at Joe Lopez's now-defunct Gallista Gallery on San Antonio's West Side featured San Diego's Chicano Aeronautic Space Agency (CASA). As *Los ChicanoNauts*, they created a multimedia installation that told the tale of a team of transborder explorers going to the "brown side of the moon."[12] Set to the music of David Bowie's "Space Oddity" (1972), "Major Tom" was dubbed "Major Juan." They installed a time capsule from the future, and the found object led audiences to decipher its entombed remnants from a long-extinct Aztec space civilization. The linguistic playfulness, such as the rhyming of MASA, CASA, and NASA, demonstrates the power of language and its bilingual slippage, re-creating cultural identity with reference to pre-Colombian culture, space technology, and humor. Together, these groups illustrate contradictions certain to offend but ultimately subvert anti-immigrant and anti-Mexican vitriol in California and Tejas, respectively.

The importance of curatorial precedents from Montross, Vazquez, and Valderas interjects a reimagining of science fiction arts across the Americas, and while there are rich histories of Latin American science fiction literature and film in Mexico, Cuba, Argentina, and Brazil, there have been only a handful of critiques about U.S. Latinidad, mainly under the guise of technoculture and speculative technology. These case studies expand the definition of Latino technofuturism in unexpected ways. Take, for instance, the little-known science fiction imaginary in Puerto Rico. A society ravaged by U.S. neocolonial occupation, corporate pharmaceutical experimentation, and economic exploitation, Puerto Rico has produced a striking science fiction visual vocabulary that responds to the ways in which American military, agricultural, and biomedical technologies control and monitor the island. The result produces what media scholar Manuel Aviles-Santiago calls a "technological embodiment of colonialism," where new technologies provoke political dissidence, pitting Boricuas against the machines.[13]

Another instance is *Cyber Arte: Tradition Meets Technology*, which was presented at the Museum of International Folk Art in Santa Fe, New Mexico, in 2001. An exhibition less about Latino science fiction, per se, and more about the relationship among representation, technology, and Chicana feminism, its curator, Tey Marianna Nunn, asked, "I wondered

how these women negotiate the borders of identity as it pertains to combining tradition and technology?"[14]

Alma López's digital print *Our Lady*, which was included in *Cyber Arte*, gained national attention because it depicts Our Lady of Guadalupe—an apparition of the Virgin central to the iconography of Catholicism in Mexico—in a bikini composed of roses conveying a lesbian sensibility. The bishop of Santa Fe called for the removal of the work and there were public debates, state regents meetings, warning labels mounted to alert visitors of the disturbing image, and threatening phone calls to the curator; finally, the state legislature held hearings on whether to withdraw funding from the museum.[15]

In the end, the museum decided to close the exhibition early as a gesture of reconciliation. The debacle is an example of what can happen when icons confront and question traditional representations through new technologies and digital art processes. The cultural impact of Nunn's show had reverberating aftereffects in Latino cultural studies, influencing Catherine S. Ramírez's polemic 2004 article "Deus ex Machina: Tradition, Technology, and the Chicanafuturist Art of Marion C. Martinez" in *Aztlán: A Journal of Chicano Studies,*[16] followed four years later by another article in *Aztlán*, "Afrofuturism/Chicanafuturism: Fictive Kin," in which a feminist framework for Chicana futurism is first enunciated at the intersection of Afrofuturist art, literature, and cultural theory.[17]

The tenets of Afrofuturism have become a foundation on which specific notions of Chicanafuturism and general notions of *Mundos Alternos* have been built. Coined in 1994 by writer Mark Dery in his essay "Black to the Future,"[18] the term "Afrofuturism" refers to a creative and intellectual genre that emerged as a strategy to explore science fiction, fantasy, magical realism, and pan-Africanism, perhaps best exemplified by African American musicians such as Sun Ra and George Clinton, and writers such as Ishmael Reed, Amiri Baraka, Steven Barnes, Octavia Butler, and Samuel Delany.

In 2006, *Space Is the Place*, organized by New York City–based Independent Curators International, traveled the United States as a group exhibition with work inspired by nostalgia and speculation about outer space. The title was taken from a 1974 science fiction film of the same name that featured Sun Ra and his Arkestra.

During the late 1960s and early '70s, Sun Ra traveled to California and taught a course titled "The Black Man in the Cosmos" at UC Berkeley. The film is based, in part, on the lectures he gave there, in which he articulated many nuanced views such as: "I'd rather a black man go to Mars . . . than to Africa . . . because it's easier,"[19] referring to the difficulty of a Westernized African American seeking roots back in Africa. The basic plot is that Sun Ra lands on a new planet in outer space and decides to settle African Americans there.

Seven years later, in 2013–14, the Studio Museum in Harlem presented *The Shadows Took Shape,* an interdisciplinary exhibition exploring

contemporary art through the lens of Afrofuturist aesthetics.[20] In one of the exhibition catalogue essays, Tegan Bristow, nearly twenty years after Dery, updates a definition of Afrofuturism:

> Afrofuturism uses science fiction and cyberculture in a speculative manner, just as cyber-feminism does. It is an escape from the externally imposed definition of what it means to be black (or exotically African) in Western culture, and it is a cultural rebellion drawing on techno-culture, turntables and remixes as technological and instrumental forms. By placing the black man in space, out of the reach of racist stereotypes, Afrofuturism allows for a critique of both the history of the West and its techno-culture.[21]

These handfuls of examples that stretch between 2001 and 2015 indicate how the visual arts have historically been looking at race and social difference through a lens of science fiction cultural production. It is from here that *Mundos Alternos* proceeds.

+++

In this book that accompanies the exhibition, more than thirty contemporary artists and groups from throughout the Americas who employ science fiction for social, cultural, and political critique are organized under several thematic constellations. Many of the themes are common tropes in science fiction literature and film, and here are infused with an eye on the Americas.

Post-Industrial Americas features works by Chico MacMurtrie, Rubén Ortiz Torres, and Simón Vega that highlight low-tech production, expounding on the forces of advanced technology that create radical change in the social order, for good and bad. In Western science fiction, the tendency has been to present this in a dystopian context, while in much of Latin America, it presents an opportunity to reimagine a self-empowered future in both a post-colonial and post-dictatorial context. In her essay in this volume, co-curator Joanna Szupinska-Myers discusses these artists and others through the concept of the "bachelor machine."

Alternate Americas explores landscapes beyond Earth that appear familiar, perhaps even true—such as images related to the moon landing—but in fact may be simulated. ADÁL, Glexis Novoa, Erica Bohm, and several works by MASA (MeChicano Alliance of Space Artists) examine the political realities of the Americas, which sometimes suggest that citizens in one nation are living in a simulated environment created by people from another, far-off nation. In this respect, the artists in this section create alternate histories and origin-myths in which historical events unfold differently, telling stories that refract other realities in parallel space and time.

Indigenous Futures includes works by Rigo 23, Guillermo Bert, and Marion Martinez that use indigenous subjects as foil against colonial visions of white space explorers hungry to conquer new worlds. Here,

pre-Columbian symbolism features prominently, forming a neo-Aztec mysticism, as scholar Itala Schmelz argues in her essay.

Time Travel looks at journeys between the present and eras of the future. An investigation into time travel provides meaningful new perspectives on several issues of ongoing hemispheric importance. For artists Beatriz Cortez, Tania Candiani, Faivovich & Goldberg, and Clarissa Tossin, the only possible remedy for historically profound social ills seems to lie in the fictional mechanism of manipulating progressive time. The idea of artwork being a portal to alternate worlds is explored in co-curator Tyler Stallings's concluding essay. Additionally, several of these artists can be viewed in the context of fantastical science fiction landscapes in popular filmic imaginary of the Amazon, as argued by Alfredo Suppia, or Argentine science fiction films, as analyzed by Sherryl Vint.

Alien Skins presents the work of AZTLAN Dance Company, Carmelita Tropicana, Guillermo Gómez-Peña, Robert "Cyclona" Legorreta, Irvin Morazán, Mundo Meza, LA David, Hector Hernandez, Claudio Dicochea, Luis Valderas, and Ricardo Valverde, who employ shape-shifting (through costume, performance, or imagination) as a means of physically embodying cosmic personae. Discussed in depth by co-curator Robb Hernández in his essay, these transformations contest the spatiotemporal structures of our current reality and open another way of being and seeing one's "alienation."

Moving Pictures/Moving Americas features works by La Gravedad de los Asuntos, Sofía Gallisá Muriente, Gyula Kosice, Jillian Mayer, José Luis Vargas, and Alex Rivera. The work of these artists creates immersive media worlds and relational experiences with speculative technologies. These offer new perspectives on colonialism, imperialism, surveillance, labor, immigration, and quests for utopia.

+++

The seven essays in this book are organized in a manner that makes hemispheric exchanges in the Americas visible through science fiction as a source of cultural analysis and visual dialogue. The opening essay foregrounds the provocative work of diasporic Central American artists. By questioning Central America's alternate and negated place in "LA/LA's" cultural paradigm, Kency Cornejo's essay "Decolonial Futurisms: Ancestral Border Crossers, Time Machines, and Space Travel in Salvadoran Art" asks a provocative question undergirding this exhibition and book: Can the future be decolonized? Her work on science-fictional intersections with Salvadorans, a vast population besieged by the struggle to forget in the aftermath of U.S.–sponsored terror in the 1980s, implicitly asks: Is there a future for a past erased? The answer lies in the decolonial epistemologies of Central American visual and embodied knowledge. Cornejo builds on her argument using the Salvadoran diasporic work of Irvin Morazán, Beatriz Cortez, and Simón Vega. In an effort to repair the devastation wrought by

the civil wars in Central America, the toxic agribusiness machinery of the United Fruit Company, and the infusion of Maya cosmology with techno-culture shamanism, she fathoms a decolonial visual art formation that adapts science fiction to reconcile the irreconcilable.

Performing otherworldly personae similarly undergirds Hernández's essay "Alien Skins: The Outer Spaces of Transplanetary Performance." Hernández explores how contemporary Latino and Chicano artists dis-orient the temporal-spatial alignment of national borders and citizenry through the re-embodiment of alternate worlds in performance and impromptu art happenings from Tejas, Los Angeles, and New York. He argues how these "cosmic personae intercede with performance rep-ertoires ranging from aeronautical proposals of airborne Latino subjec-tivities, interstellar space travel, and clandestine fashion technologies remolding the brown body." These alien personae look elsewhere toward a future Aztlán, seeking a transplanetary vision for Latinidad by turning skyward.

For Hernández, the idea of "look[ing] skyward" was an incipient prac-tice during his studio and fieldwork visits to Puerto Rico, during which he explored the island's extraterrestrial landscapes, supernatural folklore, and aerial aberrations. The work of ADÁL was deeply influential here. His "mind fictions," *Sightings: UFOs over Utuado* (2011), are part of a photo-graphic series that explores the idea of alien visitations to his hometown of Utuado and the resulting impact on the local community. Considering mixed feelings about Puerto Rico being a U.S. territory, ADÁL also sug-gests that the aliens may have chosen Puerto Rico over the mainland for their visitations, that is, the United States' sense of exceptionalism does not translate necessarily on an intergalactic level.

Szupinska-Myers's essay "Máquinas Solteras: On the Bachelor Machine in Latino and Latin American Art" explores the concept of the "Bachelor Machine as a means to grapple with technology's possibilities as related to the living body." She springboards from Marcel Duchamp's concept of "La Machine Célibataire," or "the Bachelor Machine," as an entry point for discussing the oscillation between "self and other, male and female, ego and superego, robotic and organic, and science and faith." Szupinska-Myers explores what she defines as the *mestizo* object in the works of Rubén Ortiz Torres, Chico MacMurtrie, Roberto Matta, José Clemente Orozco, Graciela Iturbide, and Frida Kahlo. For her, these artists grapple with machines and the mechanized body in order to "generate narratives of empowerment and liberation as well as dark, dystopic read-ings about gender, technology, and power."

Mestizaje is constitutional to Schmelz's essay, "The Insubordination of Alternate Worlds." She interweaves thoughts on colonialism; tropicalism; U.S.-Mexico border relations; humor, and parody; and the ways in which representations of Mexico's indigenous population weave in and out of all these political and social threads. Focusing on Mexican science fic-tion films, such as *The Aztec Mummy vs. The Human Robot* (1958), she

draws on Bolívar Echeverría's concept of *la blanquitud* or "whiteness" to explore the dialectic between Mexico's indigenous world and the nation's strides toward modernity as represented allegorically in Mexican science fiction film. Schmelz concludes that such films become sites of resistance within globalization when they become "an unintentional parody . . . that is a form of appropriation, or a parodic *tropicalization*, of the colonizers' imaginaries that is aimed, not at imitating, but rather sabotaging the dominant models of identity." She brings this analysis to bear on artists such as MASA, Rubén Ortiz Torres, ADÁL, and Guillermo Gómez-Peña, as a way of showing how neo-Aztec mysticism has manifested itself through border transmigrations in which the ancient Aztecs, modern-day Mexico, and Hollywood science fiction films overlap in a hybrid or *mestizaje* universe "in which the ancient Mesoamerican gods are situated face-to-face with the cyborg gods of progress."

The mythologizing of not only indigenous people but also Brazil in science fiction films from the United States and Latin America is central to Suppia's essay, "Memories of Green: On Literary and Cinematic Representations of the Amazon." Suppia's point of departure is Arthur Conan Doyle's novel *The Lost World* (1912) and its cinematic adaptation, which provide some of the earliest literary and cinematic representations of the Amazon as an enigmatic place. They contribute to a body of writing, film, and visual discourses in which, as Suppia writes, "the Amazon is set as a utopian/uchronian landscape, and a repository of both power and damnation." He discusses Brazilian films alongside those from the commercial Hollywood industry, such as *Creature from the Black Lagoon* (1954) and *Anaconda* (1997).

The Amazon's science-fictional conveyance fascinates Suppia, particularly as a demonstration of how "the monster persists usually incarnating the jungle in all these commercially oriented films," a stand-in for Western and European invaders, whether from the Conquest in the past or from today's encroaching globalization. As if Schmelz and Suppia are nodding to one another across the Americas—he in Brazil and she in Mexico—he also discusses Brazilian films that use parody, in the manner that Schmelz discussed in her essay, to offer a different perspective on the Amazon. Suppia examines Ivan Cardoso's Brazilian comedy *A Werewolf in the Amazon* (2005), which satirizes, as he writes, "foreign cinematic representations of the Amazon by overtly undermining the relevance of white male characters, and by 'carnivalizing' ancient myths and the encounter between Westerners and native Amazonians." In essence, for Suppia, the Amazon is represented as both a utopian resource of life's abundance and a dystopian setting in which its dense foliage and hungry fauna devour those who stray away from their "civilized" worlds.

Vint's essay, "The Other Worlds We Live In: Latin American Science Fiction Film," situates the use of science fiction motifs in Latin American art in a larger conversation about science fiction studies. She brings into focus how Hollywood-style filmmaking is often countered by a Latin

American style that emphasizes realistic storytelling and documentaries. But by drawing on science fiction scholar Darko Suvin's influential premise that the genre functions as a reflection *on* reality rather than a reflection *of* reality, Vint explores "why many Latin American countries, particularly those in post-dictatorship contexts, have used science fiction to capture aspects of their reality that exceed the representational possibilities of realism." According to her, "sometimes an invented reality can prove the best way to confront and ultimately transform an existing one." Focusing on two Argentine films, *La Sonámbula* (1998) and *La Antena* (2007), she writes that "post-dictatorship Argentina is perhaps the Latin American country that has most embraced the possibilities for science fiction cinema" as a way to bring to light painful times during the *Guerra Sucia* (or Dirty War), a period of state-endorsed terror between 1974 and 1983 that could not be voiced then, and is still difficult to voice today.

Unhinging science fiction cinema from contemporary art and spatial aesthetics is central to Stallings's essay, "Slipstream Islands of Strange Things: Building *Mundos Alternos* in the Americas." Although original book cover art, comic books, and movie posters are classic visual texts within the science fiction genre, he argues that they are produced ready for reproduction and absorption through other reproducible media such as magazines and computer screens, so to interact with them is simply to view them in their reproduced, mostly illustrative, sense. Stallings emphasizes artist-made physical objects, or slipstream, science-fictional artifacts, by thinking through the tangled and alternative worlds these artists build albeit in the art studio, collector's home, plaza, or museum environment. The profound phenomenological effects of interacting with the materiality of the artworks as speculative technology and as portals were critical to the encounter. Glexis Novoa, LA David, Rigo 23, Beatriz Cortez, Faivovich & Goldberg, Gyula Kosice, and Alex Rivera engender complex domestic constellations of art, artifact, and space.

These science fiction environments are keys to "alternate worlds" or "slipstream islands," as Stallings puts it. *Slipstream*, a term coined by science fiction author Bruce Sterling in 1989, is applied to speculative fiction in order to create a sense of the uncanny, of weirdness in the world, of dissonance between what one thinks is real and the feeling that other layers exist beyond the senses upon which we rely, or at least the dominant manner in which they are utilized for perceiving the received world around us. In essence, he argues, art making itself represents a kind of science-fictional process that results in a slipstream artifact, or strange thing. Thus the science fiction collectible and popular ephemera are jettisoned for the otherworldly "touch" of artists' alien environments in a pseudo-pilgrimage.

+++

While Chicano, Latino, and Latin American science fiction is a burgeoning area of study that has gained momentum within the past ten years, with an emphasis mostly in literature and film, our hope is that this book

and the accompanying exhibition, with their focus on visual art, will be groundbreaking. The swath of artists selected from across the Americas—the States, Mexico, Central America, the Caribbean, and South America—have created artworks that point to *Mundos Alternos* in which self-determination and autonomy can occur in a present that is already the past pointing to a future.

As you read this book and view the work in the exhibition, we hope that you feel like your thoughts and experience are part of proto-science fiction, Argentine writer Jorge Luis Borges's unbounded library, or that you have inklings of the Aztec empire existing on the moon. Or perhaps you may walk the streets of Los Angeles and have a moment in which you feel that you are part of the first Xicano science fiction novel, Ernest Hogan's *Cortez on Jupiter* (1990),[22] in which Pablo Cortez sprays graffiti across Los Angeles and paints in zero gravity, all in an effort to make a masterpiece for the universe and his barrio.

NOTES

1. For more on "México en el año 1970," see Rachel Haywood-Ferreira, *The Emergence of Latin American Science Fiction* (Middletown, CT: Wesleyan University Press, 2011), pp. 18–19. For Posada in relationship to Halley's Comet, see Miguel Ángel Fernández Delgado, "Saudade for Space, Utopia, and the Machine in Latin American Art," in *Past Futures: Science Fiction, Space Travel, and Postwar Art of the Americas*, ed. Sarah J. Montross (Brunswick, ME: Bowdoin College Museum of Art; Cambridge, MA: MIT Press, 2015), pp. 50–51. On *El Eternauta,* consider Adam Rosenblatt, "The Making and Remaking of *El Eternauta*," *International Journal of Comic Art* 9, no. 2 (2007): 81–92.

2. Jacqueline Barnitz, *Twentieth Century Latin American Art* (Austin: University of Texas Press, 2001), p. 358.

3. Mari Carmen Ramírez, "Inversions: The School of the South," in *Inverted Utopias: Avant-Garde Art in Latin America*, ed. Mari Carmen Ramírez and Héctor Olea (New Haven: Yale University Press, 2004), p. 73.

4. This comment was brilliantly relayed to Hernández by contributor Kency Cornejo.

5. Mari Carmen Ramírez, "Constellations: Toward a Radical Questioning of Dominant Curatorial Models," *Art Journal* 59, no. 1 (2000): 14–16.

6. *Mundos Alternos* was curated by Robb Hernández, assistant professor in English at UC Riverside; Joanna Szupinska-Myers, curator of exhibitions at UCR ARTSblock's California Museum of Photography; and Tyler Stallings, interim UCR ARTSblock executive director.

7. Sarah J. Montross, "Cosmic Orbits: Observing Postwar Art of the Americas from Outer Space," in Montross, *Past Futures*, p. 19.

8. Ibid., pp. 14–31.

9. *Plan 9 from Aztlán* is a riff on Ed Wood's infamous B movie, *Plan 9 from Outer Space* (1959).

10. Vasquez's curatorial contributions are conveyed in Matthew David Goodwin, "The Fusion of Migration and Science Fiction in Mexico, Puerto Rico, and the United States" (PhD diss., University of Massachusetts, Amherst, 2013).

11. Irma Carolina Rubio, "Project M.A.S.A., MeChicano Alliance of Space Artisans," *Chicano(a) Art*, July 2006, p. 15.

12. Ibid., p. 23.

13. Manuel G. Aviles-Santiago, "The Technological Embodiment of Colonialism in Puerto Rico," *Anthurium: A Caribbean Studies Journal* 12, no. 2, (2015): 1–20.

14. Tey Marianna Nunn, "The Cyber Arte Exhibition: A Curator's Journey through Community and Controversy" (paper presented at the Interpretation and Representation of Latino Cultures: Research and Museums national conference, Center for Latino Initiatives, Smithsonian Insitution, Washington, DC, November 2002), http://latino.si.edu/researchandmuseums/presentations/nunn.html.

15. Ibid.

16. Catherine S. Ramírez, "Deus ex Machina: Tradition, Technology, and the Chicanafuturist Art of Marion C. Martinez," *Aztlán: A Journal of Chicano Studies* 29, no. 2 (2004): 55.

17. Catherine S. Ramírez, "Afrofuturism/Chicanafuturism: Fictive Kin," *Aztlán: A Journal of Chicano Studies* 33, no. 1 (2008): 185–94.

18. Mark Dery, "Black to the Future: Interviews with Samuel R. Delany, Greg Tate, and Tricia Rose," in *Flame Wars: The Discourse of Cyberculture*, ed. Mark Dery (Durham: Duke University Press, 1994), p. 180.

19. Recorded lecture from 1971 when Sun Ra served as artist-in-residence at UC Berkeley and offered the course African-American Studies 198, "The Black Man in the Cosmos," https://ubusound.memoryoftheworld.org/ra_sun/Ra-Sun_Berkeley-Lecture_1971.mp3.

20. For more on "Shadows Took Shape," see Naima J. Keith and Zoe Whitley, eds., *The Shadows Took Shape* (New York: Studio Museum in Harlem, 2013).

21. Tegan Bristow, "We Want the Funk: What Is Afrofuturism to Africa?," in ibid., p. 81.

22. Ernest Hogan, *Cortez on Jupiter* (New York: Tor Books, 1990), https://www.createspace.com/5026216.

DECOLONIAL FUTURISMS

ANCESTRAL BORDER CROSSERS, TIME MACHINES, AND SPACE TRAVEL IN SALVADORAN ART

KENCY CORNEJO

Can the future be decolonized? Can a decolonial future only exist in creation and imagination, in *seeing* and *being* in a liberated world before it actually exists? The Zapatistas, the army of indigenous Mayans who pledged full battle against neoliberal globalization in the fight for autonomy, live in the present as if they already won. Their world is one "where many worlds fit," and through their "intergalactic encounters" they build a network of solidarity for humanity and against neoliberalism.[1] Their struggle is ongoing, but the future they envision is not one predicated on a Western linear timeline of progression, and thus not something to reach in the far distance; it is now. Similarly, historically oppressed and marginalized communities are currently envisioning future worlds as states of liberation through the tools of speculative creativity, as in afro-, feminist, Chicana, and native futurism.[2] By intervening and subverting hegemonic narratives through science fiction, filmmakers, writers, and artists of color create alternative futures in response to, and departing from, their own histories of oppression in which they become agents and architects of those futures and not merely subject matter or warnings of dystopia. Art, in particular, offers the platform and liberty to imagine and create worlds that defy the rules of modernity/coloniality beyond textual iterations and into material and bodily manifestations.[3]

Decolonizing the future, therefore, entails a decolonization of the past and present, a temporal simultaneity that delinks from a Western rationality of time and space in the making of decolonial epistemologies and ontologies that can exist in a pluraverse.[4] The problem of modern ontology is the assumption that there is only one universe (the Western universe). This stands in contrast to indigenous philosophies of a multiverse, or pluraverse, such as that of the Zapatistas who claim a world where many worlds coexist. Only a pluraverse gives way to multiple ontologies, cosmologies, cultures, and ways of knowing that in turn offer infinite possibilities for profound social transformation. Therefore, decolonizing the future entails the invention of multiple radical worlds by those whose worlds are still clenched by coloniality. Three Salvadoran

artists, Irvin Morazán, Beatriz Cortez, and Simón Vega, imagine decolonial futurisms through an alien entity in a borderless space, a memory-insertion machine, and a tropical space capsule. Their work speaks to a specific Salvadoran experience and unique perspective that deserves consideration, yet is also rooted in colonial legacies and U.S. intervention that appeals to a broader Central American context. Their sculptural and performative works help us think decolonially about the relationship between science fiction and art in the making of liberation, as they expose the colonial history of the past and present in order to envision a just future for Central Americans within the region and beyond its borders.

THE COLONIALITY OF TECHNOLOGY, TIME, AND SCIENCE FICTION

First, one must consider the role of colonialism in the genre, as well as the coloniality of time and technology in the Americas in order to comprehend why the *imagining* of future decolonial worlds through the lens of speculative science fiction narratives and technoculture can be a radical gesture. In Western exceptionalism, there has been only one valid order of nature, one science to make sense of that order, and only one society—Western society—viewed as capable of producing that science.[5] Meanwhile, technologies and knowledge of colonized peoples across the Americas have been deemed underdeveloped, primitive, lacking reason, and founded on superstition or fantasy. The uneven distribution of technologies inscribed Western technology as a marker of imperialism and capitalism, where the West has been the sole producer and the rest of the world either consumes or becomes the subject of technological and scientific studies. Moreover, while Western scientific advancements are sold as admirable discoveries advancing civilization, their harmful and destructive consequences are blamed on Third World political carelessness and ignorance. One only need notice how environmental destruction, arms industries, pandemics, toxic residues from nuclear testing grounds, food deserts, and medical experimentation are played out in geographical areas inhabited by people of color, indigenous communities, and throughout Latin America (for example, Hiroshima, New Orleans, Los Alamos, Alabama, and Guatemala). If today everyone lives in a global modernity propelled by Western scientific technologies, then there are some who live in its darkest corner, its underside.

Western concepts of time, space, and future are also embedded in the language, philosophy, and science used against colonized peoples. The idea of "progress" alone, as a definitive marker of capitalism and imperialism, is linked with Western orientations of time and space. In this case, a lineal view of time as opposed to a cyclical view that predominates in many indigenous cultures such as Maya cosmologies. Western compartmentalization of time and space, moreover, produces binaries used to shape gender roles and social behavior, and to dictate people's relationships with landscape, labor, and leisure. Therefore, time is used as a tool of social control.[6] Thus time, space, and technology are framed as

belonging only to the West, and historically they have been used as markers of superiority *against* colonized and oppressed peoples, first through colonialism and now with coloniality. If futurity in time and space is still to come, but space and time remain colonized, then the future will be defined and structured in the service of coloniality. A decolonial future, therefore, requires a decolonization of time and space, of yesterday and today.

The narratives in the emergence of Western science fiction are also trenched in ideologies of colonialism and imperialism. The motif of exploration and conquest into unknown lands, encounters with extraterrestrials, and the link between superior and inferior civilizations with technological wealth, along with ideas of human origins and possible futures, were fueled by evolutionary theory, anthropology, and colonial discourse of the nineteenth century. Encounters with alien creatures perpetuated a colonial gaze, and notions of the exotic Other. And both landscape and peoples represented primitive remnants of the past. As John Rieder explains of early American science fiction, fantasies of progress motivated characters into narratives that echo the Westernization and Christianization efforts of the time.[7] Therefore, if science fiction as a genre explores the relationships between technology, time, and society, one cannot ignore the role of Western scientific technologies in the modern/colonial world and, in this case, in Central America.

For instance, since the nineteenth century, the United Fruit Company (UFC) has corporately colonized, exploited, and transformed a diverse Central American tropical ecosystem into a chemically infested monoculture. Through its plantations, it has controlled workers' time and space. This process was framed as "bringing modernity"—through capitalism, science, and medicine—to the useless jungles of Central America where the potential for profit was considered wasted by its people.[8] The deplorable living conditions on the plantation, however, were made worse by the chemical pesticides that were spread over unprotected workers and their families, causing sterility among men and diseases among children. Scholar Ana Patricia Rodríguez has even noted how early writers referred to the abjection of Central American children working in banana production, describing them as "greenish" children whose bellies were "stuffed with worms, amoebas, ankilostomas and God knows how many monsters."[9] UFC's technological and scientific modernity turned Central American children into "green monsters," a contrast to the healthy American children who were nourished by the bananas marketed to American consumers.

UFC later played a role in inciting U.S.-funded Central American wars. For instance, after president Jacobo Árbez's agrarian reform law, which expropriated hundreds of thousands of acres from the UFC for distribution to Guatemalans, the UFC collaborated with the CIA to support the overthrow of Árbez in a 1954 coup, thus protecting American investments.[10] In other words, the UFC was protecting the control of land, space, time, and its profits. The coup then set the stage for a thirty-six-year-long

civil war in Guatemala (1960–96). During that time, a series of U.S.-funded wars spread throughout the region, resulting in mass killings, disappearances, and migration. These wars resulted in the development of various anti-insurgent groups, such as the Kaibiles in Guatemala, who have been described as "killing machines."[11] Meanwhile, their targets—indigenous children—have been referred to as "bad seeds," an oppositional juxtaposition of technology over nature.[12] If "colonial invasion" in early science fiction narratives, as Rieder states, "is the dark counter-image of technological revolution," then the corporate colonization by UFC in Central America is but one example of how the coloniality of technology produced the dark corners of modernity, where children are turned into "green monsters" and men into "killing machines."[13]

What is at stake then, for artists to envisage and create fantastical and future alternative worlds? What is at stake for those of us whose histories have been erased, with injustices committed against us unresolved, for whom history repeats itself, with new wars in Central America, new refugees at the borders, new canals to destroy our lands, new systems of repression, and new methods of criminalizing us? What does it mean to decolonize the space and time that maintain cycles of oppression? While these Salvadoran artists subvert characteristics known to science fiction, they should not be confused or reduced to a mere inclusion in, or diversification of, the genre. Life is at stake. For historically oppressed peoples, imagining future narratives and worlds from which they have been imagined out of, rewriting narratives that defy colonial logics of time and space in order to assert and claim their own futurity, and exposing injustices produced and silenced by the tools of Western progress are radical gestures of creation and a decolonial act, particularly from one of the smallest countries in the Americas, and from one of the smallest corners of modernity—El Salvador.

COLONIAL TEMPORAL DISPLACEMENT AND FUTURIST BORDER-CROSSER

As a child growing up in El Salvador, forgotten archaeological sites became Irvin Morazán's playground, fueling his interest in the country's original habitants and ancient indigenous civilization. Yet he received no answers to his childhood inquiries about them, in part due to a lack of information and knowledge about these sacred spaces, but also due to erasure of Salvadoran indigenous histories, which had been increasingly enforced since the 1932 genocide of thirty thousand indigenous men in El Salvador.[14] This erasure forced Morazán to *imagine* indigenous ancestors through his own childhood drawings in which he created ancient Mayan priests with elaborate headdresses that would later become a key component of his performances. Now based in the United States, Morazán fuses his connection to indigenous cosmologies with his own childhood migration experience to challenge the current anti-immigrant rhetoric that draws on colonial fantasies of alien encounters. Through his

performances, he creates a borderless future where mobility is both free and healing.

For *Illegal Alien Crossing* (2011), Morazán wore a metallic headdress that gave him the appearance of a hybrid half-man, half-machine extraterrestrial creature (see fig. 1). He walked the landscape in ritual and then crossed the Rio Grande, the geographical border between the United States and Mexico—a site historically traversed by countless immigrants searching for a better world. As he submerged his body in the river, his metallic headdress reflected the sun's rays onto the water, creating a mystic field around him. Morazán thus incarnated two alien connotations—the extraterritorial creature and the immigrant—to evoke the idea of a futuristic border crosser. The supernatural image he created forces us to question what migration might look like in the future. Who will migrate and in what direction? And if political borders ceased to exist, what would Central American movement and mobility across these lands look like? All are valid questions that take into account Salvadoran migrant children who are currently fleeing from one violent context to another.[15]

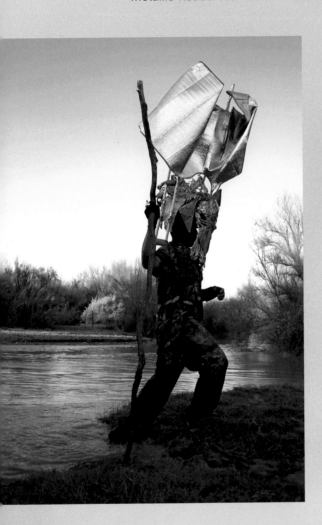

While Morazán's performance references both the current immigration crisis for Central Americans and the artist's experience as a child migrant, it also further challenges colonial temporal displacement. Morazán unsettles the colonialist rhetoric that aims to dislocate people from their contemporaneity and into a past for the purpose of imposing biased hierarchical values on human lives. The U.S.-Mexico border has become one more point of encounter for colonial temporal displacement. There, U.S. imperialist superiority and futurity confronts a supposed Latin American backwardness and past. U.S.–enforced border patrols and right-wing vigilantes enact science fiction fantasy encounters of the third kind in their hunt for "illegal aliens," as has been the case with the Texas Rangers, Minutemen, and, more recently, Immigration and Customs Enforcement (ICE) and its surveillance technology. In these encounters immigrants' lack of material possessions and technology, as well as physical exhaustion, are juxtaposed against the border patrols' technologies, including night-vision goggles, weapons, cars, and both ground and airborne sensors to establish a temporal disjuncture. The desert landscape evokes the final frontier, uninhabited land, and hunting ground, and the capture and detention of immigrants at the border reinforces both Western fantasies of progress and science fiction constructions of triumph over invading extraterrestrials—all to secure human and earthly resources. Beyond racist and nationalist, this anti-immigrant act is played out as a victory over mankind for world protection.

Morazán's performance inverts this narrative by decentering science fiction narratives from colonialist fantasies and instead departing from the immigrant experience while re-inscribing healing associations rooted in ancient Maya relationships with the land. In Mayan cosmologies, the earth and all its elements and corners are sacred and interconnected with human existence, thus requiring respect and reciprocity. When Morazán

FIGURE 1
Irvin Morazán
Crossing Performance
2013
Digital C-print, 30 × 20 inches (76.2 × 50.8 cm)
Courtesy of the artist

migrated as a young boy from El Salvador to the United States, a dog was placed over his body in order to hide his existence as the *coyote* drove him in a truck across the border.[16] This invisibility becomes symbolic of the way migrants are forced to live in the shadows. Morazán contrasts the pain of this secrecy, illegality, and shaming with the hyper-visibility of the metallic headdress whose solar panels reflect the sun's rays, creating a luminous shield as they bounce off the water around him. By exalting his presence in this manner, Morazán turns trauma of negation into a healing ritual of light and preservation. Moreover, in the Rio Grande's water, countless migrants' lives have been lost as stricter border control forces them into more dangerous routes, and many drown in its canals and ditches.[17] Morazán delinks from the river's violent associations and instead returns to its healing powers and the sacredness of water through the rituals he enacts during the performance. He thus subverts the "alien encounter fantasy" by evoking an ancestral past into the present, connecting it to today's Central American migrant crisis to imagine a decolonization of borders as a decolonial future.

COUNTERING COLONIAL ERASURE THROUGH HISTORICAL MEMORY INSERTION

Erasure of colonized peoples' histories, cultures, languages, systems of knowledge, and ways of being is a key tactic of colonization. Only through erasure can colonizers then rewrite histories where they are victors, establish their culture as dominant and superior, and disseminate their knowledge as universal truth. Erasure is then secured through the control of memory. For it is not in the interest of colonizers that the colonized recall events of violence and injustices as they unfolded in the process of their repression. Memory and the recovery of memory by oppressed peoples, therefore, can be one of the strongest decolonial acts. With this in mind, one can view Salvadoran, Los Angeles–based artist Beatriz Cortez's sculptural installation *Memory Insertion Capsule* (2017) as art that exposes the stakes of memory recovery by laying bare the historical amnesia of white supremacy (see fig. 2).

In the installation's exterior, one sees an open, hexagonal sphereshaped machine with the appearance of a spaceship covered in metal and mirrors that reflect surrounding lights as well as viewers' presence and movements. The interior resembles the inside of a house with a navigation station that includes a steel desk, fireplace, and bookshelf on one side, and a refrigerator, microwave, and stove on the other. In the center, a reclining chair with a helmet component invites viewers to enter the futuristic machine and steer through a sensorial experience of images, sounds, smells, and sensations, as lost historical facts are inserted into the participant's brain through the helmet. The virtual reality component merges a futuristic experience with images of nineteenth- and early twentiethcentury technology, creating a feel of both time travel and a simultaneity of modernities for participants. With the simple press of a button, the *Memory Insertion Capsule* releases a series of historical moments, as

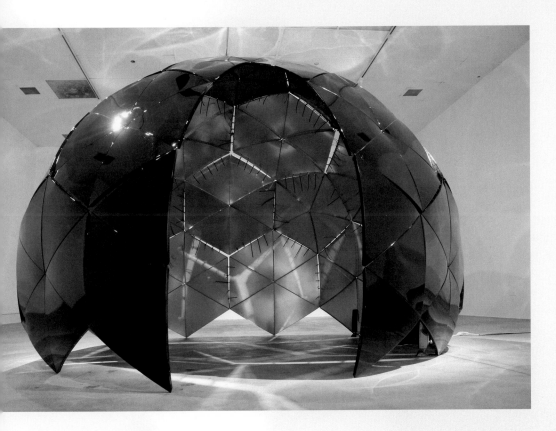

memories, found through the artist's own archival research on past eugenics projects in Los Angeles and at UFC.

The memories are of various historical figures, moments, locations, and events that are actually interlinked in collaboration toward the support of white supremacy. For instance, they include references to Frederick Wilson Popenoe who was the chief agronomist of the UFC in 1925. For decades the company represented U.S. imperialism and the epitome of corporate colonization in Central America. And though it changed its name to Chiquita Brands International in the 1980s, its use of toxic pesticide continues to cause birth defects, cancer, and sterility among workers. Such name-changing strategies (just as the School of the Americas was renamed the Western Hemisphere Institute for Security Cooperation in 2001) are superficial tactics of deterrence and attempts to erase history. By bringing forth these "memories," Cortez exposes the underlying rationale of race, racism, and white supremacy that links UFC to Central American wars, and to Los Angeles, to reveal how white supremacy functions across borders.

For instance, another series of memories exposes the Popenoe connection to a Los Angeles–based institute that supported eugenics projects and served as a model for the Nazi Holocaust. The American Institute for Family Relations was established by Paul Popenoe, Wilson Popenoe's brother. Paul fiercely advocated for the sterilization of the mentally ill, physically challenged, poor, and immigrants, and he used his work on

FIGURE 2
Beatriz Cortez
Black Mirror, **part of** *Your Life Work* **exhibition at the Cerritos College nahuArt Gallery, Norwalk, California**
2016

family therapy as a platform for supporting white supremacy.[18] Through memories, Cortez further connects such cases with other U.S.-sponsored experiments on racialized peoples, such as the Tuskegee syphilis experiment (1932–72) during which 399 black male sharecroppers in Alabama's poorest sector were studied for syphilis progression and were either not informed that they carried the disease or were left untreated. The data was collected through autopsies, thus the men were left to deteriorate until their deaths, as only then were they useful for the experiment. In Guatemala, a similar experiment infected a population of 5,500 prisoners, sex workers, psychiatric patients, and children with sexually transmitted diseases to study the value of different medications.[19] Beyond the imaginative efforts of the *Memory Insertion Capsule*, Cortez serves as curator of these memories, carefully finding those moments of overlap in colonial projects of white supremacy to reveal links between perceived isolated cases in colonial erasure.

Cortez's *Memory Insertion Capsule* centers precisely on this violent history and its reach into the contemporary. This time travel through different geographical locations and times not only reminds participants of historical events that produced suffering, pain, and death in the service of imperialism and scientific discoveries but also places the participant/time-traveler in confrontation with the present, a crucial epistemological intervention for a path toward decolonization efforts. It asks us where coloniality functions today? Where is white supremacy today? And what other colonial and imperial projects through invasive biomedical technologies are being erased *at this moment* from our consciousness and histories? What is at stake in memory, especially for Central Americans, whose presence and histories in the United States are actively forgotten through exclusion? Thus Cortez's work alludes to the idea of bearing witness.

Colonial erasure happens in the present when there is no one to acknowledge, recognize, or speak against injustices. Through *Memory Insertion Capsule*, Cortez takes control of technology, space, and time to navigate history and recover the present for the possibility of a decolonial future.

ASTRO-COLONIALISM AND TROPICAL SPACE TRAVEL

The scarcity of technology has been used as a measure for human progress and superiority, fueling competition among nations for imperial global supremacy. The "arms race" and "space race," offshoots of the Cold War between the United States and the Soviet Union in 1940s–90s, exemplified the aggressive drive in establishing military dominance among nations. When in 1957 the Soviets launched Sputnik 1 as the first successful artificial satellite in outer space *before* the United States, the event set a crisis in motion, a competition for technological advancement beyond Earth's limits. The United States frantically amassed vast resources and reallocated government entities, which led to the establishment of the National Aeronautics and Space Administration (NASA), and the launch

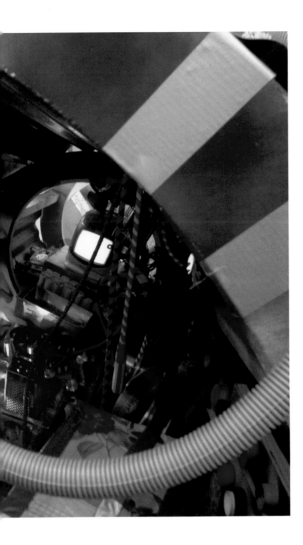

of space capsules into orbit to explore possibilities for the military occupation of space. Considering these nations could potentially destroy each other with nuclear weapons, they instead fought the Cold War through proxy wars, with other nations as battlefields and collateral damage. The Vietnam War and Central American civil wars are prime examples.[20] This rivalry sought both ideological and military domination, and it opened the possibility for a new battlefield in the war for imperial control and colonial expansion—outer space. It also inspired the growth of science fiction in the United States.

With his installation *Tropical Mercury Capsule* (2010), Salvadoran artist Simón Vega offers a space travel machine from the *other* battlefield, the one with no access to NASA technology and no access to global powers, but in which the violence of war and colonial legacies manifest (fig. 3). The installation is a parody representation of NASA's Project Mercury.[21] In contrast to the sleek appearance of metal and durable materials, Vega constructs the capsule out of wood, cardboard, and metal roofing, all materials used in improvised architectural structures in Salvadoran homes, or in shantytowns across the Americas, like Brazilian favelas. Quotidian materials like rope and plastic water vessels maintain the structure intact. Tropical plants seep through its openings. The installation is displayed in a post-crash landing setting, with debris surrounding the structure. Openings offer glimpses of the capsule's interior navigational board where one sees a stereo, a car seat, an electrical fan, and an icebox full of beer. The space capsule is a clear enunciation of its geographical and geopolitical point of departure, El Salvador. There is no attempt to suppress the emerging tropical plants that evoke the Salvadoran landscape, or the everyday objects in a Salvadoran home. Instead, Vega offers a glimpse into what a Central American space program could look like by creating it in a future past tense. It has already landed.

The race for world-destroying nuclear weapons and space machines draws on colonialist fantasies of progress in which unpopulated and uncharted frontiers are explored and developed. Whereas earthly landscape became a trope of the "past" in American science fiction, the exploration of space evokes the future due to its technological requirements for access. The questions then, of who belongs in that future, who will navigate it, who will own everything in its eternal abyss, and who will exploit it for supreme domination, are the concerns of "astro-colonialism." With a humorous lens, *Tropical Mercury Capsule* asserts itself into modernity's narrative of technological progress and space exploration—a narrative in which its only (forced) participation is as battleground for superpowers—thus doing so from modernity's underside, coloniality. However, as indicated through its makeshift structure and reference to technological scarcity, the capsule distances itself as a participating competitor for domination. Rather, it is a machine of intervention. Tropical space travel does

FIGURE 3
Simón Vega
Tropical Mercury Capsule
2010
Wood, aluminum, tin roofing sheets, cardboard, plastic, TV, fan, icebox, boombox, and found materials,
Capsule: 67¹¹⁄₁₆ × 129¹⁵⁄₁₆ inches (172 × 330 cm); overall: 118⅛ × 236¼ inches (300 × 600 cm)
Collection Pérez Art Museum Miami, gift of Mario Cader-Frech and Robert Wennett
Photo by Tyler Stallings (inside detail)

not imply playing the game by its rules. Its mere existence is a defiance of such rules. Emerging from a Cold War hot zone, the capsule conveys creativity as a tool of survival and resistance.

TOWARD A DECOLONIAL FUTURISM TODAY

Decolonial futures are created by people who still endure the legacies of colonialism, who have been imagined out of histories and futures, and whose bodies and lands have been forced to serve as testing grounds and battlefields in Western narratives of progress. They function on a simultaneity of being, a defiance of a linear timeline of progression, where past, present, and future bend, rotate, and reverse to graze each other and locate colonial wounds wherever they may hide. A temporal and geographical mobility of creativity defies the logic of Western reason. And the speculativeness of science fiction is countered with historical and embodied knowledge to heal the present, and thus claim and shape the future. Decolonial futurity is not a role reversal of the same modern/colonial world system, but a disruption, intervention, and possible dismantling of it through the creation and imagining of alternative worlds. Art in this sense becomes the tool, road map, model, and instruction manual for creating that alternative pluraverse.

Morazán, Cortez, and Vega create such road maps through their installation and performance art. Morazán offers a blueprint with which to imagine worlds where politically imposed borders cease to exist, and where our human right of migration can be a healing reconnection with our ancestors and the sacredness of our lands. Cortez provides a time-traveling machine with which to bear witness to past injustices and refuse to forget atrocities committed against us, thus countering colonial erasure in our fight against white supremacy. And Vega offers a space capsule that asserts our presence beyond this earth as an act of defiance and as intervention in dominant superpower wars for supremacy. These artists' works may play on humor and evoke characteristics of science fiction and speculative narratives, thus appearing not to pose a "real" threat to the structures of coloniality that continue to erase us and imagine us out of their future. However, a decolonial futurism is grounded on the decolonization of our imaginations today. That is where the real power and threat lie. For only when we decolonize our imaginations is anything possible.

Dedicated to the memory of my aunt, Ana Morena Cornejo, who lost her battle to cancer in El Salvador during the writing of this essay. Thank you Tía More, for supporting my dream of better worlds.

NOTES

1. For a history of the Zapatismo emergence, see Gloria Muñoz Ramírez, *The Fire and the Word: A History of the Zapatista Movement* (San Francisco: City Lights Books, 2008). For more on actions and intergalactic encounters, see Jill Lane, "Digital Zapatistas," *Drama Review* 47, no. 2 (2003): 129–44; and Roger Burbach, *Globalization and Postmodern Politics: From Zapatistas to High-Tech Robber Barons* (London: Pluto Press, 2001).

2. For discussions on these narratives, see Ytasha L. Womack, *Afrofuturism: The World of Black Sci-Fi and Fantasy Culture* (Chicago: Chicago Review Press, 2013); Catherine S. Ramírez, "Afrofuturism/Chicanafuturism: Fictive Kin," *Aztlán: A Journal of Chicano Studies* 33, no. 1 (Spring 2008): 185–94; and William Lempert, "Decolonizing Encounters of the Third Kind: Alternative Futuring in Native Science Fiction Film," *Visual Anthropology Review* 30, no. 2 (2014): 164–76.

3. I refer to coloniality (as opposed to colonialism) and the modern/colonial world as theorized by Aníbal Quijano. See Aníbal Quijano, "Coloniality of Power, Eurocentrism and Latin America," *Nepantla Views from South* 21, nos. 2–3 (2007): 168–78; and "Coloniality and Modernity/Rationality," *Cultural Studies* 21, no. 2 (2007): 168–78.

4. César Carillo Trueba, *Pluriverso: Un ensayo sobre el conocimiento indígena contemporáneo* (Ciudad de México: Universidad Nacional Autónoma de México, 2012).

5. For a collection of writings on the history and role of Western science and technology through a post-colonial lens, see Sandra Harding, ed., *The Postcolonial Science and Technology Studies Reader* (Durham: Duke University Press, 2011).

6. As Maori anthropologist Tuhiwai Smith notes, "the indigenous world view, the land and people, have been radically transformed in the spatial image of the West. In other words, indigenous space has been colonized." See Linda Tuhiwai Smith, *Decolonizing Methodologies: Research and Indigenous Peoples* (London and New York: Zed Books, University of Otago Press, 1999), p. 51.

7. These include the "Discoverer's Fantasy," where inhabited land (whether by humans or not) is considered unclaimed land, or not used to its productive potential due to the inhabitants' lack of technology and knowledge; the "Missionary Fantasy," in which the disruption of traditional ways of life, despite resistance, is seen as serving the best interest of natives; and the "Anthropologist's Fantasy," where encounters with natives are seen as those with people from the past, the colonizers' past. See John Rieder, *Colonialism and the Emergence of Science Fiction* (Middletown, Conn.: Wesleyan University Press, 2008).

8. John Soluri, "Accounting for Taste: Export Bananas, Mass Markets, and Panama Disease," *Environmental History* 7, no. 3 (2002): 393.

9. Ana Patricia Rodríguez, *Dividing the Isthmus: Central American Transnational Histories, Literatures, and Cultures* (Austin: University of Texas Press, 2009), p. 65.

10. George W. Lovell, *A Beauty That Hurts: Life and Death in Guatemala,* 2nd rev. ed. (Austin: University of Texas Press, 2010), p. 134.

11. Daniel Rot Rothenberg and Comisión para el Esclarecimiento Histórico, *Memory of Silence: The Guatemalan Truth Commission Report* (New York: Palgrave Macmillan, 2012), p. 26.

12. Egla Martínez Salazar, *Global Coloniality of Power in Guatemala: Racism, Genocide, and Citizenship* (Lanham: Lexington Books, 2012), p. 103.

13. See Rieder, *Colonialism and the Emergence of Science Fiction*, p. 33.

14. See Virginia Tilley, *Seeing Indians: A Study of Race, Nation, and Power in El Salvador* (Albuquerque: University of New Mexico Press, 2005).

15. Elizabeth Kennedy, "No Childhood Here: Why Central American Children Are Fleeing Their Homes," The American Immigration Council. Washington, D.C., 2014, http://www.immigrationpolicy.org/sites/default/files/docs/no_childhood_here_why_central_american_children_are_fleeing_their_homes_final.pdf.

16. I briefly mention this work and Irvin Morazán's child migration experience in reference to my own communication with the artist. See Kency Cornejo, "'Does That Come with a Hyphen? A Space?': The Question of Central American–Americans in Latino Art and Pedagogy," *Aztlán* 40, no. 1 (2015): 189–210.

17. See Wayne A. Cornelius, "Death at the Border: Efficacy and Unintended Consequences of US Immigration Control Policy," *Population and Development Review* 27, no. 4 (2001): 661–85. For more on violence due to an increase in recent migration trails via cargo trains, see Oscar Martínez, *The Beast: Riding the Rails and Dodging Narcos on the Migrant Trail* (London: Verso, 2013).

18. Molly Ladd-Taylor, "Eugenics, Sterilization and Modern Marriage in the USA: The Strange Career of Paul Popenoe," *Gender & History* 13, no. 2 (2001): 298–327.

19. Kristen Minogue and Eliot Marshall, "Guatemala Study from 1940s Reflects a 'Dark Chapter' in Medicine," *Science* 330, no. 6001 (2010): 160.

20. For a chronicle on American intervention in Central America during the Cold War, see Stephen G. Rabe, *The Killing Zone: The United States Wages Cold War in Latin America* (New York: Oxford University Press, 2012); and William M. Leo Grande, *Our Own Backyard: The United States in Central America, 1977–1992* (Chapel Hill: University of North Carolina Press, 1998). For the history of American policies in Vietnam during the Cold War, see Michael H. Hunt, *Lyndon Johnson's War: America's Cold War Crusade in Vietnam, 1945–1968* (New York: Hill and Wang, 1996).

21. For information on the Project Mercury missions and astronauts, see Eugen Reichl, *Project Mercury* (Atglen, PA: Schiffer Publishing Ltd., 2016).

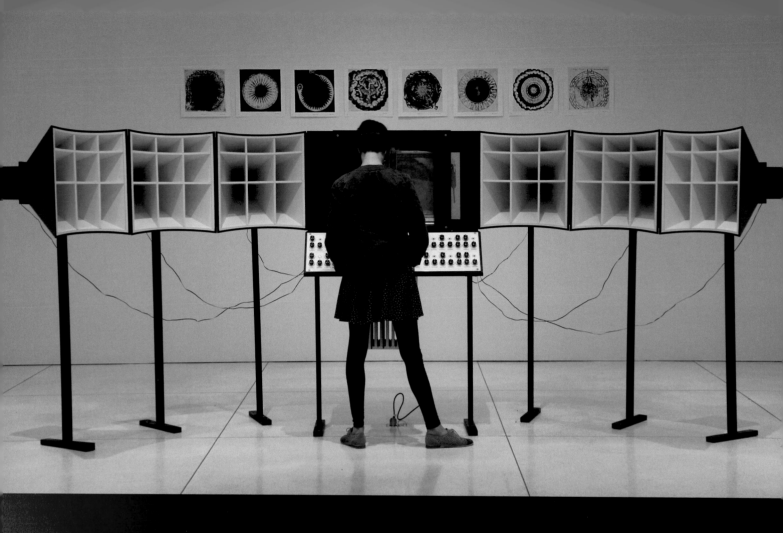

PLATE 1

TANIA CANDIANI
Engraving Sound
2015

Intersections among language systems, sound, and technology are the primary interest of artist Tania Candiani. Her work elicits nostalgia for the obsolete, but often does so through analog technologies that appear futuristic in nature. Most of Candiani's work is based on the history of science, the recovery of antique technologies, and the possibility of reinventing narratives. *Engraving Sound* (2015) is based on historical cosmological models, notions of translation, and analog technology. For the project, Candiani has selected eight seventeenth-century cosmological engravings by English physician and polymath Robert Fludd, who held extensive interests in science and the occult and engaged in discourse with his contemporary Johannes Kepler. Expanding on the continuing threads of language and sound in much of her work, Candiani worked with a

images, though their primary function is not to be printed but to be "played" with a needle. The engraved grooves are read as sound waves, much like a record, and are emitted via analog synthesizers. *Engraving Sound* is interactive; visitors choose a copper plate engraving to play in the machine and are able to modify the sounds using a large soundboard. The sound produced varies depending on the individual playing it and the unique character of the electricity contained within their body. Positive, printed images from the plates accompany the installation, offering a visual reference point to the project and another layer of translation to the images. This project was originally commissioned on the occasion of the *Trienal Poligráfica de San Juan de Puerto Rico* in 2015.

KATHRYN POINDEXTER

PLATE 2

BEATRIZ CORTEZ
*Los Angeles Vernacular: Space Capsule
Interior,* installation at Monte Vista
Projects, Los Angeles, 2016

In her installation *Memory Insertion Capsule* (2017), Beatriz Cortez invites visitors to piece together the fragments of an obscured history that draws connections between eugenics and U.S. corporate interventions in Latin America. Mining oppressive pasts, Cortez offers a laboratory for speculative thought, a venue to creatively imagine an alternative, life-sustaining future.

Cortez migrated from El Salvador to the United States in 1989. Her work is informed by her experiences of loss, migration, and armed conflict, and she often explores memory, time, and simultaneity through the juxtaposition of modern and historical technologies. Cortez's work is both technically astute in its material construction and theoretically nuanced, drawing on the philosophy of Spinoza, Deleuze, and Karen Barad, among others.

Eschewing the sterility of the classic Western space capsule, Cortez's immersive installation includes cozy amenities like a bookshelf, desk, and fridge. A fireplace built from steel river rocks evokes indigenous architectural methods. Through the "memory insertion" helmet, visitors can individually reassemble archival materials that illuminate neocolonial entanglements between the United States and Central America. The work stresses the need for historical reflection combined with a thoughtful consideration of which technologies and materials we will carry with us into the future.

RUDI KRAEHER

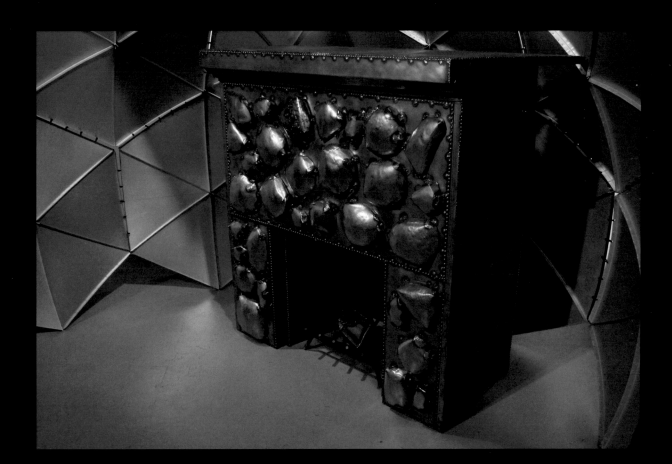

PLATE 3

FAIVOVICH & GOLDBERG
detail from *A Guide to Campo del Cielo*
2006–present

In 2006, Faivovich & Goldberg began *A Guide to Campo del Cielo,* an ambitious project that revolves around the cultural impact of a meteor shower that occurred in the region of Chaco four thousand years ago. The large masses of iron left by the event have been a source of endless mystery and wonder, leading to human pilgrimages to, and study, reconstruction, and reinterpretation of the site. Visual, oral, and written histories aim to identify the historical and contemporary implications of this meteorite shower. Faivovich & Goldberg's approach to the subject includes bibliographic inquiry, archival research, and interacting with people who have been involved in the region's history and wide-reaching fieldwork.

During the Space Race, interest in the meteorite field in Chaco grew, and consecutive excavations of the area began in the 1960s and in decades following, when the United States and Argentina embarked on a joint expedition to the crater field. The installation *A Guide to Campo del Cielo* centers on a single meteorite, known as "El Taco," found in the region by this international research team. After its retrieval in 1963, the meteorite was loaned by the Argentine government to the Smithsonian Institution for further scientific research and exhibition purposes. "El Taco" was then sent to the Max Planck Institute in Germany to be sectioned, undergoing a complex procedure that took more than a year. One half of the meteorite was sent back to Washington, DC, ending up in storage at the Smithsonian Institution while the other was returned to Buenos Aires, where it has been on public display at the Galileo Galilei Planetarium.

Faivovich & Goldberg's interest in the history of "El Taco" and related archives lies in the investigation of the dynamic between the two discovering nations, who collaborated to preserve and study an ancient, otherworldly artifact that transcends all political and geographical conventions. In 2010, as part of their exhibition *Meteorit "El Taco,"* held at Portikus, Frankfurt, the artists reunited the two main masses of "El Taco" for the first time since the meteorite was split almost forty-five years earlier. Visibly parts of a whole, the two halves nevertheless bear marks of their unique recent histories: one half is pristinely preserved in the archives of the Smithsonian, whereas the other half is weathered by its decades-long display in front of the planetarium in Buenos Aires.

KATHRYN POINDEXTER

PLATE 4

CLARISSA TOSSIN
Transplanted (VW Brasilia)
2011

Clarissa Tossin investigates the effects of modernity and globalism in her work, and frequently addresses the cultural and economic exchanges between her native Brazil and the United States. Tossin's latex cast of the first car entirely designed and manufactured in Brazil by Volkswagen, *Transplanted (VW Brasília)* (2011), symbolizes the country's dual histories of inclusion in mass production on a global scale and enduring the exploitation of rubber production. The work suggests the science fiction notion of the car assuming the role of a "third skin" in consumer society, drawing interesting relationships to Brasília's founding impetus as a modernist utopia.

Other works by Tossin also explore the map and the co-presence of the rubber industry, in both Brazil and the United States, particularly the failed plantation initiated by American industrialist Henry Ford, Fordlândia, which was intended to produce a rubber supply for Ford's automotive vehicles. Examples include *Fordlândia Fieldwork* (2012) and *Geographic Accident (9,468 miles collapsed)* (2012), in which Tossin printed double-sided images of topographical maps onto cotton paper sheets, which she placed on the floor, folded, slumping, and overlapping. The works jointly picture locations in Brazil and the United States and evoke both the modernist sculptural aesthetics of artists like Carl Andre and Robert Morris and the material-conceptual effect of transposing or collapsing geographical locales.

KATHRYN POINDEXTER

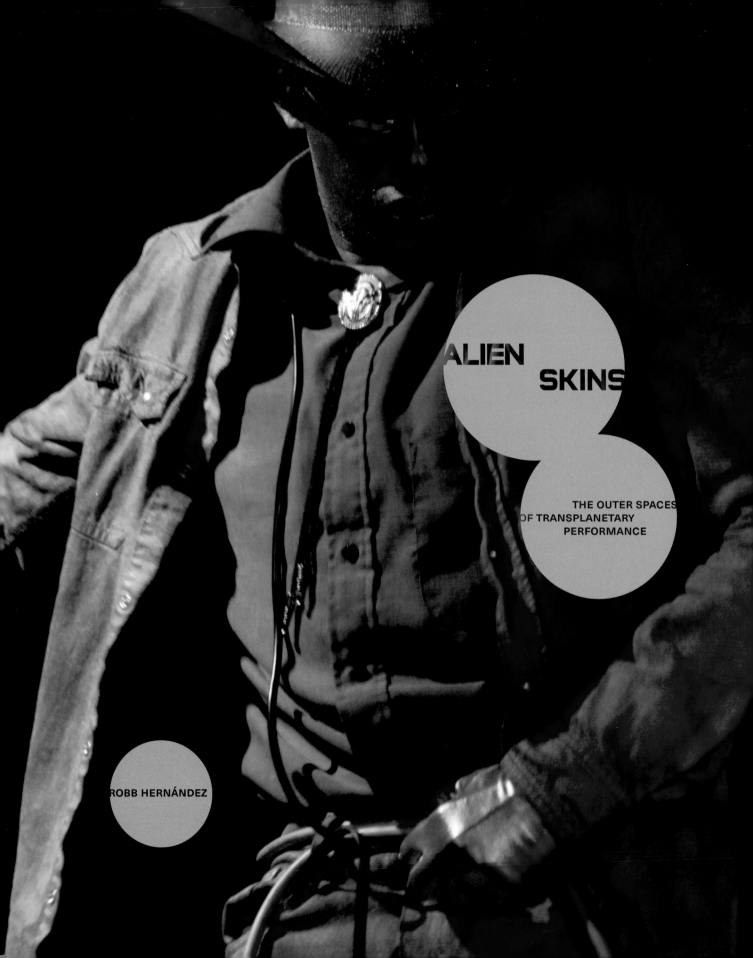

ALIEN SKINS

THE OUTER SPACES OF TRANSPLANETARY PERFORMANCE

ROBB HERNÁNDEZ

When Museo Alameda opened in San Antonio's Market Square on April 13, 2007, it was a Tejano utopia realized.[1] An extraordinary venue for the 1.2 million Latino residents in the city, the ambitious forty-thousand-square-foot postmodern architectural palace representing future promise was projected to attract four hundred thousand visitors per year.[2] As the museum's chairman of the board, Henry Muñoz, stated, "At last, Latinos have a national museum to call their own. . . . The Museo Alameda will be inclusive, enlightening and inspiring for generations to come."[3] For these reasons, it was no wonder that the opening day's festival was a futurist spectacle.

With twenty thousand people in attendance, two astronauts in silver space suits appeared like Tejano extras from an episode of *Lost in Space* (fig. 1).[4] Representing Project MASA—the MeChicano Alliance of Space Artists, a humorous riff on NASA located ironically in nearby Houston, Texas, and the cornmeal subsistence of pre-Columbian societies—artists Luis Valderas and Paul Karam made a future world tangible, one in which Tejanos had taken intergalactic flight. These cosmic travelers arrived in an otherworldly pocket of time and space, actualizing the utopic enterprise of Museo Alameda, a venue in service of "imagining better futures" but one that ultimately came to pass.[5] However, by 2012 hope had turned bleak. Despite its cultural potential, accusations of financial mismanagement, impending lawsuits, outstanding fines, and dwindling philanthropic support forced the museum to close its doors.[6] A Latino utopia became dystopia, causing the *San Antonio Current* to lament, "[B]efore the museo existed, there were dreams."[7] Indeed, and where there were dreams there were also nightmares.

What is fascinating about the Museo Alameda story is not its end in ruin. Rather, it is the way its rise and fall reads something like science fiction. In fact, throughout the history of Chicano art and performance, visitations by otherworldly beings like MASA's space cadets punctuate benchmarks of muséal accomplishment, yielding the promise of Chicano art exhibitions as vehicles of cultural progress, of Latino futurism.

Paul Karam and Luis Valderas
Masa Mission 2.5
2007
Photograph from performance, image
courtesy of Luis Valderas

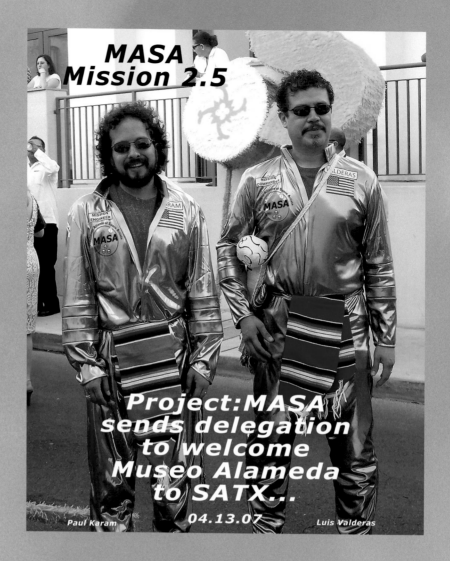

MASA
Mission 2.5

Project:MASA
sends delegation
to welcome
Museo Alameda
to SATX...
04.13.07

Paul Karam Luis Valderas

And yet the indescribable appearance of alien personages demon-
strates the profound way art museums' utopic enterprises curiously
intertwine with the strange outer spaces of Latinidad, that ethno-racial
identity complex of "multiple locations for frequently divergent ideological
goals," as Deborah Paredez argues.[8] Performing transplanetary Latinidad
is not bound to San Antonio museum culture. It can also be observed in
Los Angeles.

Take, for instance, when curator Jane Livingston opened *Los Four* in
1974, the first Chicano art exhibition in the history of Los Angeles County
Museum of Art (LACMA). Defining "Chicano art" for the general public
through narrative-based paintings and figurative aesthetics, the expres-
sive acrylics, brushy canvases, and aerosol paints of Carlos Almaraz, Gil
"Magu" Lujan, Frank Romero, and Roberto de la Rocha shaped a Chicano
visual vocabulary rooted in East Los Angeles. However, the avant-garde
conceptual artists, Asco (Spanish for "nausea") crashed the party. Here,
they introduced something else, something disruptive, even alien, at the
opening. The group—which just two years earlier had spray-painted their

names onto the museum's façade to protest how LACMA's elite culture was relegating Chicano art to the museum's outer spaces—embodied their liminality by appearing in shimmering fabric, towering platforms, and blue face paint (fig. 2).[9] Remembering the opening, Asco member Willie Herrón recalls, "We painted our faces. We hung things from our bodies. . . . And we just went like wanting people to see some part of Chicano art that still didn't exist, that wasn't in that show that we felt had to be in that show. . . . We performed without even performing."[10] By embodying "that [which] still didn't exist," Herrón ushered in a future personae from an outward lying world, a barrio reality altered in blue face. His was a performance of predictors, an arrival forthcoming, a Chicano art to come but in the words of José Muñoz, "not yet here."[11]

Drawing on Muñoz's polemic work on "queer futurity," this essay elucidates a "horizon of being" and becoming through extraterrestrial embodiment, a Latino performance repertoire inside "alien skin."[12] Using an interplay of cosmic artifice, speculative fashion technologies, and radiant epidermises, these artists resituate their bodies in outer laying spaces and other temporal zones, finding utopia outside the restrictive barriers and suffocating gravity of their materialist circumstances. The alien skin imparts hope and futurist possibility against a Latino "historical existence in the past" and, more to this point, beyond Earth-bound existences.[13] Rather, a transplanetary Latinidad emerges as a creative reserve from which utopia can be imagined, "a temporal arrangement in which the past is a field of possibility in which subjects can act in the present in the service of a new futurity."[14] By "dragging" the future into their regressive political present, these alien personae cut across generational differences, time lags, and regional formations in major Latino art epicenters like San Antonio, Los Angeles, and New York City. Doing so, this essay illuminates a rarely examined dimension of Latino art and performance culture in these metropoles whereby Chicano subjects take flight, alternate realities are inhabited, and other worlds are created furthering a queer utopic project inside the iridescent shell of alien skin.

FIGURE 2

Still of "Members of Asco, appearing in shimmering fabric, towering platforms, and blue face paint at the LACMA opening of *Los Four* in 1974" from *Los Four/Murals of Aztlán: The Street Painters of East Los Angeles*, directed by James Tartan

(1974; Los Angeles: Chicano Cinema and Media Art Series, UCLA Chicano Studies Research Center, 2004), DVD. Courtesy of UCLA Chicano Studies Research Center

POD PEOPLE

Airborne aesthetics were indispensible to the artistic imagination of Project MASA co-founder, Luis Valderas. Born and raised in McAllen, Texas, near Reynosa, Mexico, in 1966, Valderas was immersed in a South Texas agri-technoculture, an environment punctuated by the borderlands ecology of Mexican growers, bracero labor, mechanized farming landscapes, and, arguably, rocket ships in the garden.[15] Between 1972 and 1973, Valderas's mother was responsible for proliferating avocado tree growth throughout the Rio Grande Valley.[16] By practicing a borderland botany predicated on the exchange of seeds, clippings, and horticultural specimens between binational *familias* and *vecinos* across borders, her avocado trees transplanted Mexico into the harvest. With each fruit-bearing pod, she collected seeds and replanted them in her nursery, engendering

a Tejana laboratory of science and magic. Valderas recalls, "So imagine these bowls of avocado pods . . . drying so that my mom could plant them. She had an orchard of all these one-gallon containers of avocado pods just halfway out and they kind of looked like rockets coming out."[17] The sea of plastic bottles and gallon milk jugs nurtured the pods to maturity from brown seedlings to green life forms. Casting the silhouettes of miniature rockets, this speculative "domesticana" technology stirred something inside Valderas.[18]

Scaling the branches of avocado trees and the tin roof of his house, he looked upward, exploring the distances between land and sky.[19] His focus on the avocado pod articulated an incipient metaphor for Chicano space travel, echoing the simultaneity of shapes—an Apollo command space module, the subsistent result of Mexican farming, and a penetrative projectile barreling through atmospheric barriers and gravitational forces. As Cathryn Josefina Merla-Watson observes about Valderas's work, "The avocado seedpod/rocket blends and (con)fuses various symbolically suggestive forms . . . to explore connections between the persistent binaries of the primitive and the technological, the celestial and the earthbound, the masculine and the feminine."[20] More than this, he repurposes *aguacate* to reimagine a futurist existence where Chicanos fly. This iconographic focus on astronavigation provided a launching pad for Valderas as he searched for other sites of cosmic explanation.

Languishing on the vastness of space, Valderas's metaphysical art philosophies drew influences from a variety of pop cultural, art historical, and conceptual sources. In fact, he jokingly cites *The Ed Sullivan Show*'s recurrent character José Jimenez among NASA's uncredited astronauts, as proof of Mexicans' presence in space. The incendiary ethnic caricature played by comedian Bill Dana grew popular on American TV sitcoms and variety shows in the late 1950s. It advanced ideas about aeronautical exploration that reflected the era's Space Race during the Cold War. The character's thickly accented introduction ("My name is José Jimenez") and his dim-witted responses to astronautic questions, in particular, generated laughs, typically at the ludicrous vision of a daft Mexican astronaut. Incidentally, Dana admitted that his harmonic dialect was shaped during a college trip to visit his friend's father, a colonel stationed in San Juan, Puerto Rico. The exaggerated Caribbean accent he was exposed to later fused with the José Jimenez character, creating a linguistic formation that is as much Boricua as it is Mexican in sound.[21]

Although the Jimenez persona took on other occupations, portraying the astronaut was so constitutional to the character that Dana released two chart-topping LPs that emphasized this performance, including the 1962 release, *Jose Jimenez in Orbit/Bill Dana on Earth*. The album cover depicts an empty-minded, wide-eyed portrait of Jimenez as an ethnic buffoon in a chrome-embellished space helmet (fig. 3). Dana's "brown face" portrayal is nothing less than offensive—an issue he struggled to rectify in 1970 when his comedy routine drew ire from Chicano activists.

According to Chon Noriega, "after additional pressure, Dana retired his Mexican caricature, announcing at a Los Angeles rally attended by 10,000 Chicanos, '[A]fter tonight, Jose Jimenez is dead.'"[22] Nonetheless, his performance cuing Latino spacey stagecraft evoked an optic Valderas was honing. Valderas's art is one piece of a cosmic visual aesthetic in which satire, technology, and politics are attuned to the symbolism of the space-bound Mexican astronaut.

Other Chicano artists were imbued with a skyward-bound cultural imaginary. On April 30, 2004, Valderas fortuitously encountered artists Jose and Malaquias Montoya, Esteban Villa, and Rudy Cuellar, members of the historic Sacramento-based artist collective, Royal Chicano Air Force (RCAF), at the *Chicano Art for Our Millennium* exhibition at Arizona State University.[23] Blending art for social change with imagery that incited political protest, the Rebel Chicano Art Front formed in 1969 as an art center for teaching silk-screening classes, protecting public murals, and, more importantly, supporting the United Farm Workers (UFW) unionizing efforts. However, the group's original name created confusion. As Valderas retells, "They were having an exhibit in Sacramento . . . then some tourists came in and they saw the ad and came in to see the exhibit which was the RCAF art exhibit which they thought it was the Royal Canadian Air Force and so when they were questioned one of the guys said, 'No. This is the Royal *Chicano* Air Force, we got planes and we got pilots.'"[24]

Playing with the double meaning of the acronym allowed members of the RCAF to synergize past experiences as the children of farmworkers and of military service in the Korean and Vietnam Wars, and to channel the confrontational ethos of paramilitary-styled groups like the Brown Berets and Black Panther Party for Self-Defense.[25] By fashioning themselves in accoutrements for aerial battle, the group used the pilot persona to simultaneously intimidate the public defending picket lines and boycott demonstrations while riffing on the absurdity of a Chicano special forces unit. As Ella Diaz notes, "The RCAF balanced the serious side of their air force persona with humor and farce as a means of artistic and cultural rebellion."[26] Whether landing at rallies in vans and jeeps or flying "adobe airplanes" festooned in tactical armor, goggles, and especially combat boots, their impromptu guerrilla performances embodied a simultaneity of aerial-visual artillery.[27]

As such, their self-presentations are evocative of a conceptually based performance art in which the idea of flight mobilizes other imaginings of Chicano existences in air, a subjectivity intimately tied to aeronautical technology. Reversing agribusiness ocular regimes that utilize crop dusters, pesticide clouds, and aerial perspectives to surveil and control *campesinos* on the ground, as Curtis Marez argues, "The RCAF elaborated an alternative reality where they formed an imaginary aerial counterforce to agribusiness domination of the visual field in California."[28] For Valderas, what the infusion of the cosmic astronaut and conceptual army of fighter pilots enabled was a way to use humor, performance art, and

activist structures to recircuit Earth-bound technologies that otherwise disarm Chicano subjectivities and ground them. By reimagining his social circumstances in line with alien existences, Valderas did not need a plane. What he needed was a space agency.

This is perhaps why Valderas's appearance at the opening of Museo Alameda in 2007 was so instrumental. Dressed in a luminous silver space suit bearing uniform patches that indicated rank, name, and national affiliation, "Mission Commander Valderas" descended upon the San Antonio museum public from a future world. His resplendent "alien skin" bore personalized embellishments in a futurist tense of time and place. Personalized symbols of glittering floral motifs, a regional badge declaring "TejAztlan," and the organizational emblem for the MeChicano Alliance of Space Artists (MASA) branded this spaceman within interceding imaginary geographies, regional identities, and alien worlds. A UFW flag adorned the backside of the suit, giving visual gravity to these (outer) spatial identities. A layer of hand-painted text obscured the iconic black thunderbird beneath it, reading:

> This cosmico traveler has to help in "La Causa"
> If found please tiranos esquina and send word to los primos y las primas . . .
> Que aqui estamos y no nos vamos—MASA

As a "cosmico traveler," Valderas combined the cosmic humor of Bill Dana with the political satire and technological sophistication of RCAF. In this way, he drafted his astronautical alter ego into the Chicano *movimiento*, "La Causa," and the museo utopia, but he was not alone. Playfully code-switching between Spanish, English, and regional Tejano slang, he declared, "tiranos esquina," or "have my back." Hailing the museum public to call his *familia* and assist in his safe return, his suit talked back, evoking a familiar narrative device in science fiction whereby the (space) shipwrecked alien must return home. Of course, home in this performance is questionable, especially considering the hostile anti-immigrant sentiment enveloping the United States. By the time Museo Alameda opened in 2007, nationwide protests had erupted over proposed legislation that would charge undocumented workers with felonies and mass deportations. Valderas's spaceman arrived at the right time, anointing the futurist possibility of the museum as a cultural remedy despite the political chaos. By declaring, "Que aqui estamos y no nos vamos" [Here we are and we are not leaving], the "alien" signified dual meaning that undercut an American science fiction convention. For aliens in this plot, there was no return to a distant galaxy. They were here, not going anywhere, and Valderas's *cosmico* traveler made this reality obvious.

The way in which Valderas infused humor within the darker vestige of immigration, deportation, and "criminal alien" discourse was central to Project MASA and its counter imagery. Curating three thematic exhibitions in 2005, 2006, and 2007 at Gallista Gallery and Centro Cultural Aztlan,

Valderas used gallery spaces to imagine Latino future worlds, speculative technologies, and alternative existences that subvert historic colonialism in Texas and reinvest alienness with socially transformative possibilities and utopian promise. In her review of Project MASA I, Irma Carolina Rubio concluded, "There is a sophisticated sense that even if we are deported or choose to leave planet earth, our spirituality, icons, traditions and ancestors remain present in the universe, a space free of borders, ethnic categories and human struggle."[29] Whereas MASA drew submissions from artists across the Southwest, East Coast, and Puerto Rico, it also exerted a decidedly Tejano science fiction focus. MASA's strength was in its depth of talent and collaborative art gestalt, which have long characterized San Antonio's art and socially oriented creative practice. Nothing could be truer than in the work of one MASA artist in particular who illuminated a spectacular machination of alien skin performed in the everyday: LA David.

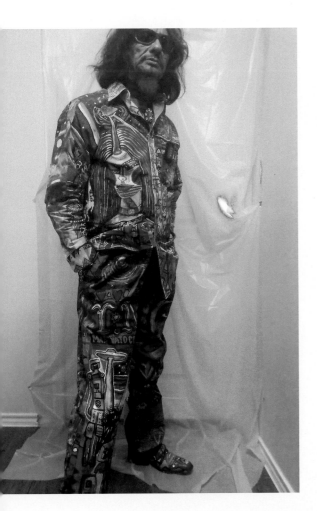

SPACE VAQUEROS

As the self-proclaimed "El Vato Cosmico," LA David is a consummate original, local icon, and recognizable fixture at Joe Lopez's well-known Tejano art establishment, Gallista Gallery. With a splash of glitter, green grease paint, and jewel-embellished *botas*, LA David molds a futurist artifice of Tejano street accoutrements (fig. 4). Vintage pearl snap shirts, creased wranglers, embroidered guayaberas, vests, and felt fedoras paired with sheik Keith Richards–looking sunglasses are refashioned in an unusual iridescent palette of thickly laden fluorescent paints. Bearing motifs of flying saucers, witty *burro* characters, and aliens gorging themselves on street tacos, LA David fabricates a dynamic alien skin consonant with the speculative fashion technology of a space vaquero and narratives of his intergalactic travels.

Contact with other worlds is inextricable to LA David's *arte cosmico* oeuvre, a story told on his clothing, which documents his self-proclaimed encounters with extraterrestrials in the 1970s.[30] His fabrics, paintings, and immersive environments conjoin whereby alien imagery bleeds from the walls of the gallery onto his body canvas. Luminous energy surrounds his art exhibition, creating the cosmic conditions to re-perform the alien encounter, to make contact, and to ride along the stars. Bathing his viewers in fields of black light, strands of Christmas tree lighting, and a battery-operated laser pin, his installations create an intertextual and multisensory experience. His rhinestone-embossed fabrics and decorative chains cast shimmering flecks of light that generate impressions of interstellar constellations. They cover him like coordinates to other worlds, exteriorizing a celestial body in alien epidermis, a transplanetary ontology sensed in one of his self-portraits (fig. 5).

Through this immersive cosmic halo, painting and fashion blur, alien and human distort, and knowable and unknowable dimensions of San Antonio come into perspective, resulting in what LA David calls, "a cosmic feeling."[31] Using his exhibition environment to instill alien/alienating

FIGURE 4–5
LA VATOCOSMICO c-s
untitled objects from studio
2008–16
Courtesy of the artist

affective relations, his cosmic atmospheres are felt, touched, and embodied. As a spectacular "walking canvas" he stirs public attention, provoking warped public perceptions.[32] He observes, "When [people] see the glitter on my face it's an attraction, it's like candy there, you convert something [there] and push them to ask questions almost like a neon light passing through the cosmos in space and there are lights, shadows, and hues and coloration and other people getting involved and that is important."[33]

Like a comet messenger trailing the sky, this space vaquero collapses proximities between cosmic worlds. His performance aesthetic is reminiscent of David Bowie's androgynous glam-rock alien persona, Ziggy Stardust, that stunning lipsticked and gold lamé–covered space traveler whose rock concerts became a "monument to glittering artifice" and his embodiment of "science fiction personified."[34] Without overstating, what David Bowie did for the United Kingdom, LA David does for San Antonio. Besides a shared surname, both are synergistic cultural nexuses of music performance, punk fashion, and defiant tenors in attitude and style. This corollary is transmitted by one reporter from the *San Antonio Express-News,* who called LA David's "flamboyant" personage a "distinctive rock 'n' roll rebel image."[35] Like a headliner for his own Bowie art-concept band, he is a rock star persona filtering different facets of the area's music scene and hosting semi-regular "burro fest" concerts—an amalgamation of art exhibition, poetry reading, DJ spinning, bands, and self-display. Here, he harnesses Tejano showboating flair. In fact, LA David's intersection with art, alien, and punk echoes his cameo appearance in *Clumsy Skin* (2007), a video directed by local filmmaker Jimmy Mendiola for the band Girl in a Coma.[36] His "fashionista cosmico style" accentuates the cross-generational frenzy of erratic pulsating beats stoked by this group of Tejana punkeras in a bucolic cantina.[37]

Akin to the way Ziggy Stardust "exaggerates the strangeness of his appearance . . . seem[ing] not to belong to the urban landscape in which he appears," LA David does the same, amplifying his displacement from the temporal rhythms and social palate of the urban landscape.[38] In fact, clues to his dislocation are cued in his name. Being dubbed "LA" is a euphemism for his Hollywood theatricality, a code for his alternate existence, and perhaps a shorthand for his bodily mispronunciation of the *machista* syntax in San Antonio. Unlike Bowie, his "alien skin" was not a temporary role but rather a liberating decision to remove a socially imposed mask.[39] As performance scholar Philip Auslander notes, "[Bowie] imagined himself early on as a stage actor who would take on a series of roles without necessarily articulating a single, consistent persona through them."[40] LA David's embodiment actualizes the absurdity of the present, and as such, he turns to the future. By "dragging . . . the temporal" future, his existence has the capacity to upend his surroundings, opening another space-time dimension that is not a temporary theatrical façade, but rather an otherworldly, more cosmic way of being Tejano.[41]

FIGURE 6
Paul del Bosque
poster from AZTLAN Dance
Company's "Sexto Sol: A
Cumbia Cruiser's Guide to the
Galaxy" performance
2012
Directed by Roén Salinas
Courtesy of Paul del Bosque,
Nora Salinas, and AZTLAN Dance
Company

FIGURE 7
Documentation from AZTLAN Dance Company's "Sexto Sol: A Cumbia Cruiser's Guide to the Galaxy" performance with performer Paul del Bosque
2012
Directed by Roén Salinas
Photo by Nora Salinas
Courtesy of Nora Salinas and AZTLAN Dance Company

A consequence of LA David's "alien skin" re-circuits the cultural romance discursively shaping the Norteño vaquero body. Mystifying him within the cosmos, he is remade more ornamental, radiant, and ultimately, flamboyant. The queer potential of Tejano masculinity is implicit in these alien skins and yet cautiously negotiated in performance. Theatrical cosmetics, delicate fabrics, and self-styling idioms concealing the masculine body are carefully orchestrated, eclipsing the bisexual connotations and androgynous excess of Ziggy. Paul Del Bosque's performance as the Silver Sky Dancer in the show *Sexto Sol: The Cumbia Cruiser's Guide to the Galaxy* is further indicative of this shaky relation (fig. 6).

Organized by the Austin-based Aztlán Dance Company in 2012, the show was a cheeky response to the ancient Maya prophesy foreseeing the End of Days on December 12, 2012.[42] In the show, Del Bosque's skin was an aluminous silver façade (fig. 7), and he danced to the Norteño Latin pop rhythms of Los Pikadientes de Caborca's rendition of Michael Jackson's "Billie Jean" (1982/2009). Humming to the vibration of the galaxy, his choreography broke into a moonwalk, pushing his mechanistic robot movement against the surface of the alien planet. Akin to the light fields that are central to LA David's spatial practice, Silver Sky Dancer used tangles of electrical cords to revive ancient Maya space travelers, arousing them with harmonic surges generated from his chrome accordion. They rose from the floor out of hyperbaric slumber, resuscitated by a space vaquero with a penchant for techno-filtered Norteño music and ceremonial crotch grabbing. His phallic comportment proved Tejano heteromasculinity will survive Mesoamerican predictors of future disaster.

Whereas Del Bosque's Silver Sky Dancer is a brilliant and ultimately nour-ishing dance machine, his cyborg masculinity is a legible part of Latino futurism. However, alien personae in Los Angeles gravitated toward more sexually transgressive possibilities that embrace the effeminate gestures of science fiction and the queer otherworldliness of the city. As Joey Arias puts it, "I live at night."[43] A performance artist described as "the E.T. of drag," his remark underscores a familiar view of Los Angeles as an apoca-lyptic technofuturism, as popularized in the film *Blade Runner* (1982), or as a socially nihilistic dystopia.[44] Asco co-founder Harry Gamboa Jr. forwards this dark vision, arguing that "growing up in East Los Angeles was funda-mentally a segregated experience, if not an almost otherworldly experi-ence."[45] Chicano conceptualists who had intimate knowledge of Southern California's racial and sexual exclusion, urban violence, and generalized apathy catalyzed more experimental body vocabularies.

For Asco, converting Bowie's gender and sexual fluidity galvanized the city's alien worlds. For example, Willie Herrón, an Asco founder and front man for the punk band Los Illegals, cites Bowie among his influences. Herrón appears in the classic No Movie *The Gores* (1974), a photo-performance of filmic negation, in which Gronk, Patssi Valdez, and Humberto Sandoval star. Herrón's image is a cross between the physical comportment of Spider-Man and excessive self-styling of Ziggy Stardust replete with towering platform boots and body-accentuating costume in spandex.[46] Gronk sans eyebrows bears a haircut coiffed in Ziggy's iconic shag silhouette. He describes it as an aesthetic allegiance to British sci-ence fiction B films like *Devil Girl from Mars* (1954), a salacious tale about an alien queen sent to breed with contemporary humanoid studs.[47]

Other performers besides those from Asco were direct descendants of Bowie's queer science fiction corpus, brethren to his garish alien skins. A drag artist like Joey Arias reimagined his life through the sky. He recalls, "I liked to constantly reinvent and search and looked into space. I always looked to the sky and look at the clouds and look at formations and just see things looking at me and thinking 'that's what I want to do.'"[48] Joey Arias graduated from Cathedral High School in 1970, an all-men's Catholic preparatory school located northeast of downtown Los Angeles near Chavez Ravine that became an important epicenter for the Escandalosa Circle, a queer avant-garde formation of contemporary Chicano art.[49] In 1976, Arias left Los Angeles for New York City.[50] There, his penchant for fashion, music, and the kitschy excesses of science fiction film found a kindred spirit in East Village art fixture and German operatic singer Klaus Sperber, who later dubbed himself Klaus Nomi, his last name an anagram of *Omni* magazine, a popular science fiction serial published in 1978.[51] The pair's boundless creativity morphed into draggy alien spectacles. Together, they created an otherworldly palette of outrageously hued hair, thickly powdered pale complexions, and contoured dark lips.

The opening scene of a 1980 news story from NBC's *Real People* is indicative of this façade. Featuring the live mannequin antics of "New Wave" windows at Fiorucci's department store, Arias and Nomi appear among the shock performers, a vision of men dramatically framed in futurist makeup.[52] A close-up shot focuses on Arias, who is applying blood-stained tint over his luscious lips. Another scene introduces Nomi to the viewing public stating, "I'm Klaus Nomi from the Planet Nomi. I'm wearing black lipstick so you can see my lips and see what I'm doing with them."[53] He puckers, kissing the somatic membrane of the camera shot and sending an alien kiss through network technology, which televises his queer desire into ordinary living rooms of domestic TV consumers.

For Arias and Nomi, a tube of lipstick engendered an otherworldly reinvention of self. Their visages remodeled a speculative pliancy that used cosmetic appliques to remake body surfaces, intensifying an "out-of-this-world look."[54] The resulting "alien skin" was an infusion of the pair's creative exchanges, mutual fascination with extraterrestrial beings, exhaustive image studies, and fantasies of the sky. As Arias notes, "I'd play with Klaus's image. I'd fix his hair, and we'd try different looks with his make-up. We shot slides of his face and projected them on the wall . . . the way the light hit Klaus in one of the slides made his hair look like a fin. Klaus loved it."[55] The iconic "Nomi look" is traced by Arias, thus Chicano performance practice becomes an inextricable element of their queer alien personae (fig. 8).[56]

The apotheosis of their creative partnership reached a critical juncture on December 15, 1979.[57] The notoriety they achieved at Fiorucci's led to their scene-stealing appearance as David Bowie's backup dancers in his first appearance on *Saturday Night Live*. Bowie's rendition of "Man Who Sold the World," a single from the last of his Berlin Trilogy albums, with Arias and Nomi in the backdrop, added a queer futurist milieu to the stage.[58] Moving with automaton precision in matching triangulated finned hairdos and body-hugging red and black tube dresses, the alien couplet did more than welcome viewers to the cusp of New Wave music, they introduced them to Planet Nomi, a queer utopia in alien skin that like its namesake "offered the exhilarating prospect of total freedom—freedom to build one's own identity independently of any models or of any preexisting normative identities."[59] Alas, their queer, alien, world-making proposal was ruptured by disaster. In 1983, Nomi died from AIDS-related causes at the age of thirty-nine.[60] Arias eulogized Nomi in a poetic metaphor about the early 1980s, "We'd popped the champagne bottle, we heard the bang and felt the bubbles, but the bottle was empty. There was nothing left."[61]

Nomi's death was emblematic of the confusion and chaos surrounding the AIDS epidemic. It happened quickly and without warning. Entire aesthetic practices, artistic proposals, and audiences were decimated. The early years of the crisis propagated national anxiety, calls for quarantines, and the closure of public sex institutions, whereby the symbolic gains of sexual liberation were erased. Anti-gay vitriol was palpable, making vast

FIGURE 8
Klaus Nomi and Joey Arias photographed in NYC on January 30, 1980
© Michael Halsband

social prejudice, such as housing and employment discrimination, justifiable under rudimentary discourses of public health and safety. The AIDS onslaught propelled those touched by the virus into another reality, an existence likened to the twilight zone.

AIDS is an allegory for the way plagues and bioterrorism reoccur in science fiction narratives. This trope is further derivative of stories about biotechnologies advancing and, oftentimes, mutating humanity. This turn in speculative fiction is summated by Joan Slonczewski and Michael Levy, who conclude that "the quest for outer space has given way to the quest for the genome. The great adversary is no longer an alien superpower, but the enemies within."[62] Invasive biomedical inspection and public outcry against people suspected of having and spreading contagion are further indicative of this science fiction reality. AIDS activist Sean Strub captures this eerie alternate world in his memoir *Body Counts*: "People on the street stopped short of running from you. Instead, you were considered the walking dead."[63] Bodies are scanned for the physical manifestations of infection, for clues of diseased mutation, often the result of body wasting: Karposi Sarcoma (KS) lesions, skin rashes, and CMV retinitis.

The residual isolationism Latino artists endured, in particular, is strangely reminiscent of that experienced by the late Chicano conceptual artist Mundo Meza. Like Arias and Nomi, Meza worked at the cutting edge of New Wave fashion trends in performance art, retail, and window trimming. His queer knowledge of perceptual provocation and his capacity to paint photo-realist images with uncanny accuracy made a place for him in window-display design. With English fashionista Simon Doonan, he installed shocking and confrontational street-front tableaus at Maxfield's, Flip's Jeans, and Melon's Boutique on trendy Melrose Avenue in the early 1980s.[64] When KS lesions began to invade his body, he and his lover, Jef Huereque, retreated to a loft at the Brewery, an artist compound in downtown Los Angeles, where they lived in socially imposed exile.[65]

Like many people living AIDS-symptomatic, commercial cosmetics were politicized appliances for covering the necrotic traces of KS. Makeup blurred with biomedical technology, transforming complexions and body surfaces and giving gay men, in particular, the capacity to camouflage during the day and exist at night. Reflecting on his personal experience with KS in 1994, Strub recounted, "The lesions could be cut out surgically, radiated into oblivion, injected with powerful chemotherapy, or masked with makeup. . . . Treating them cosmetically was important to many people but not to me."[66] His choice to brandish KS challenged the public's refusal to see people living with AIDS. For Meza, the discriminatory gazes and psychological aftereffects were traumatic, especially in the early years of the outbreak.[67] Makeup and fashion provided someone like Meza the visual technology to escape ostracism while seeking a utopic elsewhere in otherworldly garb. Subverting socially sanctioned prejudice, he maneuvered through a clandestine acrobatic, a jump that only an alien skin could make.

For the upcoming Halloween party at Palette, a trendy West Hollywood nightclub that attracted the usual fair—raucous gays, urban debutants, and crowds of cutting-edge fashion connoisseurs—Meza required an outfit that not only mirrored the club's chic surroundings, outmatching the discriminating eyes of fashion aesthetes, but also disguised the visual signifiers of AIDS. With Huereque, he fabricated an avant-garde alien drag that adapted cosmic motifs, metallic surfaces, plastic piping, and found material to create an extraterrestrial glamour (fig. 9). Concealing his body in a hooded black sheath dress with matching gloves, Vulcan ear appendages, and antennae headdress, Meza coated his skin to thwart any ocular inspection. For Meza, science fiction fashion aesthetics were more than dress-up. In this moment, alien skin allowed his safe passage to enter the decadent biosphere undetected. In fact, Huereque reflects, "We took first place and it was *real* competitive because it was a real hard core fashion crowd at [Palette]. . . . We had a really great time. . . . We bought a bottle of Cristal and I was out and I came back to the loft and I said, 'Oh, what happened to all the champagne?' and he said, 'Oh, I drank it.' And I said, 'Oh, right on!' Poor man, he was in so much pain."[68] Cloaked in layers of fabric, wire-encrusted space rocks, and thickly coated black grease paint, Meza accomplished something quite rare. He masked evidence of his disease and for one night ironically donned alien skin and escaped his alienation. He tasted the utopic fruits of "ecstatic time," and finished the champagne.[69] He drained it leaving the bottle dry. On February 11, 1985, Meza passed away from AIDS complications. He was twenty-nine.[70]

Within Latino art history and performance culture, otherworldly existences have punctuated narratives of cultural progress, a queer futurism permeating museum institutions, exhibition benchmarks, and impromptu art happenings ranging from Tejas to Los Angeles and New York. Under the guise of alien skin, these artists embody a dynamic science fiction lexicon that ranges from aeronautical proposals of airborne Latino sub-

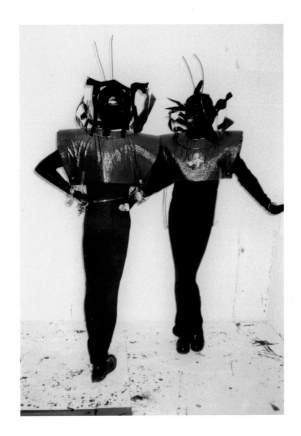

FIGURE 9
Photo documentation of *Mundo Meza and Jef Huereque, Halloween Party*
1983
Courtesy of Jef Huereque and Simon Doonan
Photo by Simon Doonan

jectivities and interstellar space travel to clandestine fashion technologies that remold the brown body through the charged end of a makeup brush. These artists perform the outer limits of Latinidad, inhabiting other realities—other reversals of time, space, and dimension. Whether appearing as spacey apparitions in Latino exhibition history or as harbingers of something forthcoming but not yet known, alien personae demonstrate the way speculative existences historically pervade art and politics. Consider how Chicanos organized their civil rights movement around a unifying struggle predicated under the mythic homeland called Aztlán. As William Calvo assesses, "Aztlán enabled Chican@s to understand their past, to make sense of their present, and to have hope for their future."[71] However, the wait for utopia is long. Turning skyward, these alien personae look toward a future Aztlán, seeking a transplanetary vision for Latinidad up above and pressing against the punishing gravity and border-bound limitations of this dimension.

NOTES

1. By "Tejano" I am referring to a Texas Mexican ethnic formation instilled by centuries of U.S. colonial occupation, domination, and "a history of economic and political disenfranchisement in the state," as performance scholar Deborah Paredez argues. Consider Paredez, *Selenidad: Selena, Latinos, and the Performance of Memory* (Durham: Duke University Press, 2009), p. 11.

2. Edward Rothstein, "Celebrating Hispanics from Both Sides of a Hyphenated Identity," April 21, 2007, *New York Times*, http://www.nytimes.com/2007/04/21/arts/design/21smit.html?_r=3.

3. Ron Jackson, "San Antonio's Newest Treasure Museo Alameda Showcases Hispanic Heritage," June 3, 2007, *Oklahoman*, http://newsok.com/article/3060900.

4. Rothstein, "Celebrating Hispanics from Both Sides of a Hyphenated Identity."

5. Curtis Marez, *Farmworker Futurism: Speculative Technologies of Resistance* (Minneapolis: University of Minnesota Press, 2016).

6. Scott Andrews, "The Struggle to Save the Museo Alameda Hinges on a Big Bottle," September 20, 2011, *San Antonio Current,* http://www.sacurrent.com/sanantonio/the-struggle-to-save-the-museo-alameda-hinges-on-a-big-bottle/Content?oid=2241813.

7. Ibid.

8. Paredez, *Selenidad*, p. 24.

9. These alien characters are visible in James Tartan's *Los Four* documentary. See *Los Four/Murals of Aztlán: The Street Painters of East Los Angeles*, directed by James Tartan (1974; Los Angeles: Chicano Cinema and Media Art Series, UCLA Chicano Studies Research Center, 2004), DVD.

10. Willie Herrón, interview by Jeffrey J. Rangel, February 5–March 17, 2000, Smithsonian Archives of American Art, Washington, DC.

11. José Esteban Muñoz, *Cruising Utopia: The Then and There of Queer Futurity* (New York: New York University Press, 2009), p. 12.

12. Ibid., p. 22.

13. Ibid., p. 16.

14. Ibid.

15. Gary D. Keller, Mary Erickson, and Pat Villeneuve, eds., *Chicano Art for Our Millennium: Collected Works from the Arizona State University Community* (Tempe: Bilingual Press/Editorial Bilingüe, 2004), p. 59.

16. Luis Valderas, interview by author and Tyler Stallings, September 16, 2014.

17. Ibid.

18. Consider, Amalia Mesa-Bains, "'Domesticana': The Sensibility of Chicana Rasquache," *Aztlán* 24, no. 2 (1999): 157–67.

19. Luis Valderas, "Project MASA: MeChicano Alliance of Space Artists" (unpublished exhibition catalogue, San Antonio, 2014), p. 5.

20. Cathryn Josefina Merla-Watson, "(Trans)Mission Possible: The Coloniality of Gender, Speculative Rasquachismo, and Altermundos in Luis Valderas's Chican@ futurist Visual Art," *Aztlán* 40, no. 2 (2015): 247.

21. "Bill Dana on Creating the Character of Jose Jimenez," YouTube video, September 1, 2011, https://www.youtube.com/watch?v=rGAm_7yRSCI.

22. Chon A. Noriega, *Shot in America: Television, the State, and the Rise of Chicano Cinema* (Minneapolis: University of Minnesota, 2000), p. 43.

23. Valderas, "Project MASA," p. 5.

24. Ibid.

25. Ella Maria Diaz, "The Necessary Theater of the Royal Chicano Air Force," *Aztlán* 38, no. 2 (2013): 42. On the stylish image of the Black Panthers, see Erika Doss, "Imaging the Panthers: Representing Black Power and Masculinity, 1960s–1990s," *Prospects* 23 (1998): 483–516.

26. Ibid., 61.

27. Ibid., 59. For "Adobe airplanes," see "Royal Chicano Air Force: Commandante General Jose Montoya and the RCAF Pilots," YouTube video, April 24, 2013, https://www.youtube.com/watch?v=MtNo5gEMdqs.

28. Marez, *Farmworker Futurism,* p. 27.

29. Irma Carolina Rubio, "Project M.A.S.A.: MeChicano Alliance of Space Artists," *Chicano Art Magazine,* July, 2006, p. 21.

30. LA David, interview by author and Tyler Stallings, September 18, 2014.

31. LA David, interview by author, August 8, 2016.

32. Ibid.

33. Ibid.

34. Philip Auslander, *Performing Glam Rock: Gender & Theatricality in Popular Music* (Ann Arbor: University of Michigan Press, 2006), pp. 138, 134.

35. Hector Saldaña, "Latin Notes: Burro Fest to Bow Out," June 20, 2012, *San Antonio Express-News*, http://www.mysanantonio.com/entertainment/article/Burro-Fest-finale-3646121.php.

36. "Clumsy Sky—Girl in a Coma," YouTube video, May 11 2007, https://www.youtube.com/watch?v=N0gJ5iiEBp0.

37. LA David, interview by author, August 8, 2016.

38. Auslander, *Performing Glam Rock,* p. 126.

39. LA David, interview by author, August 8, 2016.

40. Auslander, *Performing Glam Rock,* p. 111.

41. Rebecca Schneider, *Performing Remains: Art and War in Times of Theatrical Reenactment* (London and New York: Routledge, 2011), p. 36.

42. Paul Del Bosque and Roen Salinas, interview by author and Tyler Stallings, September 21, 2014.

43. Dominic Johnson, *The Art of Living: An Oral History of Performance Art* (London: Palgrave, 2015), p. 178.

44. *Arias with a Twist: The Docufantasy*, directed by Bobby Sheehan (New York: Working Pictures, 2013).

45. C. Ondine Chavoya, "Social Unwest: An Interview with Harry Gamboa, Jr.," *Wide Angle* 20, no. 3 (1998): 66.

46. Willie Herrón, interview by LA County Museum of Art, Los Angeles, 2011, http://www.lacma.org/art/exhibition/asco.

47. Max Benavidez, *Gronk* (Minneapolis: University of Minnesota Press, 2007), p. 17.

48. *Arias with a Twist: The Docufantasy.*

49. Joey Terrill, personal communication with author, September 13, 2016.

50. Johnson, *The Art of Living,* pp. 181–82.

51. Ibid., p. 185.

52. Ibid., p. 176.

53. "Klaus Nomi and Joey Arias Dancing in Fiorucci Windows NYC—Real People," YouTube video, December 16, 2009, https://www.youtube.com/watch?v=G-pMwDzK8uw.

54. Armand Limnander, "Alien Status," *New York Times*, August 27, 2006, http://www.nytimes.com/2006/08/27/style/t_w_1507_remix_nomi_.html?_r=1.

55. Johnson, *The Art of Living,* p. 185.

56. Ibid., p. 186.

57. Ibid., p. 175.

58. *Arias with a Twist: The Docufantasy.*

59. Zarko Cvejic, "'Do You Nomi?': Klaus Nomi and the Politics of (Non)identification," *Women and Music: A Journal of Gender and Culture* 13 (2009): 66.

60. Limnander, "Alien Status."

61. Johnson, *The Art of Living,* p. 189.

62. Joan Slonczewski and Michael Levy, "Science Fiction and the Life Sciences," in *The Cambridge Companion to Science Fiction,* ed. Edward James and Farah Mendlesohn, pp. 174–85. (Cambridge: Cambridge University Press, 2003), p. 174.

63. Sean Strub, *Body Counts: A Memoir of Politics, Sex, AIDS, and Survival* (New York: Scribner, 2014), p. 315.

64. For more on the disastrous aftereffects of the AIDS crisis on Meza's little known oeuvre, consider Robb Hernández, "Frozen World/Mundo Congelado: AIDS, Chicano Art, and the Queer Remains of Mundo Meza," in *Curatorial Dreams: Critics Imagine Exhibitions,* ed. Shelley Ruth Butler and Erica Lehrer, pp. 105–26 (Montreal: McGill-Queen's University Press, 2016).

65. Jef Huereque, interview by author, June 9, 2016.

66. Strub, *Body Counts,* p. 318.

67. The psychological dimensions of concealing KS and physical markers of AIDS are further elucidated in ibid., pp. 318–19.

68. Jef Huereque, interview by author, June 9, 2016.

69. Muñoz, *Cruising Utopia,* p. 32.

70. Hernández, "Frozen World/Mundo Congelado," p. 124.

71. William A. Calvo-Quirós, "The Emancipatory Power of the Imaginary: Defining Chican@ Speculative Productions," *Aztlán* 41, no. 1 (2016): 165.

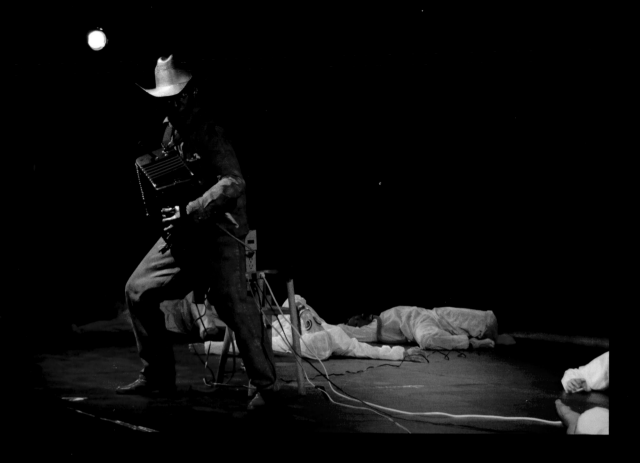

PLATE 5

AZTLAN DANCE COMPANY
Documentation from AZTLAN Dance
Company's "Sexto Sol: A Cumbia
Cruiser's Guide to the Galaxy" perfor-
mance with performer Paul del Bosque
2012

AZTLAN Dance Company was established in 1974 in Austin, Texas. Focusing on intergenerational contemporary dance under the auspices of art director Roén Salinas, the company uses the future to reflect on Mexican and indigenous pasts in the present. Amused by the national media hysteria surrounding the apocalyptic Maya prophesy on December 12, 2012, AZTLAN parodies the "End of Days" with a show titled *Sexto Sol: A Cumbia Cruiser's Guide to the Galaxy*. Riffing on Douglas Adams's science fiction radio series, *The Hitchhiker's Guide to the Galaxy* (1978), the dance company's re-appropriation took a more serious turn. By reinventing a cosmic mythos for Aztlán, the ancient homeland of the Mexican people, the group focused on an intergalactic origin for danza folkórica.

Interpreting cumbia's universal vibrations through the pulse of deep space, AZTLAN Dance Company speculates how ancestral sound moves in syncopated rhythm with the universe. The result is a reinvention of cumbia ushered by its herald, a time-traveling cyborg called "Silver Sky Dancer." Played by graphic artist Paul Del Bosque, the space vaquero arouses the dormant cumbia cruisers with the sound of his accordion. Plugging the dancers into electric cords patched into his hips, his silhouette shares a striking resemblance to the "cybracero" laborers in Alex Rivera's science fiction film *Sleep Dealer* (2008). Whereas "plugging in" in Rivera's dystopian fantasy digitizes Mexican labor, AZTLAN Dance Company energizes galaxy cruisers with the dark matter of what José Vasconcelos termed, "La Raza Cósmica." The success of this show yielded a trilogy featuring Silver Sky Dancer, which includes *Xicano Dreams: Earth, Life and Labors of Love* (2014) and *Xicano Super Heroes: Cumbia Cruiser's Chronicles—Vol. 1: The Rise of EloteMan* (2016).

ROBB HERNÁNDEZ

PLATE 6

ROBERT "CYCLONA" LEGORRETA
Transcend
1989

Harnessing the chaos of East Los Angeles into confrontational and salacious performance art and conceptual street actions, Robert "Cyclona" Legorreta adopted the alter-ego persona "Cyclona" in 1969. It infuses the rebellious spirit of World War II–era zoot-suiters with the destructive force of a meteorological aberration.

Legorreta's relationship with fellow artist Mundo Meza remains one of his most influential. After Meza's death from AIDS–related causes in 1985, Legorreta retired the Cyclona persona until 1989 when he reemerged at "Transcend," the First Anniversary Celebration for VIVA: Lesbian and Gay Latino Artists of Los Angeles. Performing a commemorative dance with choreography he learned from Meza, Legorreta moved in ethereal motion, orbiting along the surface of the floor in ghostly rotations. Bearing an astronautic headdress and adorned in mounds of pink chiffon, he remade his body through interstellar symbols, as evidenced by a star that covered his right eye, offseting his alabaster-coated façade. A third-eye sculpture mounted onto the crown channels metaphysical energy, aligning Cyclona's psyche with shifting moon cycles. Refabricated by its original designer artist, Mike Moreno, in honor of the legendary street performer, the costume design shares an uncanny resemblance perhaps inspiring the contemporary photographic works of Scott Speck and his retrofuturist portraits of steam-punk muse Electric Valkyrie.

ROBB HERNÁNDEZ

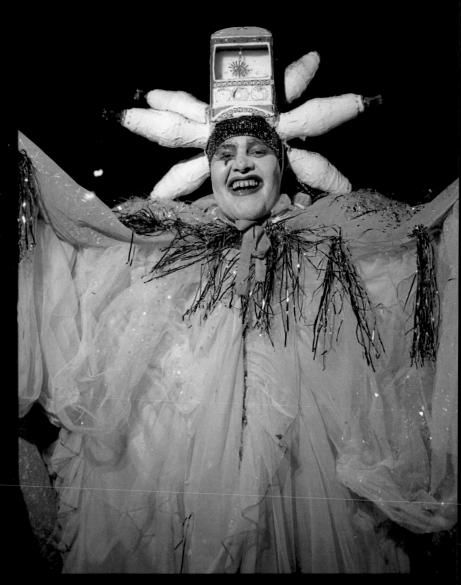

PLATE 7

CLAUDIO DICOCHEA
de la Gobernatura Suprema y Jefe Saddle
Blazing, se convierte en Marciano
(of Supreme Governance and Chief Saddle
Blazing, it turned into a Martian)
2010

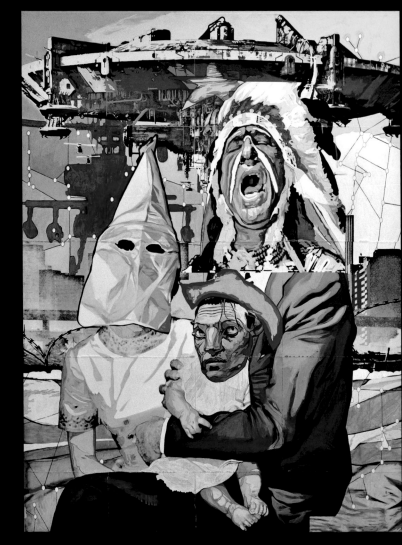

Claudio Dicochea's brightly colored, mixed-media paintings scramble historical Western art practices and popular culture in order to playfully interrogate how colonial ideology continues to inform contemporary visual culture. Using imagery from science fiction, comics, and popular music, Dicochea draws on eighteenth-century colonial *casta* (caste) painting in his work. Casta paintings depict mixed-race families and functioned as visual taxonomies of racial hierarchy. Departing from historical casta paintings, Dicochea creates his own postmodern portraits of *mestiza* families. Through a technique of re-appropriation and visual sampling, Dicochea creates unique, hybridic characters. A key element of this collage-like process is what Dicochea calls the "re-racing" of his figures: darkening or lightening the skin tone of the people he portrays.

Of Patty and Wharf, Barbarella (2016) imagines Patty Hearst as a militant version of *la virgen* hooking up with Super-samurai "Che" Worf (from *Star Trek*) to have a baby, Jane Fonda/Barbarella. *Of Chavela and Leeloo, Nagel* (2016) combines popular science fiction with visual signs of *ranchera* music to give birth to "Patrick Nagel," whose own artwork stands in for the artist himself, suggesting the ways in which—within popular culture—stereotyped representations of minoritarian subjects often replace the people themselves. These new identities forged through eccentric, even bizarre, juxtapositions recontextualize visual stereotypes and invite a serious yet fun consideration of the ways in which visual arts have structured our modern conceptions of difference.

RUDI KRAEHER

PLATE 8

GUILLERMO GÓMEZ-PEÑA
Guillermo Gómez-Peña and Saul Garcia Lopez
Robo-Proletarian Warriors
2012

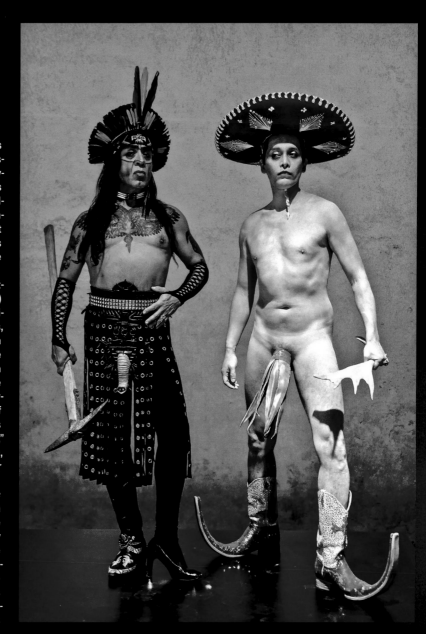

The interdisciplinary work of Guillermo Gómez-Peña breaks down cultural and political borders through a radical epistemology of Chicano "cyber Aztec"/"cholo punk" hactivism and media infiltration. His large body of work insists on the centrality of racialized embodiment in digital culture, as opposed to the disembodied transhumanist fantasies found in classic cyberpunk or contemporary Internet practices like "digital blackface." His many performances de-center dominant culture in order to open up alternative spaces for "rebel artists" and subaltern subjectivities.

Gómez-Peña's experimental and pedagogical aesthetics explore pressing questions about the borderlands, (im)migration, and globalized technoculture through a critical activation of what scholar Dora Ramírez-Dhoore calls, Chicano "cyborder consciousness," in reference to Gloria Anzaldúa. As a directing member of the performance troupe La Pocha Nostra, Gómez-Peña collaborates with other artists interested in the use of the body to generate visually complex, hybrid, queer, and interactive performances. Consistent with Gómez-Peña's *mestizo* politics of language, "La Pocha Nostra" is a neologism that combines a reclamation of the Mexican pejorative term "Pocho/a," for "cultural traitor," and the Italian mafia ("Cosa Nostra"), which refers to "the cartel of the cultural traitors" or "our impurities."

The performance *Ex-Machina 3.0: A Psychomagic Exorcism of the Tech Industry* is another addition to La Pocha Nostra's *Mapa/Corpo* series. Grounded in the series' concept of "political acupuncture" and facilitated by troupe members Gómez-Peña and Saul Garcia Lopez, the performance invites the audience to collectively participate in removing needles that have been inserted into the artist Balitronica's body. Attached to each of the needles are flags representing a collection of the largest, most heinous tech companies in the world. The performance asks the audience to take part in the reclamation of the human and political body in order to instantiate an alternative, life-affirming imaginary.

RUDI KRAEHER

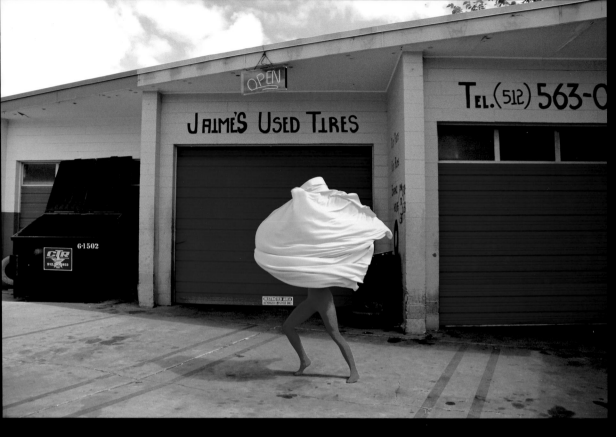

HECTOR HERNANDEZ
Bulca
2015

Hector Hernandez is an Austin, Texas–based artist who explores the relationship of the body in motion to urban spaces through his performative photographs of "jellyfish monsters" that he calls "hyperbeasts." Hernandez's hyperbeasts—cute, alien characters that move through industrial settings—reconfigure built spaces through their whimsical shapes and cartoon aesthetic. The creatures often hold a dancer's pose or seem to be running to escape the camera's frame, and the ephemeral shapes of the fabrics are created naturally by the wind rather than through the use of fans. Hernandez's work emphasizes the way in which bodies and spaces mutually constitute each other.

The title for *Bulca* (2015) is a play on words referencing both a Mexican tire shop and the famously emotionally restrained alien species from *Star Trek,* "Vulcan." The hyperbeast's intense colors complement those of the setting, the front of an Austin-area, Latino-owned tire business.

Sound of Winter (2014) also visually alludes to *Star Trek,* depicting the hyperbeast on a transporter pad. The contrast between the form of the humanoid legs and the windblown amorphous upper body suggests a *Star Trek* "beaming" in process, though whether the beast is leaving or arriving is ambiguous. The selection of the location also speaks to Hernandez's concerns with gentrification in Austin. The field seen here no longer exists, having already undergone development.

RUDI KRAEHER

PLATE 10

LA VATOCOSMICO C-S
The artist in his studio with various works
2016

Called "flamboyant" and "distinctive [in his] rock 'n' roll rebel image" by the *San Antonio Express-News,* LA VATOCOSMICO c-s (formerly LA David) is a consummate original. A self-proclaimed "walking canvas" adorned in his unique brand of "*fashionista cosmico* style," he fashions a self-image drawn from the cosmos. Like a lead singer from his own alien-infused, Tejano art–concept band, replete with Keith Richards sunglasses, he is a futuristic force in San Antonio's art-punk scene.

LA's Arte Cosmico studio—a recognizable staple at Joe Lopez's iconic Gallista Gallery on San Antonio's West Side—is a proverbial portal into what he dubs "Burro Land," where hyper Technicolor Burro rockers and taco-eating extraterrestrials intermingle in comedic vignettes rife with social commentary. Lines between painting, performance, environmental art, and the pacing of San Antonio ordinary life simultaneously distort in LA Vatocosmico c-s's work. His annual Burro Fest is evocative of his otherworldly reach. Synthesizing art exhibition with concert performance and fashion statements, LA's party atmospheres evoke what Joseph Beuys called "social sculpture," where the glitzy dimension of the cosmic burro bleeds into the Tejano everyday. The public is bathed under the black lights illuminating his fluorescent paintings and taken away, engulfed in his burro space odyssey.

ROBB HERNÁNDEZ

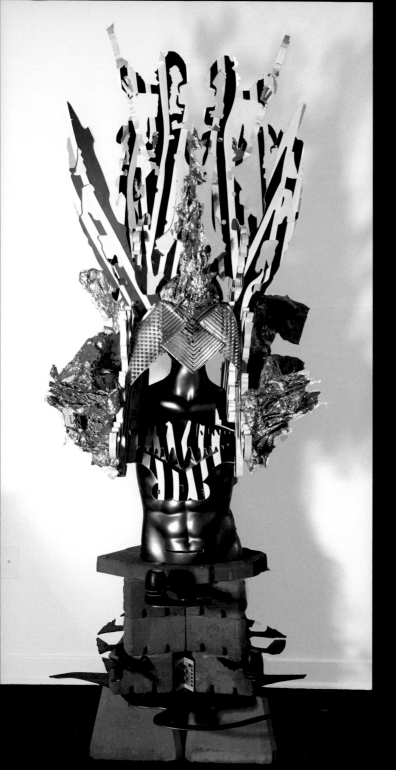

PLATE 11
IRVIN MORAZÁN
Border Headdress
2016

Irvin Morazán is a multidisciplinary artist who migrated from El Salvador to the United States in the 1980s. Morazán's work fuses Mayan ritual practices with modern street aesthetics to create ornate, otherworldly headdresses. This sculptural headdress is from Morazán's *Illegal Alien Crossing* (2011) performance in Ruidosa, Tejas. The title plays on the double meaning of the word "alien," emphasizing both an extraterrestrial aesthetic as well as the work's engagement with the perils of modern migration. "Aliens" often figure in science fiction invasion narratives, such as H. G. Wells' *The War of the Worlds* (1898). Morazán's "alien" functions instead as a spiritual guide, a cyborg-*coyote,* for all kinds of border crossers.

Morazán wore the headdress while crossing the Rio Grande U.S.-Mexico border, and his performative actions serve as a kind of offering. The headdress features a solar reflector that intensifies the sun's light, enabling the artist to bathe the river in sparkling color. It is also built with a medical crutch, which evokes issues of inequitable healthcare, disability, and injury. The wildly ornamental structure of the headdress seems at odds with a human body, emphasizing the ways in which different kinds of technological prosthetics have become integrated into our everyday embodiment.

RUDI KRAEHER

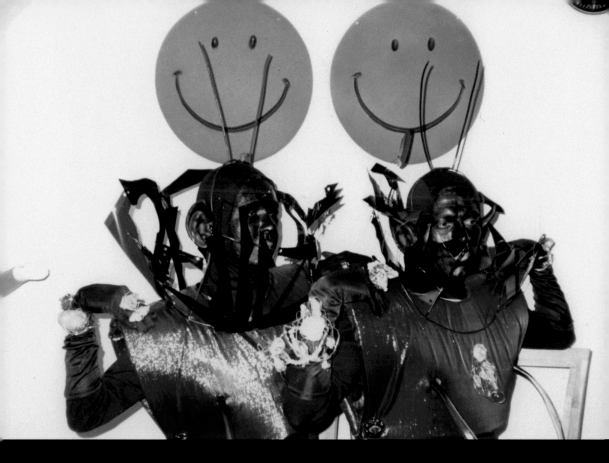

PLATE 12

MUNDO MEZA
Photo documentation of *Mundo Meza*
and Jef Huereque, Halloween Party
1983

Tijuana-born artist Edmundo "Mundo" Meza developed under the creative energy of East Los Angeles's avant-garde in the 1970s. Meza was a forerunner of Chicano conceptualism and was essential to its queer articulations, staging androgynous photo-performances with Robert "Cyclona" Legorreta and Gronk in the urban sprawl and "unnatural disunity" of coastal landscapes.

With a penchant for stirring emotion through static tableaus and performance statements, Meza forwarded provocative street theater into his window display installations. Working collaboratively with British fashionista Simon Doonan in trendy Los Angeles boutiques in the early 1980s, he created visually seditious vignettes that were redolent of the confrontational assemblage, object montage, and pop sculpture of Ed Kienholz, Duane Hanson, George Segal, and Luis Jimenez, respectively. In particular, Meza honed a "frozen art" aesthetic predicated on the stillness of mannequin comportment dusted with a hint of Mexican

magic. *The Wonder of Mundo Meza* by late Surrealist photographer Steven Arnold pictures the artist in clownish drag. Bearing a costume designed by Meza's lover, Jef Huereque, Meza is frozen in mid-air and ornamented in metallic snowflakes and cascades of foil tinsel that mimic the fiery trails of comets. Caught in suspended animation, Meza is a utopic allegory of wonder, a "freeze frame" optic withstanding the gradual decay of progressive time. Another collaboration with Huereque in 1983 costumed Meza in alien drag, perhaps showing how the postponement of time has thawed with dire consequence. Diagnosed with AIDS, Meza conceptualized a costume concealing visible traces of the disease. In a clandestine fashion technology, he reconstituted his body "alien," crossing over into a "healthy" biosphere undetected. However, the party was short-lived and on February 15, 1985, Meza passed away just shy of his thirtieth birthday.

ROBB HERNÁNDEZ

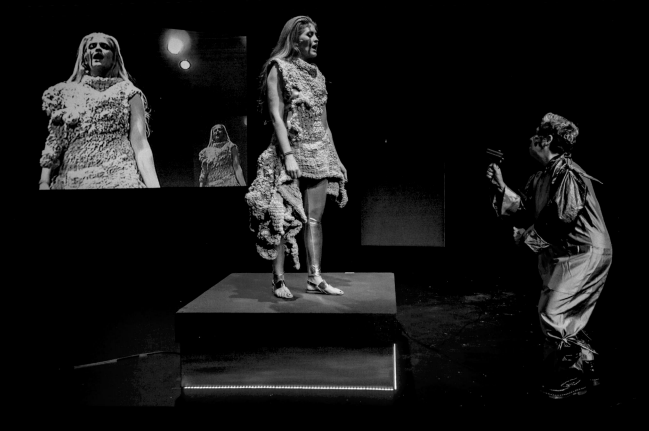

PLATE 13
CARMELITA TROPICANA
Documentation from *Schwanze-Beast*
workshop performance
2015

Carmelita Tropicana (a.k.a. Alina Troyano) is a queer, feminist Cuban American artist who has collaborated with her sister, filmmaker Ela Troyano, in New York City since the early 1980s. Tropicana's work examines cultural differences through a stylistically extravagant, humorous, and playful approach to postmodern identity formations.

Performance studies scholar José Muñoz writes about the role of camp and *choteo* in Tropicana's work. Camp enables queer cultural critique via strategies of wit, irony, and exaggeration, while choteo is a related performance style that has a specifically Cuban sensibility. As a vernacular practice, choteo enables Tropicana to mock (*burlarse de*) and find new uses for the raw materials of popular culture in her creation of Latinx, queer-affirmative *mundos alternos*.

The three costumes featured here (designed by Aliza Shvarts and Yali Romagoza, respectively) are from two dif-

ferent performances that interrogate questions of environmental devastation and the gendered nature of racialized (post)human identities. Both performances take inspiration from the matriarchal social structures of non-human animals like bees and hyenas. *Schwanze-Beast* (2015) depicts a future populated by human-animal hybrids and vegetal androids in order to address climate change and the limits of civil rights frameworks for environmental justice movements. The organic exoskeleton costume designs aesthetically draw on naturally occurring textures and materials, like flowers. *Post Plastica* (2012) stages a campy massacre of drone bees to think critically about species extinction in relation to commercial art, queer desire, and biotechnology. The *Post Plastica* costumes emphasize an androgynous, futuristic/metallic style.

RUDI KRAEHER

The potential of air and space exploration caught the imagination of Mexican American artist Luis Valderas when he was a child. Born in 1966 in McAllen, Tejas, his creative impulse was stirred by his father's *cuentos* (Spanish for "stories") and his mother's nursery in which avocado pods were nurtured in containers shaped like rocket ships. Inspired by the mythical and supernatural possibilities of the Rio Grande Valley, Valderas did not need to travel to NASA in search of alien life. This technology existed in the mythical border space that permeated his daily existence. Working in media as variant as large-scale screen prints; papier-mâché, high-relief sculpture; and, in particular, India ink drawing, he articulates another reality, a cosmic mythology drawn from pre-Columbian and astronomical semiotics.

This is visible in *St. Buzz & the Rabbit* (2003), which reflects on the July 20, 1969, event when American astronaut Buzz Aldrin walked on the moon. The monochromatic palette echoes the gritty camera technology that broadcast the lunar landing into American living rooms, a vision Valderas remembers vividly. It also reconstitutes Aldrin within a stone hieroglyphic language. Mesoamerican alien symbols decorate the astronaut, elevating him to saintly astro-deity. The miniature space capsule, the focus of the composition, signifies not only the divine nature of technofuturism in post-industrial global capitalism but also the matriarchal planting system that his mother cultivated. Valderas works through dichotomous relations, combining agriculture with machine and Earth-bound terra firma with alien vistas, resulting in a transplanetary vision for the South Tejas *frontera*.

ROBB HERNÁNDEZ

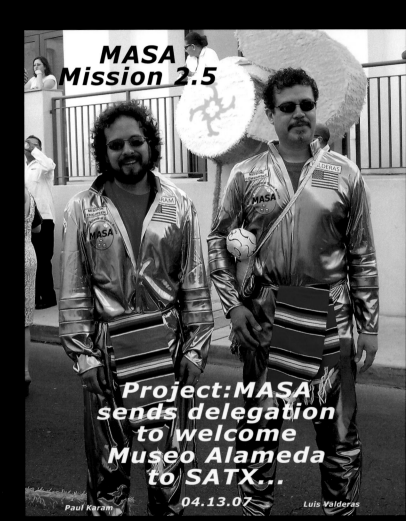

MASA Mission 2.5

Project:MASA sends delegation to welcome Museo Alameda to SATX...

04.13.07

Paul Karam

Luis Valderas

PLATE 15 RICARDO VALVERDE
 Armando y Consuelo—Two Alienz
 Muertos
 1983–91

Ricardo Valverde (1946–1998) was a conceptual and documentary photographer who developed a sophisticated set of experimental, speculative image-making techniques that cultivated a stylized, high-tech, low-life "tech-noir" aesthetic. His portraits and street photography eschew the conventions of traditional portraiture and documentary photography, foregrounding the narratives of rural laborers in Mexico or his own Chicano community (including family) in East Los Angeles during the 1970s and 1980s.

Valverde's late work involved reworking his earlier photographs by marking, scratching, collaging, ripping, and painting over his own work. His photographs are never a static image of a single moment in time. These mixed-media works challenge the boundaries between photography and other art forms through Valverde's retro-labeling (a form of time travel) and his use of photographs as an elastic, visual object whose very materiality enables creative extrapolation and world-building through mark-making.

Armando Norte: Blade Runner de East Los (1983) and *Consuelo & Marisa: Las Dos Blade Runners de East Los* (1983) appropriate the cyberpunk image of Los Angeles as seen in Ridley Scott's popular science fiction film. Valverde depicts the city as an already-science-fictional urban landscape, emphasizing East Los Angeles, while also highlighting the unique self-fashioning aesthetics of the people in the photographs (members of the Chicano conceptual art collective, Asco). Drawing on science fiction tropes that permeate the Chicano avant-garde, *Two Alienz Muertos* (1983–91) and *Alien Queen de los Muertos II* (1983–91) illustrate Valverde's techniques of altering his photographs with a tongue-in-cheek use of the term "alien" to depict these extraterrestrial characters' participation in the Día de los Muertos festivities.

RUDI KRAEHER

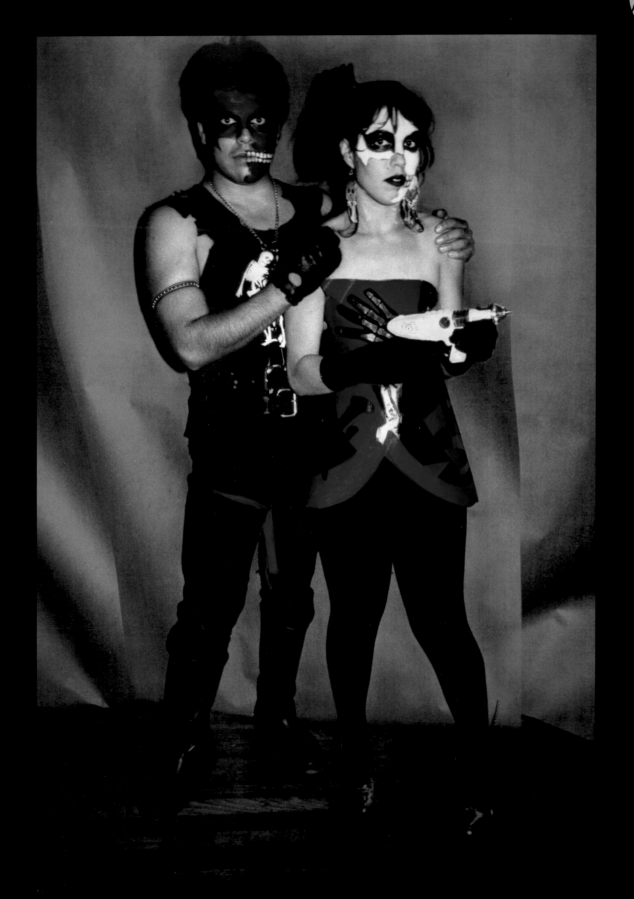

MAQUINAS SOLTERAS

ON THE BACHELOR
MACHINE IN LATINO AND
LATIN AMERICAN ART

JOANNA SZUPINSKA-MYERS

This essay explores the concept of the Bachelor Machine as found in modern Latin American and Latino art, where it is used as a means of grappling with technology's possibilities as related to the living body. Here the human or animal body is augmented figuratively or literally through human-designed technology such as robotics, genetic mutation, or the use of chemicals. "La Machine Célibataire," or "the Bachelor Machine," is an influential term invented in the early twentieth century by seminal Conceptual artist Marcel Duchamp. Spanning a century of art from Surrealism to the present, these fictional and real proposals generate narratives of empowerment and liberation as well as dark, dystopic readings.

A core strategy of speculative fiction is the bringing together of contradictory realities. In our preliminary mapping of science fiction as it appears in contemporary Latino and Latin American art, we found provocative works in which the machine especially is a central force: the mechanized and medicalized bodies of Chicago-based Marcos Raya; the genetically altered bunny of Brazilian Eduardo Kac; the endlessly mirrored texts of Chilean Iván Navarro's neon sculptures; the randomized electronic compositions of Puerto Rican Rebecca Adorno; the drawing machines of Mexican Carlos Amorales; the endlessly repeated, absurd actions of Brazilian Cinthia Marcelle; the cyborg-populated performances of Mexican Guillermo Gómez-Peña; the Kevlar-clad *soldaderas* of Los Angeles–based Nao Bustamante; or the automated search engines of Peruvian José Carlos Martinat. In these works, which grapple with technology's possibilities as related to the living body, the human or animal is augmented through technology such as robotics, genetic mutation, or use of chemicals. The result is a slippage between self and other, male and female, ego and superego, robotic and organic, and science and faith.

One effect of these slippages is the emergence of a third entity, or *mestizo* object. Rubén Ortiz Torres's *Alien Toy* (1997) was born of a white Nissan pickup truck, a model commonly used by U.S. border patrol, the

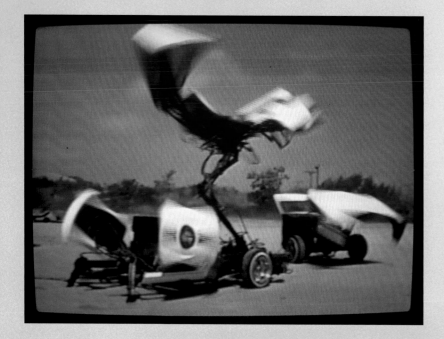

hydraulics of which were modified by lowrider Salvador "Chava" Muñoz (see fig. 1). Borrowing graphics from the border patrol logo, the vehicle is labeled "Unidentified Cruising Object" and "Space Patrol," linking it to the space travel genre within science fiction. Altered in the Mexican American tradition of customized cars that dates back to 1940s Los Angeles, when performed *Alien Toy* splits open into absurdly spinning parts, rendering the vehicle utterly excessive, "a mechanical bird flapping its wings."[1] Unlike drivable customized cars, the sculpture is so violent in its movements that it nearly self-destructs, evoking the work of kinetic artist Jean Tinguely. Ortiz Torres and Muñoz must carefully reassemble *Alien Toy* following each performance. By grafting together the disparate realities of national borders, lowrider culture, and the history of sculpture, otherwise mutually exclusive identities interpenetrate to create a truly *mestizo* object.[2] Short-circuiting its functionality as a drivable vehicle, the technology used to create *Alien Toy* contains the sculpture's logic, rendering it a machine with no purpose outside of itself.

Chico MacMurtrie and his collaborative group of artists and engineers, Amorphic Robot Works, also create robotic sculpture. But their inflatable works are decidedly anthropomorphic, with architecturally inspired fragments that evoke ribs, curling tendrils that call to mind intestines (fig. 2), and towers that resemble giants that can reach over the U.S.-Mexico border wall. The beginnings of MacMurtrie's *The Robotic Church* (2013), now arranged as an installation in a former Norwegian church in Brooklyn, date back to the artist's graduate school years in Los Angeles. Initially created as a puppet for a film as part of his master's thesis, the *Drumming and Drawing Subhuman* was built from discarded aircraft and Disney automation scraps. The "subhuman" alternately drums with his hands and draws

FIGURE 2
Chico MacMurtrie/ARW
Organic Arches
2014
Exhibition view at SESC Santana, São
Paulo, Brazil. Co-produced with SESC
SP, Automatica and Molior in 2014
Courtesy of Chico MacMurtrie/ARW.
Photo by ARW

on an upright surface with black ink, seemingly documenting the action of the younger robots that are performing nearby. MacMurtrie personi-fies the sculptures when he speaks of them, indicating that the subhu-man was longing for a partner, which led to the birth of additional robots: musicians and artists, squawking dog monkeys, and *Tumbling Man,* who somersaults, nearly self-destructing as he goes, his eyes flying out of their sockets. "They're reborn as saints," MacMurtrie offers, "and they appreci-ate it."[3]

Once recognized, there is an undeniably strong presence of the robotic body in the practices of artists throughout the Americas. The contempo-rary works of Ortiz Torres and MacMurtrie may find some commonalities with those of the Mexican muralists working in the first half of the twenti-eth century. José Clemente Orozco's *Dive Bomber and Tank* (1940) depicts the heavy machinery of war—a pile of steel, with chains, bolts, hooks, and the wings of a bomber jutting into one another—while a pair of human legs sticks up from the mound, the body's torso apparently gobbled down into the wreckage headfirst (fig. 3). Three boulder-like heads are pierced with nails and chains through eyes, ears, mouth, and nose. The sky is dark with smoke and fumes. Commissioned by the Museum of Modern Art for an exhibition devoted to Mexican art, Orozco painted *Dive Bomber and Tank* as a six-panel, movable mural that could be reorganized in various arrangements, to be hung using three, four, or six of the panels. In a state-ment about the mural, Orozco refers to the work itself, in its changeability, as a machine: "the whole acts as an automatic machine," he writes. "Each part of a machine may be by itself a machine to function independently from the whole. The order of the interrelations between its parts may be altered, but those relationships may stay the same in any other order, and

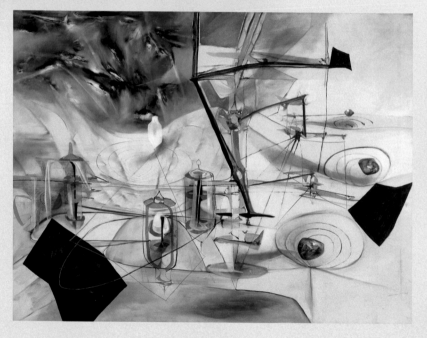

unexpected or expected possibilities may appear."[4] This idea of a painting as a machine that produces new meanings, yet is contained onto itself, suggests that the work acts both on the viewer in our reception, and internally on its own logic—a closed circuit that has little to do with the viewer, much as *Alien Toy* is not meant to be driven, and the characters of *The Robotic Church*, according to MacMurtrie, draw, drum, and tumble with their own agency. In these ways, they are all *máquinas solteras*.

Duchamp's original Bachelor Machine may provide a useful frame through which to understand these works. Painted on two large panes of glass, *The Bride Stripped Bare by Her Bachelors, Even* (1915–23), also known as *The Large Glass*, depicts an erotic encounter between a bride—a haloed, mechanical, pseudo-insectile, and monochrome-shaded geometric form—and nine bachelors hooked below her into an elaborate Bachelor Machine (fig. 4). "*The Large Glass* has been called a love machine," writes art critic Janis Mink, "but it is actually a machine of suffering. . . . The bride is hanging . . . in an isolated cage, or crucified. The bachelors remain below, left only with the possibility of churning, agonized masturbation."[5] Again, here the artwork functions on multiple levels; it is at once a picture, at once transparent. Whereas Orozco's work is changeable in its arrangement and installation, *The Large Glass* morphs in other ways. One cannot look at the picture without also looking through it, or without taking in the shadows and reflections cast nearby by the paint, varnish, lead foil, and wire that make up the forms on the glass. Furthermore, after it was broken in transit a few years following its completion, the resulting cracks in the glass cannot be ignored—in all their accidental compositional and reflective effects.

The Chilean artist Roberto Matta, working two decades later on ideas of infinite space, took inspiration from *The Large Glass* for his painting *The Bachelors Twenty Years Later* (1943) (fig. 5). Paying homage to that earlier allegory of frustrated desire, Matta's bachelors dance in their contraption, perhaps finally united with the bride through the chaos of lines harkening the unintended breakage; the figures are "energized by the . . . incisive linear markings, recalling the symmetrical cracks in the original work."[6] In *The Bachelors Twenty Years Later*, "the sexual tension that permeates the *Large Glass* is translated into an explosive electromagnetic force field, as the excitement of the transparent, lamplike bachelors generates an illuminating gas that mixes with other nebulous vapors to produce a vision of primary chaos, with slivers of stormy crystalline light."[7] In this work, as in Duchamp's, Matta brings together mechanical and organic elements to create an unreal but debaucherous world.

Similarly, in the contemporary máquinas solteras discussed above, technology becomes symbolic both of a utopic, automated future in which the natural world is totally under the control of humankind, and a horrific "churning" reality. MacMurtrie's *Subhuman* of industrial parts can be reborn as a mechanical saint, and the flailing *Alien Toy* of Ortiz Torres is rendered utterly nonfunctional as a vehicle through all his alterations. It is

a machine that does not produce, but exists only for its own sake. In these ways, the concept of the máquina soltera accommodates closed-circuit masturbatory processes aimed for pleasure or destruction rather than utilitarian function or reproduction, as well as agency for a body within a prosthetic or machinic contraption.

Another view embodying contradictory realities of the human and technological, one less of a closed-circuit, masturbatory sensibility, and more of self-determination and empowerment, may be found in the works of Frida Kahlo and Graciela Iturbide. A thirty-three-year-old Frida Kahlo lies in bed, drawing (fig. 6). White sheets, white nightshirt, white eyelet covering, and white bandages; her head is secured in a sling and below her neck, her body lies still and straight.[8] Her friend, the painter Miguel Covarrubias, looks to the unknown photographer from the other side of the bed, Kahlo's work-light grazing his face dramatically. Immersed in her work, she seems not to notice these figures despite their apparent closeness. Kahlo's ring-clad left hand rests easily on her abdomen, and her gaze is concentrated as she draws with her right on a surface above, invisible to us. An easel is propped at her shoulders and hips, completing a circuit in which her mind, body, and the apparatus that allows her to work is sealed. The prosthetic is an extension of her otherwise physically limited body in which the machinic and organic come together.

The easel appears again in Kahlo's self-portrait *Without Hope* (1945) (fig. 7). The artist lies in her bed, which is here transported into the Mexican desert landscape with sun and moon hovering in the sky and planets adorning her bedspread. Tears stream down her cheeks as she looks to the viewer—a look perhaps pleading to be saved from this experience, or accusative for our inaction. The painting depicts the artist's painful period of bed rest and high-fat liquid diet, prescribed by her doctor in an effort to help her gain weight following continuous depleting illnesses and surgeries.[9] The chicken, sausage, fish, veal, and other bloody meats are at once funneled into her body, and vomited up as if in a nightmare. The mechan-

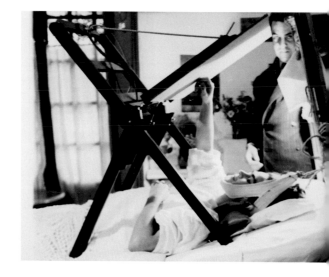

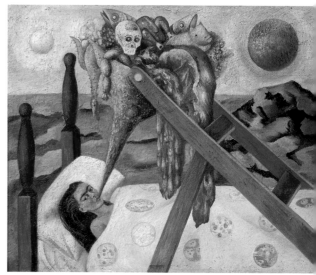

ical contraption is both one that allows her to create work, and one that in this case enables her physical torture.

More than thirty years later, in a photograph by Graciela Iturbide, we find another instance in which there is a sense of menace but also of free, dreamlike flight (fig. 8). A Seri woman in a waisted jacket and long, full skirt hikes out toward the Sonoran Desert. Long black hair flows down her back, separating into thick strands as she balances herself with her left hand against a rock and clutches a boom box in her right. "The Seris are former nomads. For me, this photograph represents the transition between their traditional way of life, and the way capitalism has changed it," the photographer explains. "I call her *Angel Woman* because she looks as if she could fly off into the desert."[10] The iconic 1979 image, made in Punta Chueca near the Arizona border, folds together traditionally understood opposites: the technology of the tape recorder, the culture evoked

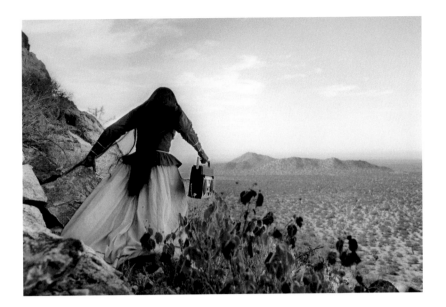

FIGURE 8
Graciela Iturbide
*Mujer ángel, Desierto de Sonora,
México* (Angel Woman, Sonora
Desert, Mexico)
1979
© Graciela Iturbide, photo courtesy
of the artist

by the woman's clothing, the stark natural world of the desert landscape before her, and the fantastical notion of a magical figure who might fly.

Spanning a century of art from Surrealism to the present, the works of Graciela Iturbide, Chico MacMurtrie, and Rubén Ortiz Torres, as well as Frida Kahlo, Roberto Matta, and José Clemente Orozco, generate narratives of empowerment and liberation as well as ominous readings. Perverted and atheistic as they are in Duchamp's *Large Glass*, in these máquinas solteras there is a pronounced relationship between the machinic bachelors and that natural or supernatural element on which they act, unraveling our assumptions about gender, technology, and power.

NOTES

1. Monika Kaup, *Neobaroque in the Americas: Alternative Modernities in Literature, Visual Art, and Film* (Charlottesville and London: University of Virginia Press, 2012), p. 285.

2. See Howard N. Fox, "Rubén Ortiz Torres," in *Phantom Sightings: Art After the Chicano Movement*, ed. Rita Gonzalez, Howard N. Fox, and Chon A. Noriega (Los Angeles: Los Angeles County Museum of Art; Berkeley and Los Angeles: University of California Press, 2008), p. 189.

3. Conversation with the artist, Brooklyn, May 2014.

4. José Clemente Orozco, "Orozco 'explains,'"

Bulletin of the Museum of Modern Art 7, no. 4 (August 1940): 8–9.

5. Janis Mink, *Duchamp*, from *Basic Art Series*, 35 (New York: Taschen, 1995).

6. Ann Temkin, Susan Rosenberg, and Michael Taylor, with Rachel Arauz, *Twentieth-Century Painting and Sculpture in the Philadelphia Museum of Art* (Philadelphia: Philadelphia Museum of Art, 2000), p. 94.

7. Ibid.

8. Disabled after a traumatic streetcar accident at age eighteen, the artist spent a lifetime enduring treatments and surgeries on her spine, pelvis, legs, and torso. See Siobhan M. Conaty, "Frida Kahlo's Body:

Confronting Trauma in Art," *Journal of Humanities in Rehabilitation*, July 8, 2015, 1.

9. Hayden Herrera, *Frida: A Biography of Frida Kahlo* (New York: HarperCollins Publishers, 1984), pp. 354–55.

10. Sarah Phillips, "Graciela Iturbide's Best Photograph: A Mexican Seri Woman," *Guardian*, September 12, 2012, accessed September 6, 2016, https://www .theguardian.com/artanddesign/2012/ sep/19/graciela-iturbide-best-photograph.

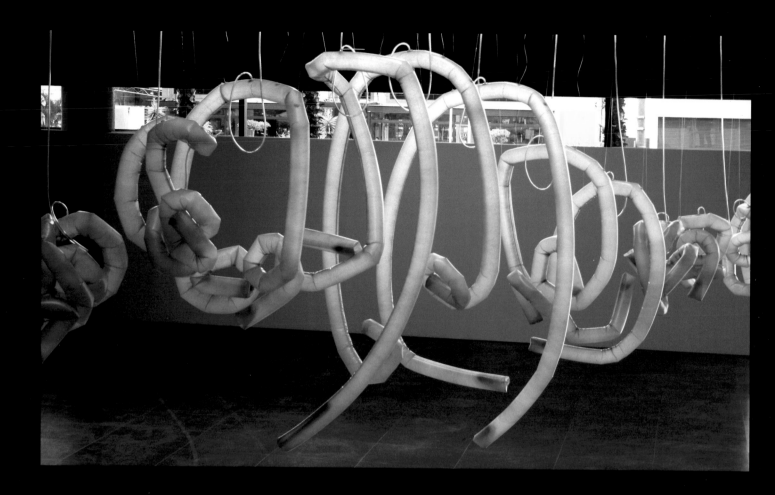

PLATE 16

CHICO MACMURTRIE/ARW
Organic Arches
2014

Chico MacMurtrie explores bodily form and movement through robotics and pneumatics (systems using pressurized air) to create apparently sentient sculptures and site-specific installations. Developed out of his earlier work in robotics with salvaged metal, MacMurtrie's recent *Inflatable Bodies* series uses "inflatable body technology" to create soft sculptures constructed from high-tensile, Tedlar fabric tubes and pressurized air. These inflatable sculptures are able to produce a range of uncannily organic movements.

Built and installed with his Brooklyn-based collective, Amorphic Robot Works (ARW), *Organic Arches* (2014/2017) is a site-specific installation made up of suspended inflatable arches that periodically inflate and deflate in response to human presence. The work performatively shifts between a set of abstract, heterogeneous coiled forms and seemingly rigid, inflatable architecture. This repeated transformation—a pressurized choreography—suggests a softer, more porous distinction between organic and machinic life.

On the level of movement and gesture, *Inflatable Bodies* eerily evokes artificial intelligence. A popular theme in science fiction, such as Stanley Kubrick's *2001: A Space Odyssey* (1968) or William Gibson's novel *Neuromancer* (1984), it is often depicted in terms of human anxieties and ethical dilemmas about artificial intelligence, especially the fear that it will surpass and subjugate humanity. MacMurtrie/ARW's *Inflatable Bodies,* however, seems to focus more on questions of mutual dependence/symbiosis and a "soft" ethics of entangled sociality in one's relationship to otherness.

RUDI KRAEHER

PLATE 17

RUBÉN ORTIZ TORRES
Alien Toy (La Ranfla Cósmica)
1997

Rubén Ortiz Torres articulates a hybrid, postmodern aesthetic developed in fluid response to the many forms of cultural exchange that occur at the U.S.-Mexico borderlands. *Alien Toy (La Ranfla Cósmica)* (1997) is a kinetic sculpture and video installation that extrapolates the customizing aesthetics of Chicano lowriding to create a remote-controlled lowrider that radically fragments itself. The accompanying video is a lo-fi pastiche of popular science fiction media and themes, like *Star Wars* and UFO sightings. *Alien Toy* illustrates a techno-logical iteration of the Chicano "rasquache" attitude of playful and irreverent flamboyance. Rasquachismo is a critical and adaptive style based in a Chicano working-class perspective of the underdog. Ortiz Torres's reliance on recycling mechanical materials and engaging with regional cultural practices represents a "techno-rasquache" art practice of juxtaposition, reversal, and the resourceful recontextualization of mass-cultural images and materials that are ready at hand.

Built by experimental customizer Salvador "Chava" Muñoz, the car hydrau-lically disassembles itself, performing a kind of frantic, mechanical dance. The front of the vehicle completely separates from the body, driving off like some rogue lowrider escape pod. The work also parodies the U.S. border patrol logo. Pivoting on the overlapping implications of the term "alien," *Alien Toy* uses humor and camp to provoke serious reflection on the ways in which xenophobia and popular representational practices intersect with discourses of immigration, street culture, and science fiction.

RUDI KRAEHER

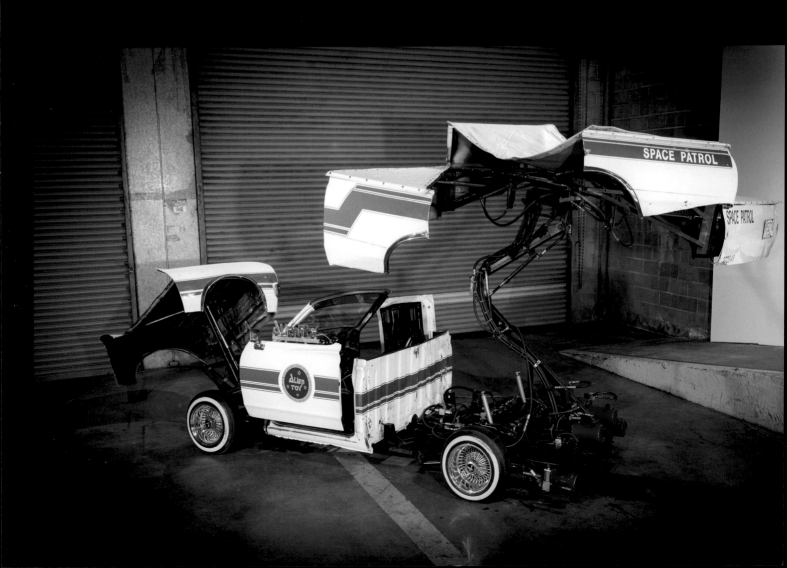

PLATE 18

SIMÓN VEGA
Tropical Mercury Capsule
2010

Simón Vega built *Tropical Mercury Capsule* (2010/2014) as part of his *Tropical Space Proyectos* series, which humorously uses found objects to comment on the effects of the Cold War in Latin America. This sculpture plays with the sophisticated, midcentury aesthetics of Space Race technology and satirically combines it with Third World, self-made architectures. Modeled on the space capsule design for NASA's Mercury Program (1959–63), the work is built from cheap, found materials, like cardboard, corrugated metal, and wood. The capsule's colorful interior is equipped with decorative plants, a Styrofoam beer cooler, a boom box, a TV set, and an electrical fan. Vega's "tropi-cold war" capsule imitates poor Salvadoran and Latin American "shanty-town" aesthetics to create a vessel designed more for daily survival and subsistence than for space exploration.

Heavily informed by the history of U.S. and Soviet influence on the Salvadoran Civil War (1980–92), *Tropical Mercury Capsule*—along with the other works from Vega's imaginary, jerry-rigged (*improvisado*) space program—uses industrial detritus to think playfully and critically about the economic, technological, and cultural impacts of Cold War interventionism.

RUDI KRAEHER

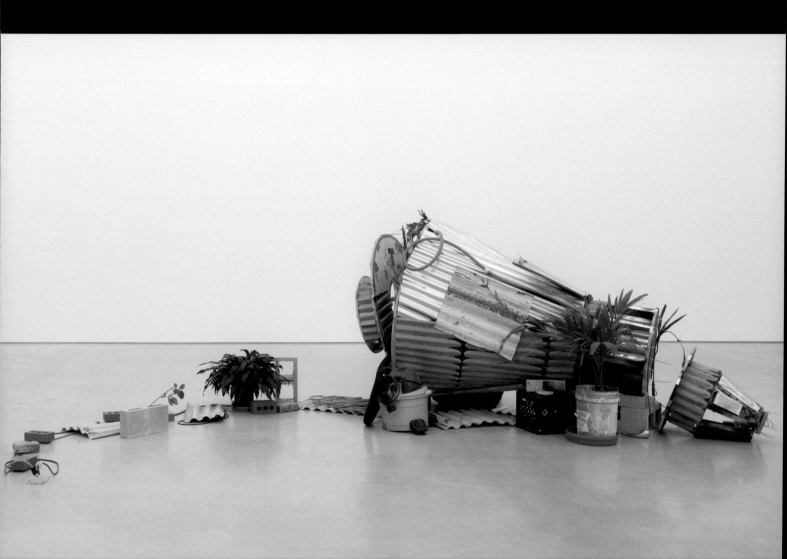

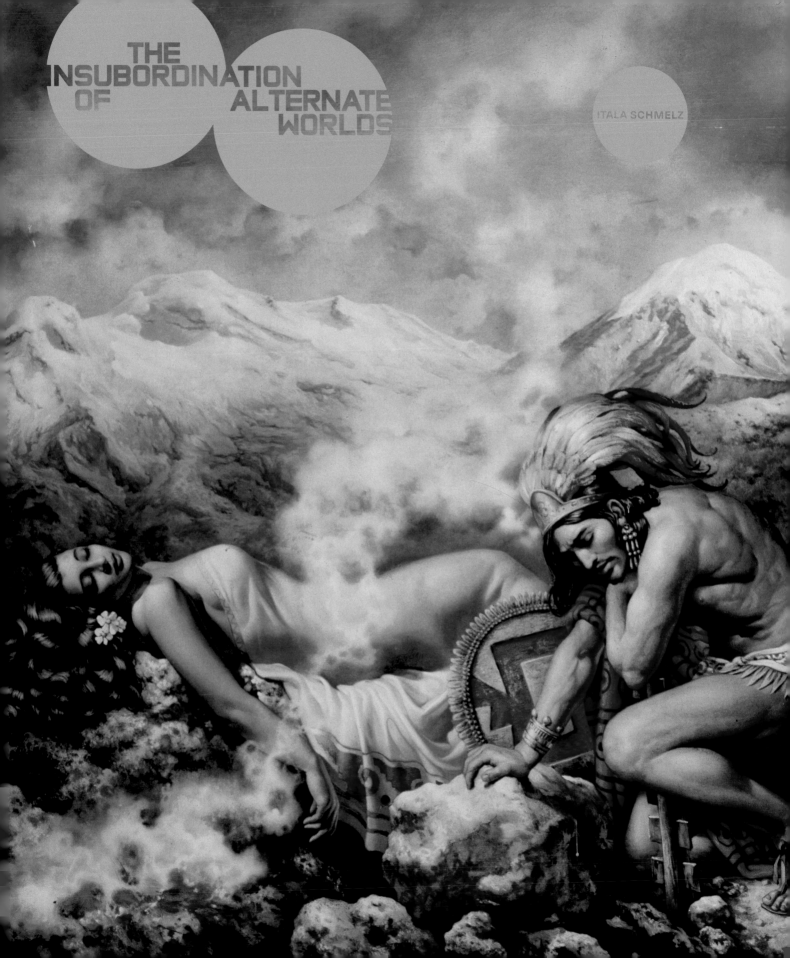

THE INSUBORDINATION OF ALTERNATE WORLDS

ITALA SCHMELZ

Mundos Alternos: Art and Science Fiction in the Americas offers a noteworthy sampling of science fiction's presence in contemporary Latin American art. It is the result of a curatorship that shares the current academic interest regarding neo-exoticisms, which, in this case, means the hybridization of modernity's favorite imaginary—science fiction—reproduced in the tropics. Historically, Latin American science fiction has been presumed to be a peripheral by-product, a poor copy, or a weak and marginal effort invoking unintentional humor. However, production in this genre "south of the border" has functioned as a strategy of resistance toward the globalization of modernity.

This phenomenon is evaluated through a reading of the philosophical theories of Bolívar Echeverría and Mariana Botey. They explore the dialectic between Mexico's indigenous world and the nation's strides toward modernity that led to the gory battle in *The Aztec Mummy vs. The Human Robot*, a popular film of the 1950s. One of the particularities of this type of science fiction is the ability for appropriation, a parodic *tropicalization* of the colonizers' imaginaries, aimed not at imitating but rather sabotaging the dominant models of identity.

ECHEVERRÍA'S WHITENESS AND SCIENCE FICTION

During the twentieth century, under the U.S. policy of cultural imperialism, the Cold War, and McCarthyism, all of which were operating within a capitalist economic system, celebration of diversity was not a popular notion. A growing aversion to all things different served to benefit a particular way of life that fed into a kind of racial or ethnic standardization defined by Echeverría as *la blanquitud* or "whiteness."[1] This philosopher, a nationalized Mexican born in Ecuador, attributed the notion of "whiteness" to the modern subject in the abstract, referring not only to people with white skin but also to the historic results of racism, Protestant morality, commercial pragmatism, and a secular faith in scientific progress. Altogether, they comprise a way of thinking that has accompanied

Western colonization processes through the centuries, including those that have occurred in the territories of science fiction and fantasy.

Among science fiction works produced in the United States, beginning with the first issue of *Amazing Stories*, published in 1926 by Hugo Gernsback, it is easy to locate this mentality of *whiteness*, which Echeverría would also refer to as the realist ethos.[2] One prototypical author is Edgar Rice Burroughs, who during the 1920s created fantastic and exotic worlds populated by barbarian races who were subjugated in the end by Aryan supremacy, predestined to conquer the universe. This somewhat naïve author was to be replaced by the hard and no less xenophobic science fiction writers who dominated the 1950s—including John W. Campbell Jr., Isaac Asimov, and Robert A. Heinlein—and who were ardent believers of technology and optimistic in the face of capitalism.

Likewise, in science fiction B movies from the United States we find the egocentric vision of that ethos projected as paranoia toward the "other," for example, *The Thing from Another World* (1951), *It Came from Outer Space* (1953), and *Them* (1954). "White" hegemony is always conceived in relation to another toward which it is dialectically opposed and with which it has an ambiguous relationship. The barbarian is the inhabitant of a lost paradise but at the same time is the stranger, the migrant, and the abject alien who threatens the *status quo* of white hegemony. In this moment of science fiction's history, which reached its climax in the 1950s, the other represents the Freudian return of the repressed, that which is denied by reason and symbolized by all types of humanoid monsters, unleashing a pleasurable sense of horror in the spectator.

On the other hand, in the countercultural environment of the 1960s and '70s, the allegorical decontextualization of the classic subjects of science fiction (intergalactic voyages, alien invaders, automatized cities, etc.) were utilized as a critical method for examining society, which often revealed that those Hollywood B movies were built on a colonialist and racist ideology. One of the fathers of that kind of critical science fiction is Ray Bradbury, who with his poetic powers turns technophile writing around and puts the 1960s generation on guard against optimism for a mechanized and Americanized future. In this regard, it is also worth mentioning the authors of the new American wave, who are in some cases openly leftist, anti-establishment, and very close to the counterculture of the period, including Brian Aldiss, Frank Herbert, and Philip K. Dick. Another example is Mike Kelley's *Destroy All Monsters* magazine (1975–79), a detonator of the use of bricolage and fanzines in contemporary art.

THE BAROQUE ETHOS

Echeverría's concept of the baroque ethos can be applied to the distinguishing characteristics of Mexican science fiction. He proposes that the baroque style, imported from Europe during the Conquest of the Americas in the sixteenth and seventeenth centuries, made it possible to produce a mix of cultures that inform our identity today: "Latin America's

first identity was a baroque identity."[3] Echeverría notes that the baroque impulse—decorative, overdone, and impure—which in Europe represented an attempt to break with classical aesthetic values, gradually managed to build a bridge over the tacit chasm caused by the encounter of the two worlds.

He refers to a parodic, theatrical, and, at times, grotesque re-creation of Western models that, while adapting the rational and mercantile dictates of the realist ethos, maintains a kind of distance that can be seen as resistance toward, and even boycott of, the culture of the conquerors:

> The phenomenon of *mestizaje* appears here in its strongest and most characteristic form: the code of European identity devours the American code, but the American code forces the European one to transform itself so that, from within, from the reconstruction of the self in its everyday manifestation, it redeems its own singularity.[4]

How does the truth of indigenous survivors forge its way among the civilizing achievements of the West? How can the Aztec gods coexist with the Christian one? We are dealing with a process of adaptation to the dominant discourse and at the same time an attack on its effectiveness, generating a different modernity. As Echeverría writes, "This is typically baroque behavior: inventing a life within death. The Indians were condemned to die, and had been dying for the entire 16th century and even still, in that way of dying they found a way to live."[5]

In Latin American popular culture, mestizaje incorporates the great stories of the West through a parodic framework, with the indigenous world transmuting the values of its own identity in order to portray itself and see itself in the mirror of the other; a disfigured image, but still a valid one. This is why, in the face of a modernity imposing its own models and stereotypes—crushing all outside cultures and swallowing them up in the capitalist system—it is important to remember that the Indians hid their idols behind altars.

The repressed and undermined indigenous world became inserted into the dominant imaginary as a kind of survival or counter-conquest on behalf of the conquered. Echeverría looks at this phenomenon through the case of the god Tonantzín, who was transmuted into the Virgin of Guadalupe: "The Indians gave up one god to create another. . . . They stole and appropriated the name of the Virgin, at the same time doing away with the name of their own goddess."[6]

"The Latin American baroque is a game of transgressions that redeploy the laws of the *realist ethos*," Echeverría observes. This can remind us of the processes of appropriation, reformulation, and reinterpretation undertaken by Mexican popular culture, first in order to assimilate Western ways of life and later to survive an Americanized modernity and the savagery of capitalism. This survival mechanism is enacted as an ongoing sabotage of the models for the configuration of meaning imposed by the dominant culture.

We can see that Mexican science fiction cinema fundamentally consists of an appropriation of the genre, and that its allegorical and satirical nature is perhaps its most unique attribute—what we could even call its primary creative contribution. Indeed, the appeal to parody speaks about not only a lack of resources but also a lack of interest in the topics of science and the future, which allows absurdity to pervert the original model. Little remains of the Promethean conquest of the universe that Hollywood has proclaimed when we see *Two Bumpkins on the Planet of Women* (*Dos nacos en el planeta de las mujeres*, 1991) taking pleasure in the sexually aroused inhabitants of Venus, who are on the hunt for their sperm.

Using science fiction as its promoter, American cultural imperialism (and its ideals) takes on a particular critical stance in the hands of Latin American culture: while on the one hand it becomes a self-portrait that reveals a Latin American's sense of inferiority, on the other hand it also produces a sarcastic rejection of the civilizing impositions of the North by Latin Americans. By parodying and assimilating science fiction plots and devices, an underlying satire is woven, one that is only possible to comprehend upon a second reading.

Continuing to follow Echeverría: the baroque act *par excellence* is to imitate modernity without believing in it. In the film *Planetary Giants* (*Gigantes planetarios*, 1965), the closest thing there is to a Mexican "space opera," an astronaut who has commanded a high-tech ship can think of nothing more than eating a bean taco. In the "creation of another dimension, challengingly imaginative with regard to the qualitative,"[7] the philosopher explains, the modernist project is placed in doubt by the Latin American baroque ethos.

NEO-AZTEC MYSTICISM

While this book covers several themes, a large portion focuses on the use of science fiction to conceptualize the "borderland" relationship between the United States and Latin America. This is the case above all in the context of the U.S.-Mexico border, the site of a never-ending war of images, and a crossroads and conflict zone for the hybridization of cultures. Mexico, given its indigenous roots, has served as modernity's other in multiple theories and imaginaries. Thus, these works put into play one of the great tropes of science fiction: the encounter with "the other."

An illegal farmworker arrives in the United States with a pack tucked under his arm containing a calendar of Jesús Helguera's *La leyenda de los Volcanes* (fig. 1); El Santo, the greatest hero of Mexican wrestling, printed on a piece of junk; and a tiny statue of the Virgin of Guadalupe. These items form a basis for his identity cocktail. But this "Portable Homeland," as Alfonso Morales referred to the combination of icons accompanying Mexicans in their transit across the border, originates in U.S. Chicano culture.[8] The mixed-race *mestizo*, the *Pocho*—retaining indigenous blood, but born on the other side of the border, while assimilating into the culture

and language of the United States—creates a characteristically baroque type of expression, in Echeverría's sense of the term:

> The baroque proposal consists of putting the codes of ancient forms into play in such an unconventional way that it forces them to exceed their capacity; meaning it consists of re-signifying them from the plane of a use or 'speech' that unhinges them without destroying them altogether. . . . It is not so much a matter of inventing or creating previously nonexistent forms as re-forming that which has already been formed, in making a pre-existing form the substance for formation itself.[9]

In the countercultural environment of the 1970s, science fiction imaginaries leapt out of teenage fanzines into the materials of social subversion and underground art. This initiated a process of recycling and deconstructive appropriation that operated in a manner very similar to the baroque ethos, which produced bricolages capable of symbolizing the tension between identities on the continent's North-South border, as well as humorously confronting the logic of Hollywood science fiction. This practice is a constant among artists in *Mundos Alternos*, such as the work of Puerto Rican artist ADÁL, in which UFOs touch down in a small town in Puerto Rico rather than in Washington, DC.

In his book *An Expedition into Mexican Science Fiction* (2001), Ramón López Castro evaluates the movements of an incipient and marginal literary trajectory, one that has always been somewhere between social protest and mockery. If in the 1980s, Mexican science fiction authors focused their attention on a prize awarded in the city of Puebla, López Castro shows that by the 1990s, the literary science fiction scene had shifted definitively toward the border: Tijuana, Tamaulipas, and Monterrey. For authors like Eduardo Alvarez, Fran Ilich, and Gabriel Trujillo, "science fiction is the chronicle of the border war," and "the science fiction of the northeast has offered the general Mexican perspective on the harsh iconography of an area in conflict with itself."[10]

The paintings of artists such as Luis Valderas and Sergio Hernandez, who exhibited in the San Antonio, Texas–based MeChicano Alliance of Space Artisans (MASA), as well as the more conceptual works of Los Angeles–based, Mexican-born Rubén Ortiz Torres, focus on a highly stereotypical and iconic narrative with regard to the encounter and intersection between worlds. Thus, we can see that neo-Aztec mysticism makes the voyage across the border on Helguera-inspired, kitschy cardboard calendars being converted into a symbol of Chicano identity. In this region, messianic post-Aztec mythology is reinforced and placed in confrontation with the mythology of Hollywood-produced films, resulting in a borderland science fiction with its own aesthetics and themes that situate the ancient Mesoamerican gods face-to-face with the cyborg gods of progress.

The San Francisco–based artist Guillermo Gómez-Peña is fundamental to understanding the border phenomenon. In an interview with Joanna

FIGURE 1
Jesús de la Helguera
La leyenda de los Volcanes
(The Legend of the Volcanoes)
ca. 1940
Collection of Museo Soumaya, Fundación Carlos Slim Collection, Mexico City

Szupinska-Myers, he spoke of the influence Ernest Hogan's novel *High Aztech* (1992) had on his generation in terms of its conceptualization of indigenous issues, the border, and hybrid identities.[11] These are topics that have informed the characters that typify Gómez-Peña's performances. They lie somewhere between cyberpunk and post–Frida Kahlo kitsch, and have invented names like *Superwetback*, *Cyber Vato*, the Aztec Vampire, *Rocker Moctezuma*, and his action art company, *La Pocha Nostra*. Present-day drug trafficking, *Narcos*, and the Zapatista Army of National Liberation (EZLN) in South Chiapas also filter through Gomez-Peña's low-tech aesthetic. They complete the image of the post-Aztec, a post-apocalyptic pastiche character that, due to its infinite adaptability, will be capable of surviving Armageddon brought on by the political and economic inertia of the North.

There has always been a branch of science fiction that borders on esotericism: astral voyages, hypnosis, alien abductions, Freemasonry, and conspiracy theories. It shares the scene with neo-Aztec messianism. Among its literary precursors is Héctor Chavarría Líu, "the primary proponent of a science fiction that integrates an awareness of Lovecraftian origin myths with pre-Hispanic legends."[12] Other science fiction authors like Mexicans José Luis Zárate, Mauricio Molina, and Chicano Ernest Hogan nourished this imaginary, giving rise to a very particular type of extremely pessimistic, chaotic, and psychotropic Aztec cyberpunk: unlocking the doors to Mictlán[13] while simultaneously unleashing the futuristic settings of William Gibson and Philip K. Dick.

INDIGENOUS MEXICO AND SCIENCE FICTION

In her essay "Zones of Disturbance: Specters of Indigenous Mexico in Modernity," Mariana Botey offers a seductive yet terrifying vision of the future in which our present is the dawn of an apocalypse prophesized by the ancient Mexicans that causes modernity to implode due to the force of "otherness."[14] Botey's work is analytically complex and fascinating. It tackles a discourse that is generally treated as having low prestige or dismissed as charlatanism but is so necessary in order to renew our view of the indigenous world and its place within the discourse of modernity. Post-Aztec messianism, which spreads to the rhythm of the *concheros*— Aztec-styled street performers—of Mexico City's central plaza, is strategically examined by Botey under the philosophical gaze of several authors, among them French intellectual Georges Bataille and French dramatist and poet Antonin Artaud, whose visits to Mexico and contact with the indigenous world profoundly impacted their texts.

Botey seeks to "trace a messianic arc through the history of modern Mexico," and she tells us the "against the grain" history of "a nation founded on an assemblage of messianic myths, regarding not only meta-history but also the administrative failure of the Conquest, which have had an indelible effect. A messianism that threatens to vanquish the stability

of the nation itself, and which moreover foreshadows the destabilization of the representation of Mexico within the discourse of Western history."[15]

The processes of colonization, conversion to Christianity, and *mestizaje* were accompanied by the massacring of the indigenous population and the destruction of their codices, as well as the subsequent genocide of African slavery, leading to ongoing destabilizing effects on present-day society. Botey observed that Latin American modernity, "established through a process of violence, . . . has an ominous double."[16] Her book deftly weaves an encrypted tale of the Mexican nation, one that involves the bones of Cuauhtémoc, the last Aztec emperor, who was subjected to torture by Spaniards seeking his hidden treasure until they killed him and abandoned his remains in the forests of Tabasco.

Finally, after a number of voyages, Cuauhtémoc's bones returned to his place of birth, the Chontal village of Ichcateopan, where they lie interred under a Christian altar by Friar Motolínea. This legend has been transmitted orally through the centuries, spreading across the border to the rhythm of drums, a wisdom belonging to the mythical realm, although history with a capital H negates its truth. This is the point of departure for Botey's analysis of the indigenous world as the ghost that haunts Latin American modernity. Despite centuries of domination and oppression, the ancient cosmogonies reappear. The author interprets this as "the return of the repressed," that is, the emergence of a subjugated identity.

After the semantic and spiritual violence involved in the conquest and colonization of the continent, the modern nation sought the idyllic integration of the indigenous in an intellectual manner. Those best intentions resulted in the construction of monuments to our ancestors, while their descendants, inhabitants of sacred grounds with a living history and culture, continued to be marginalized and banished to the hills and canyons, condemned to choose between extinction or integration into the modern capitalist model.

The golden age of Mexican film, muralism, and José Vasconcelos's educational impulses contributed to the idealization of the Mexican *mestizo*—baptized as *la raza de bronce* (the bronze race), a schmaltzy version that derived in its Disneylandization as part of the realist ethos. The raza de bronce along with all the other ethnicities transformed into tourist merchandise were integrated into the project of whiteness and adapted to the capitalist model. However, following Botey, it is important to note that the discourse of the other persists, like the ghost in the machine, haunting modernity. Botey observes, "The indigenous presence shamanizes the machine," making it clear that the indigenous existence implies the possibility and the right to a "subaltern and insurgent means of subjectification."[17]

It is enlightening to discover, reading Echeverría and Botey, that at the root of Latin American identity there is a baroque device brought about by the persistence of cultural diversity and the cosmogonical fortress of ancient thought against the totalizing machine of capitalist modernity,

operated by the large transnational corporations that export a stereotype of humanity that Echeverría refers to as "whiteness," or the realist ethos. The "baroque machine," "whose function is to dislocate the logic of domination," works due to a rhetorical and allegorical repertoire capable of generating "open interruptions in the apparatus of control and discipline, where they create noise and contaminate the message."[18]

THE AZTEC MUMMY VERSUS THE HUMAN ROBOT

Science fiction came to Mexican cinema by accident. Between the 1940s and the '60s, the film industry took plots related to space travel and sinister invasions and adapted them to the formulas of their biggest box office hits: comedians, cabaret beauties, and wrestler films. Although Mexican cinema has been considered ignorant but also innocent, it is interesting to note that by staging modernity promoted by American science fiction, these B movies made for the amusement of the masses removed themselves from imposed First World ideals.

On the other hand, the Mexican B movie genre has used frivolous and ignorant images of pre-Columbian cultures. Within the Mexican film industry, there is one character in particular who intertwines indigenous elements with science fiction motifs: the Aztec mummy. Behind this character we can hear the echoes of neo-Aztec messianism, the "messianic archive" referred to by Botey. The Aztec mummy is the sinister manifestation of the ancient Mexican redemption tales mentioned by the author.

Though it retains some indigenous elements, this character does not actually correspond to any ancient Mexican tradition, but rather is the adaptation of a Western classic in which the mummy was not Aztec but Egyptian. However, the connection is significant, in the sense that the mummy represents past empires in opposition to modernity, which is to say magical thought against rationality, the curse of the ancients upon those who seized the riches of the colonized lands.

In film, this story begins with the great Boris Karloff playing the Egyptian mummy in the 1930s, and in the 1950s it is successfully updated with *The Search for Bridey Murphy* (1956). Mexican cinema's incredible capacity for parodic appropriation during this period brought this blockbuster plot together with indigenous concepts and elements that had been explored in films like *Chilam Balam* (1955), giving birth to the trilogy *The Aztec Mummy, The Curse of the Aztec Mummy,* and *The Aztec Mummy versus The Human Robot* (1957–58) (fig. 2).

Rosita Arenas is the young woman in love with the scientist, played by Ramón Gay, a modern man with unholy ambitions who believes in science and rejects superstition. He hypnotizes her and she sees her past life, as Xochitl, the Aztec maiden destined to be sacrificed to Tezcatlipoca, the god of war. The brave warrior Popoca, who is in love with Xochitl, attempts to save her from being sacrificed. The two end up buried, and Popoca becomes the Aztec mummy, eternal guardian of a valuable pectoral ornament with a map to the hiding place of an Aztec treasure.

In her essay, Botey explains that Aztec messianism is known as *Mexicáyotl*, "a prophetic corpus on the return of the indigenous. The followers of Mexicáyotl believe that the discovery of the tomb of Cuauhtémoc, the last of Mexico's Aztec emperors, or *Tlatoani*, would unleash the fulfillment of the prophecy." This post- or pseudo-indigenous epic is constructed reusing Western paradigms, revealing the peculiar capacity of the baroque machine, which can be observed in the transfiguration of colonialist plots, such as the Egyptian mummy into a weird, illegitimate, and mestizo product: the Aztec mummy.

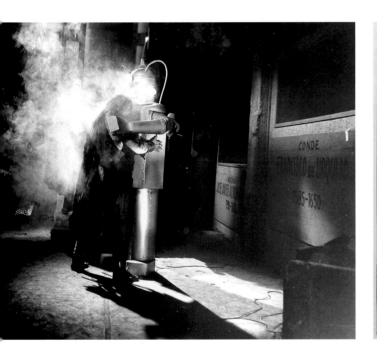
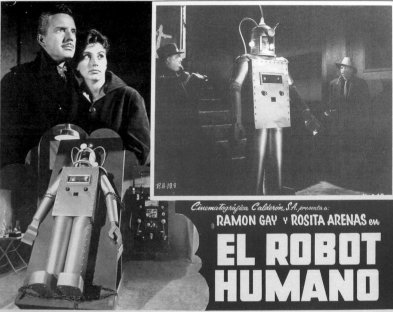

Xochitl and Popoca, in turn, are flamboyant results of the legend of the volcanoes Popocatépetl and Iztaccihuatl—an Aztec warrior and maiden who die for love (the resemblance to Romeo and Juliet is no coincidence). When these volcanoes—between which Hernán Cortés crossed when he first saw the great Tenochtitlan in the early sixteenth century—are awakened, they will give rise to a cataclysm that will flood the city of sin with lava and ash, and the great Aztec people will shake off Western impositions and overcome a history of subjugation.

The Aztec mummy, like the bones of Cuauhtémoc kept in Ichcateopan, represents the pain of a conquered people seeking vengeance, a bloodthirsty ghost, the enactment of a curse. In the final sequel of the series, the Aztec mummy, with his clumsy composure and absence of expression, runs up against an even less likely opponent, the human robot, with whom he fights until he rips his last cable in a scene that has become a cult classic (fig. 3).

FIGURE 2
Raphael Portillo
La momia azteca vs el robot humano (The Aztec Mummy versus The Human Robot)
1957
Collection of Filmoteca UNAM, Mexico City

FIGURE 3
Raphael Portillo
El robot humano (The Human Robot)
1957
Collection of Filmoteca UNAM, Mexico City

This battle is an allegory of the never-ending dialectic: modernity versus barbarism, technology versus magical thought, the United States versus Mexico, domination versus abnegation, future versus past, and avant-garde versus tradition. On one side, the human robot, the drive for power, globalizing market tendencies, technology, and the postmodern condition; and on the other side, operating the baroque machine, the Aztec mummy, the ominous return of the indigenous ancestors.

Wrestling Women vs. the Aztec Mummy (*Las luchadoras contra la momia*, 1964), is one of the many variations of the same plot in which, in addition to the performance of sexy wrestler queens, the mummy is capable of turning into a bat and flying away thanks to a nylon thread. The most thrilling scenes were filmed in Teotihuacán where, in an underground room beneath the pyramid of Quetzalcóatl, the mummy and the Aztec

FIGURE 4

"Descubren el camino al inframundo en Teotihuacán [Discover the way to the underworld in Teotihuacán]," infographic by La Razón de México www.razon.com.mx

From the "Culture" section of *La Razón*, October 30, 2014

princess are guarding a secret treasure. In fact, in 2014 the newspaper *La Razón* reported that archaeologists had located a secret passageway and chamber beneath the pyramid of Quetzalcóatl (fig. 4). The wrestlers believe that the treasure will allow them to "take on great works on behalf of our Nation." The film's antagonist insists on being called Black Dragon and is obsessed with Japanese culture, wearing a kimono despite being played by an actor who resembles, racially, the Aztecs. The mummy in this case is Tesozómoc, a *Nahual* (a human who can transform into an animal form) in love with Xóchitl, who reincarnates as one of the wrestler beauties. Events that "defy all logic, mysteries from the beyond" leave the scientific mind dumbfounded, and thus the defeated people's messianism begins working toward the future.

In order to use the pre-Hispanic ruins, the final credits of the film were required to include the following paragraph: "Calderón S.A. cinematography thanks the INAH (National Institute of Anthropology and History) for the facilities provided for filming in archaeological sites, and emphasizes that this film is not intended to reflect historical events, and that the representation of Mexico prior to Cortés is purely fictional." We must not forget that, as Botey notes, though researcher Eulalia Guzmán presented proof after being commissioned by Mexico's Education Ministry and the INAH to verify the tale of Ichcateopan in 1949, the story was officially rejected and attributed to the nineteenth-century liberal idealization of Cuauhtémoc as a national hero. However, as Botey points out, "The disappeared body of Cuauhtémoc is, in fact, the body of indigenous sovereignty,"[19] and it is this same ominous phantom that infiltrates the science fiction genre, using celluloid to give shape to the Aztec mummy and confront the human robot.

NOTES

Translated by Phillip Penix-Tadsen

1. Translator's note: Since "blanquitud" is a neologism in Spanish (coined by Echeverría), "whiteness" does not completely encompass its meaning; the term has also been translated as "whitey-ness," and Jean Franco defines the concept as "not whiteness as such, but the iconic ideal of capitalism's new man." See Jean Franco, *Cruel Modernity* (Durham: Duke University Press, 2013), p. 47. I adopt the most commonly used translation of the term, "whiteness," for purposes of readability.

2. Through phenomenology, psychoanalysis, and semiotics, Echeverría recognizes the symbolic orders from which to access the behaviors that characterize modernity, and from there he identifies four types of ethos (styles, manners, guidelines): the classic ethos, the realist ethos, the romantic ethos, and the baroque ethos. But more than definitions of historical periods, which are generally how these terms are used, Echeverría refers to the ways of experiencing modernity and of giving the civilizing process a specific shape. These ethos are reflected in customs, language, and artistic production, and although their expression has been more prominent at certain points in history, they have reached the present time and update themselves in contemporary society.

3. Bolivar Echeverría, *Modernidad en América Latina. Vuelta de siglo* [*Modernity in Latin America: Turn of the Century*] (Mexico City: Era, 2006), p. 214.

4. Ibid.

5. Ibid.

6. Bolivar Echeverría, *Modernidad y Blanquitud* [*Modernity and Whiteness*] (Mexico City: Era, 2010), p. 205.

7. Ibid.

8. Alfonso Morales is director of *Luna Cornea* magazine, a specialist in vernacular photography and Mexican popular culture, and is renowned for his research of twentieth-century Mexican calendar illustrations. "Portable Homeland" is the title of his essay for the exhibition catalogue for *La leyenda de los cromos*, which he curated for the Soumaya Museum in Mexico City in 2000.

9. Ibid., p. 96.

10. Ramón López Castro, *Expedición a la ciencia ficción mexicana* [*An Expedition into Mexican Science Fiction*] (Mexico City: Lectorum, 2001), p. 144.

11. From 2015, during the research for this show.

12. Ibid., p. 141.

13. According to Mexican mythology, this is the lowest level of the land of the dead.

14. Mariana Botey, *Zonas de disturbio. Espectros del México indígena en la modernidad.* [*Zones of Disturbance: Specters of Indigenous Mexico in the Modern Era*] (Mexico City: Siglo XXI, 2014).

15. Ibid., pp. 47, 50.

16. Ibid., p. 49.

17. Ibid.

18. Ibid., p. 39.

19. Ibid., p. 99.

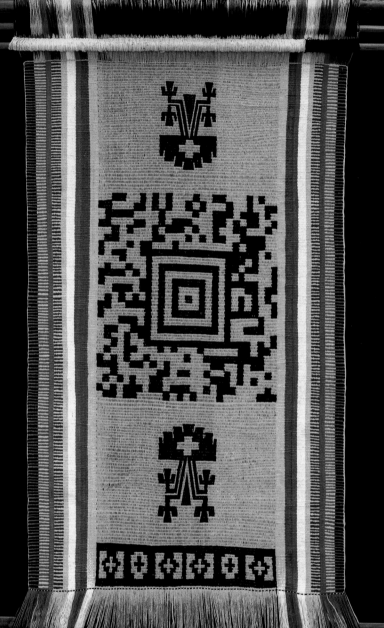

PLATE 19
GUILLERMO BERT
Lukutuwe (Fertility)
2012

Guillermo Bert archives tribal oral histories by synthesizing modern digital technologies with traditional indigenous art forms through a process of collaboration with Mapuche weavers and elders. The tapestries from Bert's *Encoded Textiles* (2012) grew out of the artist's observation that the geometric patterns of QR codes resemble the iconography of many indigenous textiles. This encryption technology can store vast amounts of information in the same way that many Mapuche weavers visually encode stories through complex symbolism in their textiles. Bert first interviewed artists and weavers in Chile, filming traditional stories, poems, and personal narratives. After digitally linking this community-generated archive to a functional QR code, Bert commissioned local artists to create tapestries that incorporate the code into the design of the textile.

Each of the textiles functions as a kind of portal, informing the viewer about indigenous cultural traditions and histories of struggle. The works in the series also ask viewers to consider how new media technologies of encoding and digitization enact forms of information translation, transformation, and loss. Finally, *Encoded Textiles* exemplifies the interest within science fiction media in data-storage technologies and archive theory, as in Jorge Luis Borges's *The Library of Babel* or science fiction gadgets like the "film-book" from Frank Herbert's *Dune* (1965).

RUDI KRAEHER

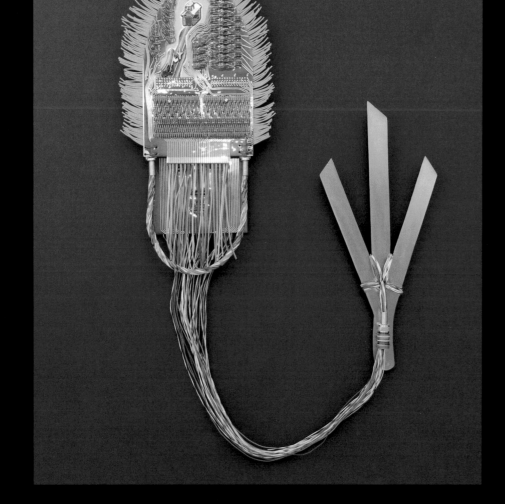

PLATE 20
MARION MARTINEZ
El Sueño del Matachin
2005

Marion Martinez creates mixed-media *retablos*, sculptures, and wearable artwork (*joyería*) out of recycled computer circuit boards. Drawing heavily on her own syncretic Indo-Hispano cultural context in northern New Mexico, Martinez repurposes e-waste to create works that participate in a long tradition of "santero" folk art while also making important claims about technological detritus and environmental justice.

Martinez grew up near Los Alamos National Laboratory (LANL), the birthplace of the atomic bomb and an important research facility for U.S. nuclear technology. Developing an art practice that is spiritual and grounded in a deep con-

from electronics discarded by LANL, repurposing high-tech trash to create intricately detailed sculptures and jewelry depicting sacred and ancient images.

The artwork shown here includes the small sculpture *Mi Casita* (2003), a *milagro* titled *Corazón del Niño/Heart of Joy* (2004), and *El Sueño del Matachin* (2005). The latter is inspired by the Danza de Matachines ritual dances in New Mexico. The matachine headdress is connected by wires to a copper "trident" (*palma*). Through its materials, methods of assembly, and iconography, this work advocates the continuation and transformation of Indo-Hispano cultural practices while always maintaining an ethical relationship

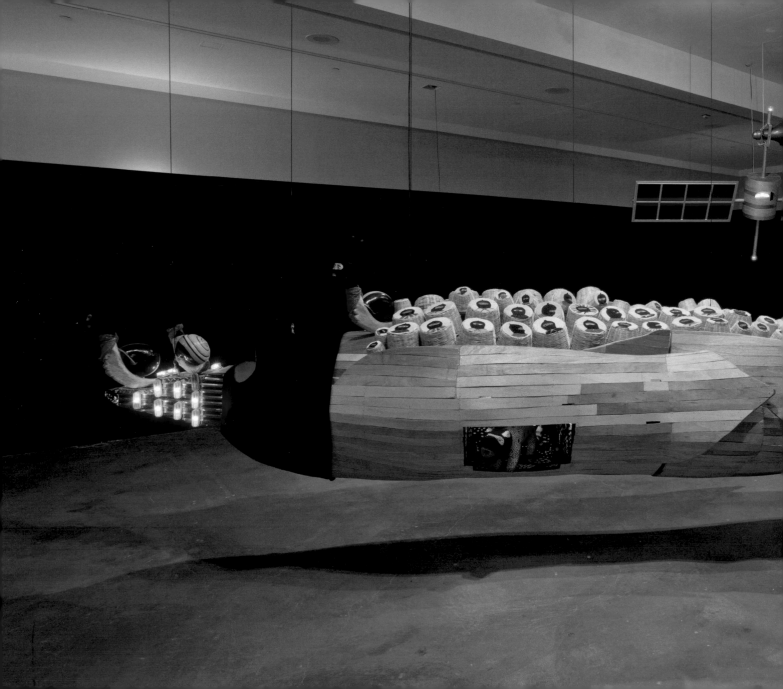

PLATE 21

RIGO 23
Autonomous InterGalactic Space Program
2009–present

Rigo 23 emphasizes community-based forms of art practice in his many paintings, murals, sculptures, and public interventions. *Autonomous InterGalactic Space Program* (AISP; 2009–present) is a collaboration between Rigo 23 and Zapatista artists and artisans in Chiapas, Mexico. After more than three years of building trust with EZLN (Ejército Zapatista de Liberación Nacional, or Zapatista Army of National Liberation) communities and artists, the original plan for a spaceship for "intergalactic" global meetings grew into an immersive "planetarium" of Zapatista iconography. The resulting artwork is a powerful vehicle for the artists' anarchist ethic of collective decision making, indigenous self-determination, and a general commitment to worldwide struggles against globalization and neoliberalism.

The focal point for this project is the corn-shaped wooden spaceship filled with handwoven baskets ("kernels") that feature a portrait of a Zapatista. The Zapatista figures wear their iconic black ski masks (*pasamontañas*) obscuring individual identities in favor of a resistant, collective identity. Three wooden snails with Zapatista faces ride in the front of the spaceship. Snails, or *caracoles,* are an important image for the group as well as the name for their autonomously governed communities. AISP also features other artworks, including sculptures of Zapatista celestial bodies and original paintings by Zapatista artists: scenes of cosmic struggle against organizations like the World Trade Organization (as a dragon) amid stars, flowers, and two torch-bearing Zapatistas, firmly grounded on the Earth within the larger cosmos.

RUDI KRAEHER

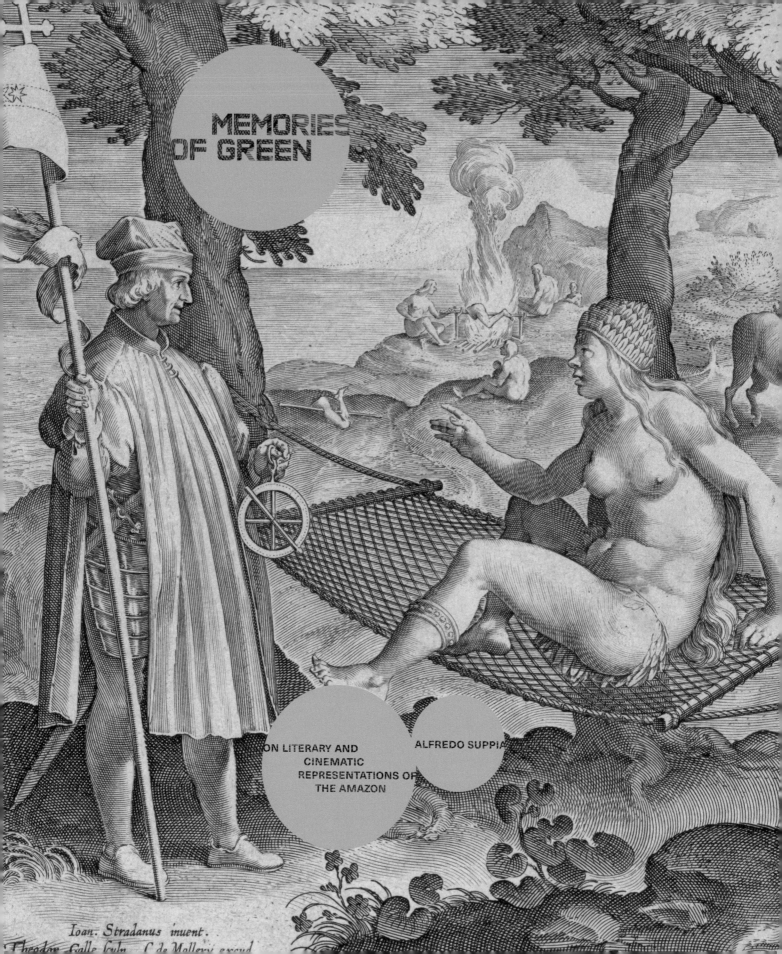

MEMORIES OF GREEN

ON LITERARY AND CINEMATIC REPRESENTATIONS OF THE AMAZON

ALFREDO SUPPIA

Ioan. Stradanus inuent.
Theodor Galle sculp C. de Mallery excud

A t 2,700,000 square miles, the Amazon Basin is three-quarters the size of the continental United States, and a million square miles larger than all of Europe exclusive of Russia. Covering two-fifths of South America and three-fifths of Brazil, the Amazon Basin contains one-fifth of the planet's available fresh water, one-third of its evergreen broad-leaved forest resources, and one-tenth of its living species. The Amazon River, the longest in the world (at 4,255 miles) and the most voluminous, has some 1,100 tributaries, seven of which are over 1,000 miles long. And the Amazon's forests, with rainfall averages of 2,300 millimeters (7.5 feet) per year, represent, along with the adjacent Orinoco and Guyanas, over half the world's surviving tropical rainforests.[1]

The Amazon is impressive for a number of reasons. Since Arthur Conan Doyle's novel *The Lost World* (1912) and its cinematic adaptation (Harry O. Hoyt, 1925), Brazil and the Amazon have often been described as a mysterious and totemic part of the world. Released in the same year as Hoyt's film, Gastão Cruls's novel *Mysterious Amazon* (*Amazônia Misteriosa*, 1925) joined a body of Brazilian narratives in which the Amazon is set as a utopian/uchronian[2] landscape and a repository of both power and damnation. In the wake of these varied forms of representation, American movies from the 1950s—such as Jack Arnold's *Creature from the Black Lagoon* (1954) and Curt Siodmak's *Curucu, Beast of the Amazon* (1956) as well as popular films of the 1980s and 1990s like Luis Llosa's *Anaconda* (1997)—promoted the idea of the Amazon as a nest for otherworldly species and undreamed treasures, a frontier through which Western "civilized" men are prone to face secrets and risks originating from times immemorial. Thus here it is worth revisiting the impact and resonance of national myths and the Amazon on science fiction and fantasy imagery in South America and the United States.

THE AMAZON IN MOTION

Neither literary nor iconographic accounts of Brazil and the Amazon are easily juxtaposed with cinematic/audiovisual representations of "the land of the future"—one of the most hackneyed phrases ever associated with Brazil, which was coined by the Viennese-born writer Stefan Zweig in his book published in 1941.[3] There is a huge gap between these two media, with film tending to reproduce mostly the more shocking and sensationalistic literary accounts of the Amazon. Cinematic representations of the mesmerizing powers of the Amazon and its myths can be seen in a certain number of auteur films, including Werner Herzog's *Aguirre: The Wrath of God* (*Aguirre, der Zorn Gottes*, 1972) and, to some extent, *Fitzcarraldo* (1982). Set in the sixteenth century, *Aguirre* focuses on the ruthlessness and insanity of the Spanish conquistador Don Lope de Aguirre (Klaus Kinsky), while he was leading an expedition in search of Eldorado. *Fitzcarraldo* transposes the grandiosity and the mythical drive to more contemporary times by telling the story of Brian Sweeney Fitzgerald (again, Klaus Kinsky), an extremely determined man devoted to the construction of an opera house in the middle of the rain forest. As noted by Keith Richards, "For the Peruvian critic Reynaldo Ledgard (1984) among others, the filming of Werner Herzog's *Fitzcarraldo* is ultimately of more consequence than the cinematic result and the film 'becomes a metaphor of its own creation.'"[4] However, it has been through the lure of science fiction and fantasy films that fictional representations of Brazil and the Amazon seem to have reached broader audiences around the world. Focusing on supernatural creatures that inhabit the heart of the Amazonian rain forest, these popular films created over the past century have shaped and guaranteed the survival of both cultural and political aberrations.

Legends about a land named "Amazonia" preempted the official discovery of the Americas. For instance, in the fourteenth century, Sir John de Mandeville referred to Amazonia as an island in the Caspian Sea populated only by female warriors: "And toward the sea Ocean in Ind is the kingdom of Scythia, that is all closed with hills. And after, under Scythia, and from the sea of Caspian unto the flom of Thainy, is Amazonia, that is the land of feminye, where that no man is, but only all women."[5] Even before that, an island named "Bresal," later called "Brasil," would have been referenced in the fifth century.[6] The discovery of the actual Amazon is surrounded by myths, hoaxes, and controversial reports (official or not), whose doubts and uncertainties will hardly be unveiled one day.[7] According to the official Spanish account of the discovery of the Amazon in 1499, the Italian explorer Amerigo Vespucci, serving the kingdom of Castile, would have visited the two mouths of the river, penetrating about fifty miles through one of them in two days of travel. In March 1499, after passing by the cape of Santa María de la Consolación, Vicente Pinzón arrived in the northern mouth of the river, through which he would have penetrated sixty miles. According to Bartolomé de las Casas, Pinzón captured thirty-six native Brazilians while navigating the river and made them slaves.[8] The

expedition that followed Pinzón's was led by Diego de Lepe, who would have entered the Marañón River in April 1500.[9] Several other expeditions into the Amazon and the Marañón River may have occurred but were unrecorded or conducted in secrecy under different national flags.

By the end of the sixteenth century, the New World was also visited by the English explorer Walter Raleigh (1552–1618), a pioneer in the British colonization of Virginia and one of the most controversial characters in the history of great navigations. Raleigh was responsible for the map "Discovery of Empire of Guiana" (1595), and his *History of the World* (1614) includes several maps. One of them, *Tabula geographica nova omnium oculis exibens et proponens verssimam descriptionem potentissimi et aurifen regni Guiana sub linea aequinoctiali inter Brasiliam et Peru*, refers to a number of teratological figures, such as Amazon warriors and a headless man with eyes on his chest. An inscription assures that the map is in accordance with original information collected from navigators that followed Raleigh's own trip.[10] Likely, Raleigh was seduced by the myth of the immense Golden Lake (El Dorado or Eldorado), which explorers had sought since the sixteenth century, and whose legendary origins are ascribed to the Greeks.[11] Gregory Claeys remarks that the search for the legendary Manoa, capital of Eldorado, would soon be associated with a more general greed and hunt for any sort of precious metals, Incan and Aztec treasures, and the conquest of trading routes. In his *Candide* (1759), Voltaire parodied the legend of Eldorado by emphasizing the religious overtones in the original myth (fig. 1).[12] Persephone Braham remarks that early Amazonian explorers' accounts of their encounters with native communities indicated the power of the myth of cannibal women who allegedly inhabited the Amazon basin, a myth expanded and reconfigured in the character of the Amazon warrior.[13] In his journal of Francisco de Orellana's expedition in search of Eldorado, down the Marañón River to the Atlantic coast in 1542, Friar Gaspar de Carvajal would have reported the first encounter with Amazons in the New World. According to his diary, the warrior women were mentioned by Indians all along the Amazon River, and were reputed to possess abundant gold, silver, "camels," and all kinds of beasts: "Carvajal's prior knowledge of the Scythian warrior women came to the fore when he was told of warlike indigenous women who demanded tribute from their neighbours, and henceforth the Marañón became known as the place of the Amazons."[14]

By the early seventeenth century, the Amazon region gained relevance in the work of European cartographers. Yet the exoticism characteristic of the first representations persisted in more accurate cartographies.[15] Toward the end of the seventeenth century, however, fabulous accounts and images of the region, with their Amazon warriors and other fantastic creatures teasing the conquistadors' fantasies, gradually disappeared from cartographic representations.

Notwithstanding, in our contemporary visual culture the monster persists and usually incarnates the jungle in a number of commercially

FIGURE 1

"New Map of the Wonderful, Large and Rich Land of Guiana," hand-colored map of Guiana (present-day French Guyana, Suriname, and Guyana)
[Amsterdam, Holanda] : Jodocus Hondius execudit, [1598]. 1 map : *gravado a cores ornamentado*, 14½ × 20½ inches approx. (36.5 × 52 cm) Collection of the National Library Foundation—Brazil

oriented films. While in Herzog's *Aguirre* the monstrosity stems from the ruthlessness of an insane European conquistador, in American films from the 1950s, '80s, and '90s, the monster is a native inhabitant of the Amazonian rain forest. According to Braham, "Monsters are arbiters of order and disorder within a given social or cultural system. The work of monsters always derives from culturally specific expectations; monsters allow us to express ideas about what is normal, and channel fears about what isn't."[16] Drawing on Braham's remarks, one might say that popular cinematic monsters from the Amazon are more symptomatic and descriptive of Western anxieties and racism than of any native Amazonian culture to which they might be related.

In Hoyt's *The Lost World*, undoubtedly one of the first science fiction and fantasy films with a story set in the Amazon, Professor Challenger (Wallace Beery) has been the laughingstock of the British scientific community for defending the idea that dinosaurs survived extinction and now live in remote areas of the planet—namely a given "plateau" in the Amazon, according to the notes left by someone who had previously ventured into the jungle. As Sir John Roxton (Lewis Stone), a supporter of Challenger, remarks in one of the film's first intertitles: "The back country of the Amazon contains over *fifty thousand miles* of unexplored water-ways. Who can say *what* may be living in that jungle—as vast as all Europe?"

In order to prove his thesis, Challenger leads an expedition to the Amazon, in search of "the lost world." As the explorers navigate the river deep into the rain forest, samples of the local fauna are displayed, such as a jaguar (*onça*), an anaconda (*jibóia*), a monkey (*macaco*), and a Brazilian sloth (*preguiça*). The enthusiasm with Amazonian fauna extrapolates to the point that a pair of little bears are caught stealing food from a camp— whereas in fact no bears inhabit the Amazon basin. Soon the presence of European white men is perceived by ape men from the plateau, and the first dinosaur seen by the explorers happens to be "[a] Pterodactyl—proving definitely that the statements in poor Maple White's diary are *true*!"

Isolated in the plateau and surrounded by dinosaurs, soon the white men use their firearms against the local species, whereas Professor Challenger himself starts working on the invention of a specific weapon to be used against the dinosaurs. A paradigm seems to be set in this early film: violence enforced by firearms (and later, by nuclear weapons) in the wake of an allegedly "scientific" expedition that is supposed to gather knowledge and bring civilization upon remote areas of the planet. However, after the arrival of Challenger's expedition at the plateau, most scenes consist of the explorers witnessing confrontations between different species of dinosaurs, as if "the lost world" were a giant battlefield in which European white men cannot do more than watch and see—and fire their weapons. Geographic mistakes, like a volcano that finally erupts, spreading chaos all over the rain forest, as well as the very existence of such a plateau in the Amazon basin, seem to provoke further estrangement regarding the jungle.

Seen in retrospect, *The Lost World* shocks any contemporary spectator in virtue of its racist content and lack of any environmentalist sensibility. By the last third of the film, the British explorers leave the Amazon, taking a living brontosaurus to be showcased as an attraction in London. As a prototype for future disaster movies—anticipating Merian C. Cooper and Ernest B. Shoedsack's *King Kong* (1933) and the Japanese *kaijū eiga* (怪獣映画) films—the brontosaurus escapes the cage and wreaks havoc on London. Under fire on the Tower Bridge, the poor Jurassic animal ends up dead after falling into the Thames. It is worth noting how the elementary formula in *The Lost World* recurred across a number of science fiction and fantasy films whose fable is set in the Amazon or equivalent "remote" lands.

This formula can be summarized as follows: (1) European or American scientists come to the Amazon in order to find evidence or investigate a mystery; (2) white men with different backgrounds and expertise take part in an expedition to far inlands, usually counting on guidance by a "native" Brazilian; (3) a "monster" is discovered and the expedition has to cope with the uncanny encounter; (4) people die in this process, usually non-white characters; (5) white men figure out a "sensible," "scientific," or simply "superior" way to face the "monster," but this way is often based on pulling triggers or firing nukes; and finally, (6) the "monster" is either killed or captured and brought to a large European or American city (London, New York), where the creature will eventually be exterminated. This six-step plot varies across a number of films, but usually remains the same over the years, particularly in terms of major blockbusters.

The aforementioned formula initially reappears in Jack Arnold's *Creature from the Black Lagoon* (1954), a film that features perhaps the biggest ellipsis or jump cut in the history of cinema, bigger than the famous scene in Stanley Kubrick's *2001: A Space Odyssey* (1968), in which a hominid throws a bone up to the sky and a cross-fade turns the bone into a twenty-first-century spaceship (or military satellite). Therein, a gap of some hundreds of thousands of years, a few million years perhaps, is cut short in a few minutes. Arnold's film, however, starts with an amorphous universe being created by God. In that context, the Earth is "created" as well, its surface cooled, and massive rains generate the oceans in which the first life-forms will thrive. The voice-over goes on to tell about how life spread from the oceans onto the continents, thus making room for the dawn of humankind. The narration ends at present times (1950s), when a "lost world creature" survives alone in the waters of a "black lagoon" in the Amazon basin.

Hundreds of million years, if not a few billion years, are didactically narrated, documentary-style, in the few minutes of this prologue. The adventure itself truly begins when a fossil is found by "native Brazilians" working at an archaeological site in the Amazon. This find makes the leading scientist, Carl Maia (Antonio Moreno), contact colleagues in order to launch an expedition, and soon a team of American researchers travel

by boat up the river and toward the "black lagoon." There the expedition members find much more than simple evidence related to the fossil: the heroes confront a humanoid amphibian from the Devonian period, which, according to one of the scientists, could be compared to the pirambóia fish (*Lepidosiren paradoxa*, found in the Amazon and Mato Grosso, as well as in the Paraná River basins) in terms of longevity of the species. Like the pirambóia, the "gill-man" (interpreted by Ben Chapman on land and by Ricou Browning in the water scenes) represents a creature that lives between two worlds, and whose origins date back to times immemorial. In its "suspension of time," the Amazon in *Creature from the Black Lagoon* is both utopian and uchronian. It keeps a secret from human civilization: the link between two worlds and the virtual immortality of a given species. Western science can neither explain nor understand it, and all the characters act as if they had returned to a primal stage while facing the "monster," which is eventually killed by the hero.

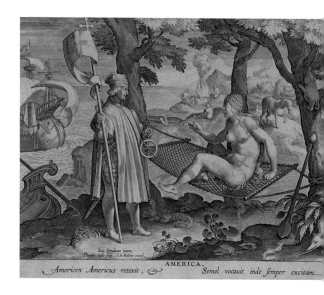

The actor, Antonio Moreno, was an early crossover star between American and Mexican film, and his star persona was enmeshed in "Latin Lover" imagery. Indeed, he played a major role in *Creature from the Black Lagoon*—but a supporting role. His casting might hint at the subversion or rethinking of the classical discourse of the white male navigator of the Amazon, but this is doubtful. First, in his supporting role, Moreno's character resorts to consulting American colleagues in order to solve the mystery of the archaeological site. Gender-neutral, he is rather subtle, lacking the intensity and agency of his peers, and he does not exactly lead the expedition, nor is he the other half of the romantic duo. Second, whereas Moreno's character can immediately be regarded as foreign or transnational by American audiences, Brazilians tend to look at him with a different perspective. His name alone, Carl Maia, hints at first and foremost Anglo-American or European descent. He is Carl, not Carlos, even though his surname, Maia, suggests Latin American heritage. Third, his accent is far from being familiar to Brazilian ears; therefore, he could hardly be immediately identified as a Mexican actor, let alone a Brazilian one.

All in all, parody has been a major force in most cinematic representations of the Amazon, and curious inversions may take place. It happens in one of the most iconic scenes from *Creature from the Black Lagoon*, which has plenty of sexual overtones. In the scene, the gill-man (Ben Chapman) "awakens" the American woman (Julia Adams)—a curious revisit of Théodore Galle (after Jan van der Straet)'s *Nova reperta*, in which Amerigo Vespucci awakens the "sleeping America" (ca. 1580). Taking the place of the European explorer, the male monster, who personifies the unruly Amazon, interrupts the "sleep" of "America"—now a white Anglo-Saxon "North America." Also, while Galle's *Nova reperta* alludes to Western patriarchy in the figure of the "civilized" white man who therein awakens a nude native American, the gill-man in *Creature from the Black Lagoon* is clearly emasculated—a "castrated" monster with no apparent genitals (figs. 2, 3).

The oft-admired scene from *Creature*, in which the gill-man mirrors Kay Lawrence (Julia Adams) while she swims in the lagoon, has already been examined from a psychoanalytical and/or feminist perspective, inspired by film theorists such as Laura Mulvey (1975).[17] But regardless of any concern for the "male gaze" motivated by the creature, the very mise-en-scène in this case might have some information on the emasculation of the monster. In general lines, the whole scene suggests sexual intercourse. However, under a certain perspective (and admittedly a rather primary reading), the Western white woman is remarkably "on top," while the monster assumes a submissive position. It is the monster who is mesmerized by the swimming young woman—and not vice versa, as in the biblical scene of the serpent seducing Eve.

Creature from the Black Lagoon had two sequels: *Revenge of the Creature* (1955), also directed by Jack Arnold, and *The Creature Walks Among Us* (1956), by John Sherwood. In the former, the gill-man is captured to be an attraction in a Florida aquarium, from which he finally escapes to exact terror in the area. In the third saga, a scientist captures the "monster" and turns him into a "human being," by means of a scientific procedure that inflicts both extreme physical and psychological pain to the former gill-man. By the third film, the creature seems to have been turned into the true "hero" of the story, and some sort of meta-criticism toward the

FIGURE 3
Still from *Creature from the Black Lagoon*
Director Jack Arnold, U.S.
1954
Photos 12 / Alamy Stock Photo

political discourse embedded in the previous films appears to emerge, in tandem with a more consistent environmentalist sensibility.

Curt Siodmak's *Curucu, The Beast of the Amazon* (1956) revisits the story of a monster who wreaks havoc in the jungle, this time shot on location in Brazil.[18] In this film, Rock Dean (John Bromfield) and Dr. Andrea Romar (Beverly Garland) travel up the Amazon River to find out why workers at a plantation have left in panic, allegedly because of attacks from "Curucu," a monster who is said to live up the river, where no white man has ever been. *Curucu* features semi-documentary scenes that take place in Rio de Janeiro, Belém, and rural areas in the Amazon, but none of these prevent the mistakes and goofs involving Brazilian fauna, language, and culture. The local fauna is portrayed as a deadly horde of animals living in an extremely violent ecosystem. Snakes, alligators, and spiders attack humans, while piranhas slaughter any moving creature that falls into the rivers. The scene in which the romantic duo are in a canoe going up the river while being attacked by snakes and alligators is particularly representative of the portrayal of the Amazon as a "green inferno" (*inferno verde*, in the sense of a harsh and deadly environment). In the first of a series of crimes against fauna, the hero does not hesitate to shoot an alligator on sight. Even the buffaloes appear as a horde of deadly animals—curiously, the movie features a herd of Asian water buffalo originally from Southeast Asia and India, and nonexistent in South America. At a certain point, Foz do Iguaçu's waterfalls (located far away in the south of Brazil, at the border area with Paraguay and Argentina) suddenly appear as if they were part of the Amazonian landscape, while the romantic duo are placed in captivity

by native Brazilians (who are mostly white men performing in blackface and wearing wigs and costumes reminiscent of native North Americans or Tarzan films). Also in *Curucu*, a local musical performance is immediately referred to as "macumba," and the film's last shot presents voodoo rites of head-shrinking putatively practiced by Amazonian tribes.

Finally, the monster that spread terror in the rain forest is revealed to be Tupanico (Tom Payne), a Brazilian who had the utopian dream of saving his people from capitalist exploitation to restore cultural traditions.[19] Tupanico takes advantage of the putative legend of Curucu in order to design his questionable utopia, but his plans are finally frustrated by Rock Dean and Dr. Andrea Romar.[20] Rock, a stereotypical hero, shoots and kills all kinds of species at will, demonstrating no sympathy for the environment whatsoever, and thus reinforcing the idea of the Amazon as a deadly wild land to be conquered by Western (armed) civilization.

While *Curucu* demystified the idea of a monster in the Amazon, subsequent movies continued to explore the trope of a lost-world creature haunting the jungle, much in the style of Arnold's *Creature*. In Luis Llosa's *Anaconda* (1997), a film crew led by Terri Flores (Jennifer Lopez) is going to shoot a documentary on the legendary "Shirishamas," or "people of the mist," an elusive Amazonian tribe that lives isolated deep in the rain forest. However, along the way, the film crew is deceived by a mysterious hunter (Jon Voight), who takes them along on his quest to capture the fearsome "giant anaconda," a blood-thirsty reptile worshiped by the natives. In spite of mostly negative reviews from film critics, this film was a box-office hit and originated three sequels, plus a crossover film with the Lake Placid franchise.[21] Directed by a Peruvian filmmaker, *Anaconda* was an American, Brazilian, and Peruvian co-production that overtly transported Steven Spielberg's idea of *Jaws* into the world's largest river. Partially shot in the Amazon, the film revisits the "lost world" trope, and its plot structure mimics much of *Creature from the Black Lagoon*.[22]

Anaconda also features a team of white Anglophone men menaced by a rampant beast and the unknown powers of a "green inferno," even though it overtly takes advantage of multiethnic casting. Indeed, Llosa's film was an important crossover vehicle for Jennifer Lopez early in her career, since in the United States Puertorriqueñas are rarely given major character roles in action or science fiction and fantasy films. *Anaconda*'s multiracial cast is in tandem with the mixed-race casting trends later popularized by the *Fast and Furious* franchise, for instance. However, ethnic identification may not occur as smoothly as it seems across Latin American audiences.

For instance, for Brazilian audiences Lopez is first and foremost an American woman—and perhaps a white American woman. Racial markers, so to speak, are substantially different in the United States and Brazil, and the star-persona of Lopez as an American actress/singer, codified as a white-woman-who-speaks-English, may have overshadowed the multiracial/cross-cultural aspects of *Anaconda*'s cast in the eyes of Brazilian spectators.

Seen in retrospect and as a whole, *Creature from the Black Lagoon*, *Curucu,* and even *Anaconda* (with its specificities), all somehow fit in the long-lasting lineage of the American B movie, a kind of cinema that consecrated its own cult films and "auteurs," such as director Roger Corman.[23]

Ivan Cardoso's *A Werewolf in the Amazon* (*Um Lobisomem na Amazônia*, 2005), loosely inspired by Gastão Cruls's novel *Mysterious Amazon*, overtly pays tribute to Corman's American B movies and exploitation cinema, much in the style of a Brazilian carnivalesque "grindhouse film," which mixes comedy and *chanchada* with American horror movies from the 1950s and '60s.[24] In the film, a group of young tourists go on a trip deep into the Amazon rain forest looking for an opportunity to drink the hallucinogenic tea known as Ayahuasca or Daime.[25] Meanwhile, the sinister Dr. Moreau (Paul Naschy, an icon from Spanish horror cinema), a caricature of H. G. Wells's character from *The Island of Dr. Moreau*, finds refuge in the jungle to carry out experiments on "artificial life."[26]

In Spanish, Dr. Moreau complains about his banishment from the world's scientific community, and he worships the war-criminal Dr. Mengele as a "genius." Possessing the Nazi's "secret personal notebook," Dr. Moureau surpasses his "idol" by chemically creating all sorts of "mutants," but particularly a race of superwomen, allegedly inspired by Spanish conquistador Francisco de Orellana's discovery of Amazon warriors in 1541. By the time the tourists enter the jungle, a series of murders have taken place in the area. The crimes are investigated by Professor Scott Corman (Nuno Leal Maia), who suspects a wild animal has been attacking people. Yet the serial killer is actually a "werewolf" that runs amok under the full moon. The creature's victims multiply as it crosses paths with the young tourists in the jungle. One of them, Natasha (Danielle Winits), is believed to be the reincarnation of the Amazon queen.

Not a single scene from Cardoso's film is shot on location in the Amazon. The whole movie was filmed in the Tijuca Forest in Rio de Janeiro, and aerial shots of the Amazon rain forest were added later during editing in order to design the film's creative geography. The parodic combination of both the werewolf and the Amazon queen may stir an interesting reframing of old antinomies involving gender in the context of the first expeditions into the New World. The scientist/werewolf character, played by a popular Spanish actor, clearly stands for the European conquistador (racially codified as white), masculine rationality, and everything else associated with the Western male presence in a virtually feminized environment. The Amazons, particularly their queen, represent the indomitable Nature, the "female" rain forest, both fascinating and lurid, mesmerizing and dreadful— the Amazon as a harsh mistress. Not surprisingly, the arrogant conquistador is finally destroyed by the unknown powers of the jungle, pathetically killed by the "true" Amazon queen. This is evocative of Braham's comments on regionalist novels such as José Eustásio Rivera's *La Vorágine* (1946, written in 1924) and Rómulo Gallegos's *Doña Bárbara* (1988, first published in 1929):

Appearing in scientific narrative by Alexander von Humboldt and other foreign observers, the warlike Amazon came to represent the Latin American sense of alterity and exoticism with respect to Europe and the United States. The terms of the Latin American engagement with Western liberal precepts were reaffirmed in the regionalist novel, which condemned the non-modern as aberrant or monstrous. The resulting clash of modern and premodern belief systems was staged against the backdrops of the Colombian *llanura* and the Amazon jungle. In keeping with contemporary anthropological paradigms, modernity was typically personified in an enlightened, urban male protagonist who must attempt to tame or civilize a barbaric, feminized landscape which threatened him with spiritual and physical annihilation. The great regionalist novels *La vorágine* (1924) and *Doña Bárbara* (1929)—once Latin America's best-known novel—mapped this confrontation to the medieval figure of the *vagina dentata*, a voracious sexual predator who is embodied by a powerful female antagonist.[27]

Braham's remarks could be perceived as archaic cultural traits that survive in contemporary film and TV production.

In a number of American science fiction and fantasy films set in the Amazon, a simple formula seems to prevail: one in which a team of scientists and daring English-speaking men come to the rain forest to carry out scientific investigations (to set the Promethean fire of knowledge in the poor minds of the native people) and eventually to exterminate or capture a "lost-world creature," a monster reminiscent of times immemorial. This formula with subtle variations casts a foreign sight on the Amazon and its legends. It is being challenged by film franchises or movie sagas as a whole (but not always in every single film), as well as by contemporary casting practices motivated by international co-productions targeted at transnational audiences, a topic that has systematically been investigated by authors such as Mary Beltrán and Camilla Fojas.

For instance, in her essay "Mixed Race in Latinowood," Beltrán scrutinizes the exploration of the public image campaigns of actresses Jessica Alba and Rosario Dawson, arguing that Alba initially garnered more mainstream success because she could be more readily coded as white, whereas Dawson was cast in more supporting roles (until recently) because she could be more readily coded as black.[28] One wonders if the same reading might be applicable to Jennifer Lopez in *Anaconda*. Would Lopez stand in between Alba and Dawson in terms of racial codification? From the Brazilian perspective, Jennifer Lopez is probably coded as white, as much as Alba, whereas Dawson's racial coding could perhaps be more ambiguous.

On the other hand, it is worth noting how some films directed by Latin American filmmakers further subvert, invert, or shatter this formula, offering a different perspective on the Amazon, its characters, and stories.

As previously discussed, Cardoso's Brazilian comedy *A Werewolf in the Amazon* parodies patterns and logics in terms of foreign cinematic representations of the Amazon by overtly undermining the relevance of white male characters, and by "carnivalizing" ancient myths and the encounter between Westerners and native Amazonians.

A much more serious example of counter-hegemonic cinematic representation of the Amazon can be found in Ciro Guerra's *Embrace of the Serpent* (*El Abrazo de la Serpiente*, 2015). Here, rather than Nature being dependent on scientist heroes who will restore its balance, it is the rain forest that provides the cure and knowledge to the European man of science. Based on the diaries of Theodor Koch-Grunberg and Richard Evans Schultes, *Embrace of the Serpent* features the convergence of two worlds in times when Western science and rationale are rather meaningless in the context of the rain forest. In lieu of civilization brought about by European/American scientists, it is the Amazon that instills utopia in the mind of rational white men who are finally overwhelmed by the splendor of the rain forest.

CONCLUSION

Both literary and cinematic representations of Brazil and the Amazon seem to have been strongly influenced by the first "sensationalist" accounts of discovery and encounters with native societies. Centuries after the debunking of several myths, and even after the prevalence of anthropology and the rise of environmentalism, exotic, stereotyped discourses and figures continued to populate a number of literary texts and audiovisual media with a focus on the Amazon and Brazil, both by Brazilian and foreign authors.

Across a variety of texts, the Amazon is depicted as a powerful uchronia or, at least, a locus where time has been suspended, thus allowing the appearance of "lost worlds" and "lost races," from dinosaurs to Atlanteans. Perhaps not by chance, Brazilian science fiction and fantasy authors so often venture into alternate history, a genre seemingly very appropriate for intellectual reflections upon glorious present times that have never come true in "the land of the future."

In addition to its powerful uchronian dimension, the Amazon is also both utopia and dystopia. As utopia, that vast piece of land is often regarded as a sanctuary, a source of life and biodiversity, a place for total human-nature integration. However, as dystopia, the Amazon is also frequently depicted as a "green inferno" in which "civilized" people are shocked by beasts, deadly species, and rituals, all tempered under a stereotyping Western perspective. But then again, would it be possible to reconcile these seemingly opposite poles?

The monsters featured by all the films mentioned here seem to be icons of such ambivalence: they are all "two-worldly," "living-on-the-edge" creatures who incarnate expanded dualities that encompass territories and the ideals of territories. Thus by reflecting on the idea of two fictional

characters and tales that revolve around two opposite dimensions, worlds, or poles, the idea of a possible Amazonian counterpart might be evoked.

If there is such counterpart, if there is such a duality of worlds and territories in Brazil, the extreme opposite of the Amazon might be the Brazilian capital Brasília, the modernist/futurist city designed by Lúcio Costa and Oscar Niemeyer—and also a uchronian/utopian land with a clear dystopian dimension. By putting both uchronias/utopias in perspective—the ideal of the Amazon and the ideal of Brasília—it may be possible to better understand a nation stuck halfway between past and future, archaism and modernity. In his notes on the new capital of Brazil, the Brazilian art critic Mário Pedrosa stated that we Brazilians were condemned to be modern: "We neither yield to Nature nor rule it. A mediocre *modus vivendi* has been established. We never had a past, nor its footsteps behind us." Still, according to Pedrosa, "That is why the project of Brasília, in its immediacy, is somewhat immature and, at the same time, anachronic."[29] By "anachronic" one may also think of the suspension of time, of misplaced and/or overlapping times, as if the Amazonian "lost world," a land where time stood still, resurfaced in Brazil's most daring utopia, that of a futurist city informed by modernist architecture and socialist ideals.

Pedrosa's ideas might be useful for a deeper understanding of the uchronian utopias or, better still, anachronic utopias that seem to be so pervasive in Brazilian culture. Perhaps Brasília and "the idea" of the Amazon can be seen as two extreme points in the same axis, two utopian drives very characteristic of Brazilian culture, two territories (a city and a vast land) informed by two abstract ideals—one artificial, carefully planned and designed; the other extremely wild but also often representing Nature "in peace" with "a land of the future." In other words, two complex uchronian utopias, expanding the territories to which they have been attached.

NOTES

1. Seth Garfield, *In Search of the Amazon* (Durham/London: Duke University Press, 2013), p. 8.

2. By "uchronian" I mean a time-wise counterpart of "utopian," a time in suspension or an idealized time which may or may not have existed in the historical world.

3. Stephan Zweig, *Brazil: Land of the Future* (New York: The Viking Press, 1941).

4. Reynaldo Ledgard, "Review of *Fitzcarraldo* and *Burden of Dreams*," in *Hablemos de Cine* (Lima, 1984), p. 81, and Keith Richards, "Export Mythology: Primitivism and Paternalism in Pasolini, Hopper and Herzog," p. 61, in *Remapping World Cinema: Identity, Culture and Politics in Film*, ed. Stephanie Dennison and Song Hwee Lim (London and New York: Wallflower Press, 2006).

5. John Mandeville, *The Travels of Sir John Mandeville* (London: Macmillan and Co. Limited; New York: The Macmillan Company, 1900), p. 98.

6. Gregory Claeys, *Searching for Utopia: The History of an Idea* (London: Thames & Hudson, 2011), p. 73.

7. Paulo Miceli, *O Desenho do Brasil no Teatro do Mundo* (Campinas: Editora Unicamp, 2012), p. 152.

8. Bartolomé de las Casas, *História de las Índias* (Madrid: Imprenta de Miguel de Ginesta, 1875).

9. Miceli, *O Desenho do Brasil no Teatro do Mundo*, p. 152.

10. Sir Walter Raleigh, *The History of the World* (London: William Stansby, 1614).

11. Miceli, *O Desenho do Brasil no Teatro do Mundo*, pp. 156–57.

12. Claeys, *Searching for Utopia*, pp. 81, 82.

13. Persephone Braham, *From Amazons to Zombies: Monsters in Latin America* (Lanham: Bucknell, 2015), p. 64.

14. Ibid.

15. Miceli, *O Desenho do Brasil no Teatro do Mundo*, p. 159.

16. Braham, *From Amazons to Zombies,* p. 9.

17. Laura Mulvey, "Visual Pleasure and Narrative Cinema," Screen 16, no. 3 (1975): 6–18. See also Brigid Cherry, *Horror* (London and New York: Routledge, 2009), and Seven Jay Schneider, *Horror Film and Psychoanalysis: Freud's Worst Nightmare* (Cambridge: Cambridge University Press, 2009).

18. Curt Siodmak was a German screenwriter, author, director, producer, and actor. He directed movies such as *Bride of the Gorilla* (1951), *Love Slaves of the Amazons* (1957), *The Magnetic Monster* (1953), *The Devil's Messenger* (1961), and *Ski Fever* (1966).

19. Born in Argentina, Tom Payne had a career in the Brazilian film industry, notably during the golden age of the Brazilian studio known as Vera Cruz (1949–54), which was located in São Paulo's metropolitan area.

20. M. Night Shyamalan's *The Village* (2004) seems to rely on the same kind of plot: a utopia based on the fear of a monster, which ends up being revealed as an artifice put forth by a mastermind.

21. Released on April 11, 1997, *Anaconda* cost $45 million to produce. The film earned $65,598,907 at the domestic box office and $136,998,907 worldwide. Its sequel, *Anacondas: The Hunt for the Blood Orchid*, was directed by Dwight Little and released on August 27, 2004. *Anaconda III*, also known as *Anaconda: The Offspring*, directed by Don E. Fauntleroy, was released on October 21, 2008. Finally, *Anacondas: Trail of Blood*, also directed by Fauntleroy, was released on June 2, 2009. See http://www.the-numbers.com/movies/franchise/Anaconda#tab=summary.

22. *Jaws* is obviously indebted to Arnold's *Creature*, as Spielberg himself has admitted. See Phil Hardy, *The Overlook Film Encyclopedia: Science Fiction* (New York: Overlook Books, 1995), p. 144.

23. Perhaps *Anaconda* cannot be easily labeled a B movie, given the fact that it took advantage of a substantial budget and big studio backing. The film is ranked in the 1,140th position on the list of all-time most expensive films (see http://www.the-numbers.com/movie/budgets/all), having been released in the same year as John Cameron's *Titanic*—then the most expensive movie ever made, at $200 million. The gap between the two films is significant, and if the "B" label cannot be applied to *Anaconda*, Llosa's movie is clearly a genre film that pays tribute to Universal's 1930s "monster movies," not to mention the "B horror movie" in general and the "disaster movie," as illustrated by films like Gordon Douglas's *Them!* (1954) or Jack Arnold's *Tarantula* (1955). Moreover, the original "American B movie" label hardly fits in the contemporary Hollywood system for a number of reasons, including new production models. Seen in retrospect, even *Creature from the Black Lagoon* might be questioned as a "genuine" American B movie. Released in 1954, *Creature* featured cutting-edge submarine cinematography (by William E. Snyder) and fine makeup and art direction (for example, the work by Milicent Patrick, who designed the gillman) with a modest production budget, pushing the boundaries of what might then be regarded as a genuine B movie.

24. In a nutshell, *chanchada* is a Brazilian-specific film genre, a kind of musical comedy that became very popular in the 1940s. According to Lisa Shaw, "From the mid 1930s until the end of the 1950s Brazilian cinema was dominated by a popular tradition which came to be known as the *chanchada*, a term that was coined in the 1930s by journalists and film critics to refer scathingly to the highly derivative, light musical comedies that were used to promote carnival music and were often modeled on Hollywood movies of the same era. In time this designation became the accepted way of referring to increasingly polished productions, particularly those of the Atlantida studios, founded in Rio de Janeiro in 1941, which enjoyed unprecedented popular success in Brazil." Lisa Shaw, "The Brazilian *Chanchada* and Hollywood Paradigms (1930–1959)," *Framework: The Journal of Cinema and Media* 44, no. 1 (Spring 2003): 70.

25. The Ayahuasca tea referred to as Daime is used in rituals by practitioners of the syncretic religion known as Santo Daime, founded by Raimundo Irineu Serra (a.k.a. Mestre Irineu) in the 1930s in the Brazilian Amazonian state of Acre. Also called *yagé*, the tea is made of the *Banisteriopsis caapi* vine and the *Psychotria viridis* leaf. It is used as a traditional medicine by native peoples of Amazonian Peru.

26. H. G. Wells, *The Island of Dr. Moreau* (1896; Jefferson: McFarland, 2012).

27. Braham, *From Amazons to Zombies*, p. 15. See also Rómulo Gallegos, *Doña Barbara* (Caracas: Editorial Panapo, 1988), and José Eustasio Rivera, *La Vorágine* (Bogotá: Editorial ABC, 1946), http://www.banrepcultural.org/sites/default/files/libros/brblaa619043.pdf .

28. Mary Beltrán and Camilla Fojas, eds., *Mixed Race Hollywood* (New York: New York University Press, 2008).

29. Mário Pedrosa, "Reflexões em torno da nova capital," in *Brasília—Antologia crítica*, ed. Alberto Xavier and Julio Katinsky (São Paulo: Cosac Naify, 2012), pp. 34, 35. "No Brasil, nem nos entregamos à natureza, nem a dominamos. Estabeleceu-se um *modus vivendi* medíocre. Nunca tivemos passado, nem rastros dele por trás de nós. Aqui não houve, por exemplo, as formidáveis vias de penetração dos velhos impérios, como o romano na Europa, e, às nossas costas, o inca. E se não tivemos, num passado remoto, essas indestrutíveis vias calçadas de lajes para por elas passarem respeitáveis legiões pedestres, também não temos, ainda hoje, estradas de penetração para locomotivas. Temos, entretanto, algo novíssimo: linhas aéreas de comunicação, mas que não penetram (saltam apenas), não varam como as estradas de pedra das legiões romanas ou incaicas, nem como as de ferro da velha Rússia dos czares ou da jovem república burguesa norte-americana (p. 34)." "Eis por que o programa de Brasília, no seu imediatismo, tem algo de imaturo e, ao mesmo tempo, de anacrônico (p. 35)."

COCONAUTS IN SPACE

X0014

PLATE 22

ADÁL
detail from
*Coconauts in
Space*
2016

ADÁL is a Puerto Rican, multimedia artist who investigates issues of bicultural experience through satirical, conceptual artwork. *Coconauts in Space* (2006) is a photo series made from digitally altered photographs from the 1969 NASA moon landing that create an alternative history of an earlier moon landing in 1963 by Puerto Rican astronauts. By hacking an actual event in the history of the United States, the series works within ADÁL's larger myth-making project of creating what in science fiction discourse is called a "parallel universe." *Coconauts* includes a text-based narrative in which "Comandante ADÁL"—the pilot of the lunar landing craft "Domino 1"—explains in vaguely absurdist terms the Coconaut Space Program and the fictitious, whimsical state apparatus in which it operates.

The series combines ADÁL's signature wit and sense of humor with a serious consideration of the effects of U.S. expansionist policies and acts of historical revisionism by a dominant culture. Keeping in mind the particular colonial history between Puerto Rico and the United States, the work also resonates with the science fiction trope of colonial expansion into extraterrestrial territories. Ultimately, *Coconauts* reminds viewers of the ideologically constructed nature of historical narratives, but it also makes a claim about the empowering possibilities for Boricuas of (re)writing and revising histories. *Coconauts in Space* is a component of the *Blueprints for a Nation/El Puerto Rican Embassy* project, 1994–2016. This iteration of the project was realized during a fellowship at the National Air and Space Museum (NASM)/Smithsonian Institution in 2016.

RUDI KRAEHER

PLATE 23

ERICA BOHM
Tycho Crater_Moon
(from *Planet Stories*
series)
2013

In her photographic series *Planet Stories* (2013), Buenos Aires–based artist Erica Bohm explores the science-fictional landscape while touching on issues surrounding verisimilitude, anachronistic technologies, and the photograph as a supposed testament to bearing witness. Long interested in both science fiction and unpacking conventional notions surrounding photographic media and authorship, Bohm used an Instax Fujifilm camera (a "dye coupler" photographic process that reads formally as a Polaroid instant photograph) to re-photograph NASA's extant images of outer space. The resulting works read as instant "snapshots" of content that is inaccessible to the vast majority of human beings: distant planets, moons, and cosmic terrain. The only existing images generated of these remote corners are produced and regulated by space institutions like NASA, but Bohm reclaims them as her own, thus adding her own layer of authorship. The imposed intermedia translation adds, but also always removes, something from these photographs: specifically, the ability for the viewer to use visual clues to infer the various eras in which these photographs were originally captured. Whether sourced from the Apollo missions of the 1960s and 1970s, the 1990 Magellan mission to Venus, or the recent Mars Exploration Program, the works are leveled to one mode of photographic codification controlled by Bohm's mediation. The artist's strategy positions her as fictional witness to a fantastical-appearing reality that is ultimately based in veracity.

PLATE 24

GLEXIS NOVOA
Benares (The last photograph)
2013

Glexis Novoa is a Cuban American artist who received his training in post-revolutionary Cuba. Novoa uses a sophisticated symbolic lexicon in work that analyzes the relationships between ideology, discourse, architecture, and power. He creates what he calls "discourse as landscapes," or "architectures of power." These small, detailed drawings on marble reference the visual idioms of Constructivism, Bauhaus, and Futurism to depict menacing dystopian cityscapes. Novoa's dark architectural fantasies are reminiscent of Piranesi's speculative prison etchings or Fritz Lang's science fiction epic, *Metropolis* (1927).

In *Benares (The last photograph)* (2013), Novoa offers a surrealistic vision of this sacred Indian city in decay. The present-day image of the city, with its cupolas and riverfront steps, is powerfully defamiliarized. Buildings sink into a drying riverbed while blob-like towers from some Gaudí nightmare loom in the background.

Mamayev Square (2011) immerses the viewer in an urban wilderness of hard angles and cheerless pyramids. The title of the piece alludes to the Russian monument commemorating the siege of Stalingrad. Rather than overlooking the city, however, the statue becomes just another fixture within a monolithic skyline. Novoa's work reminds us how deeply history, as discourse, is written into the built spaces we inhabit every day.

RUDI KRAEHER

PLATE 25 SERGIO HERNÁNDEZ
El Chuy from Mars
2006

PLATE 26
TONY ORTEGA
*To the Moon with
Lupe Liberty*
2005

MASA (MECHICANO ALLIANCE OF SPACE ARTISTS)

In 2005, Tejano artist and San Antonio resident Luis
Valderas came to an important conclusion. He saw sci-
ence fiction as a powerful visual language in Latino art
that allegorized liberation, escape, and possibility amid
perilous times. A groundswell of anti-immigration alarm
emboldened this artistic tendency. The passage of the
Sensenbrenner-King Border Protection, Anti-Terrorism, and
Illegal Immigration Control Act by the U.S. Congress per-
petuated divisive "alien" discourse that increased paranoia,
criminal penalties, and fines for immigrants. The act fur-
ther resolved to secure the U.S.-Mexico border with a sev-
en-hundred-mile, double-layered fence. For Valderas, it was
not surprising that Chicano artists turned to outer space, a
limitless platform where another world could be imagined
as a form of political intervention.

With his artistic collaborator Paul Karam, physicist Ray
Gonzalez, and University of Texas–San Antonio curator
Arturo Almeida, Valderas organized Project MASA: the
MeChicano Alliance of Space Artists. Riffing on the dou-
ble meaning of MASA, which combines the cornmeal sub-
sistence of Pre-Columbian civilizations with the National
Aeronautics and Space Administration (NASA) located in
nearby Houston, he cultivated an *alliance* in conceptual
terms. That is, MASA theorized the Chicano future through
a line of investigation predicated on a futurist optic that
looks at Latino cosmology, new mythology, and a techno-
futurist reinvention of barrio urbanism. More creative con-
stellation than art collective, Project MASA organized three
exhibitions between 2005 and 2007. Participants were
selected less as "science fiction artists" and more as space
artisans imagining a future that otherwise seemed bleak.

Individual submissions were procured from open calls,
guest invites, and word of mouth. Each show averaged
approximately forty artists. The reach of Project MASA
expanded after its inaugural show in 2005, going beyond
familiar Tejano art circuits and attracting artists from
California, Arizona, New Mexico, and Colorado. By its third
iteration in 2007, MASA even reached Dominican and
Puerto Rican artists from East Harlem and Williamsburg in
New York. Though Project MASA was short-lived, it high-
lighted a confounding array of media and genre. Pieces
ranged from more traditional fare like Raul Servin's acrylic
painting *The Chicano Universe* (2003), Sergio Hernández's
Invaders from Aztlan (2007), and Valderas's *St. Buzz and the
Rabbit* (2003) to other art processes such as Tony Ortega's
hand-colored solar etching *To the Moon with Lupe Liberty*
(2005) and the surprising rendition of metalwork by San
Antonio sculptor Luis "Chispas" Guerrero.

Chispas's submission to the 2005 show included small-
scale cybernetic *Braceros* art pieces such as *La Mano del
Diablo* (1999) and *Lágrimas y Sudor* (1999). These metalwork
sculptures in found material fabricated futurist *braceros* in
chains, hooks, and the treacherous *cortido,* the short-han-
dled hoe that led to the debilitation of workers' spines in the
process of harvesting crops for agribusiness corporations.
Though these pieces were unusual for Chispas because of
their staunchly political nature (*Lágrimas y Sudor* is welded
to a metal plate with "Huelga" etched into the platform's
surface, for instance) his works in the *Toys from Mars*

PLATE 32 LAURA MOLINA
Amor Alien
2004

surface of the painting. The composition centers a per-spectival horizon through a field of pink geometric triangles towering at mid-ground. Luciano constructs a visual depth of space, which intensifies mythic origin stories predi-cated on the greatness of Meso-American pyramids in Mexico and Central America or the sacred Incan temples at Machu Picchu. Because the archaeological remains of Taino civilization are classic rock petroglyphs close to the Earth's surface, *Cosmic Taino* is a speculative reimagining that surpasses Latin America's architectural monoliths. By aligning Boricua ancestry with the stars, Luciano engen-ders a powerful mythos for the Tainos escaping colonialism and U.S. commercialism through astral projections into the aerial realm.

Though MASA was short-lived, what it accomplished was something otherworldly. MASA artists dared to cre-ate possibilities unbounded by geographical boundaries, citizenry, and militarized national borders. Latino futurity galvanized their imaginations. These exhibitions harnessed science fiction's creative capacity to ridicule and dis-mantle xenophobic discourses in legislation, border patrol abuses, and forced deportations, all of which was surpris-ingly made possible in a MeChicano epicenter like San Antonio. Despite the challenge, one thing was for certain, as Valderas argues, "In space, we are all alien."

ROBB HERNÁNDEZ

THE
OTHER WORLDS
WE LIVE IN

CYBRACERO

DE 285

LATIN AMERICAN
SCIENCE FICTION FILM

SHERRYL VINT

A t first glance, [Trujillo] was just your prototypical Latin American *caudillo*, but his power was terminal in ways that few historians or writers have ever truly captured or, I would argue, imagined. He was our Sauron, our Arawn, our Darkseid, our Once and Future Dictator, a *personaje* so outlandish, so perverse, so dreadful that not even a sci-fi writer could have made his ass up.

—JUNOT DÍAZ[1]

There are basically two kinds of filmmakers: one invents an imaginary reality; the other confronts an existing reality and attempts to understand it, analyze it, criticize it, judge it, and, finally, translate it into film. In the latter case, the lasting validity of the work can only be corroborated in space and time, that is, by history and geography. The New Latin American Cinema movement, as it has evolved and spread over the length and breadth of Latin America during the past twenty years, has somehow justified those of us who decided so many years ago to seek out our own national reality and try to communicate it. Not to invent it, but to re-invent it: to interpret and transform it.

—FERNANDO BIRRI[2]

Science fiction has not been a dominant cultural mode in Latin America and, particularly within film, at first glance the genre's aesthetic strategies seem at odds with the dominant focus on documentary within Latin American cinema. Moreover, at least since the release of *Star Wars* (George Lucas, 1977), popular science fiction cinema has become synonymous with the special effects blockbuster, another factor mitigating against the development of a strong tradition of science fiction cinema within Latin America. Nonetheless, the region has produced a number of compelling films that address contemporary political contexts with science fiction metaphors, and as we move into the twenty-first century

film industries in Mexico and Argentina, in particular, have increasingly turned to science fiction icons and plots. Despite the apparent distance between science fiction and documentary modes, there is a strong yet counterintuitive affinity between these representational strategies. As Andrea Bell and Yolanda Molina-Gavilán argue in *Cosmos Latinos: An Anthology of Science Fiction from Latin America and Spain*, "In times of political repression . . . the science fiction mode has proven to be an excellent tool to foreground a particular ideological position or to disguise social criticism from government censors."[3] Indeed, academic study of the genre has long been premised on noted science fiction scholar Darko Suvin's claim that science fiction should chiefly be understood as a reflection "*on* reality," in contrast to realism's reflection *of* reality.[4] This essay will provide a context for understanding how science fiction can be a valuable tool for interrogating the given assumptions about the world and thus how and why many Latin American countries, particularly those in post-dictatorship contexts, have used the genre to capture aspects of their reality that exceed the representational possibilities of realism. Sometimes an invented reality can be the best way to confront and ultimately transform an existing one.

Latin American films often seek explicitly to counter the style and expectations taught to audiences by global Hollywood cinema, which emphasizes the narrative as what drives the film and generally seeks to answer the audience's questions about the action rather than leave them perplexed about what they have witnessed. Chiefly, it is a cinema that seeks to gratify rather than unsettle viewer expectations. Hollywood style relies on linear narrative, continuity editing, and the unification of space and time such that events in the cinema seem to take place as if we are watching life. The Cinema Novo moment in Brazil cultivated an emphasis on documentary modes specifically to resist the tendencies of Hollywood style and sought to use the medium to capture specifically Brazilian daily life. Even when Latin American filmmakers turn to familiar plots and settings from this Hollywood tradition, they reshape and otherwise play with its features, reinventing it to speak to the local context.

For example, in the viral outbreak film *Fase 7* (Nicolás Goldart, 2011) from Argentina, we never see the hordes of zombified or otherwise infected monsters we have come to expect from viral films such as *World War Z* (Marc Forster, 2013)—or even the Spanish *[REC]* (Jaume Balagueró and Paco Plaza, 2007)—but instead see only the action within an isolated apartment block as residents try to piece together what has happened from news reports that are mainly from the United States and in English. The emphasis thus shifts away from the energizing spectacle of such films' action sequences and toward the fearful intensity of living in such an uncertain situation, which also drifts into boredom as nothing seems to happen and news reports are contradictory. *Fase 7* thus leaves audiences asking if zombies ever existed in the film, or if reports of the infected were misinformation designed to cover up some other kind of military action,

and the story becomes a more intimate one of how people respond to crisis rather than the adrenaline-fueled theatrics of Hollywood zombies. Like many such films, the action involves a possible conspiracy for the release of the virus: in this case, the phrase "new world order" and an excerpt from President George H. W. Bush's 1991 speech (justifying the invasion of Iraq) situate the narrative within globalized relationships of American hegemony, adding a larger political frame within which to understand the familiar narrative. Thus, as Deborah Shaw points out, Latin American films provide the "high-quality entertainment" of Hollywood models but "without the loss of a socially committed agenda."[5] Although his work has mainly been in the related genre of horror, films by Mexican director Guillermo del Toro, such as *El espinazo del diablo* (2001) and *El laberinto del fauno* (2006), use otherworldly beings such as ghosts and fairies to show us how deeply our political realities are informed by fantasized projections and unvoiced desires, such as the sadism that suffuses social relations under a dictator like Francisco Franco, or the powerful emotions of guilt that can debilitate survivors of traumatic violence. The speculative genres make these metaphors literal.

As its name suggests, science fiction is frequently concerned with the social impact of changes in science and technology, and such changes have been integral to histories in Latin America—histories of colonial resource extraction, military intervention, and surveillance. The role that such technologies have played in creating and sustaining power relations, within and between countries is examined and critiqued in science fiction films, especially in the case of dictatorships. The displaced setting made possible by the genre—to another time or another world—enables certain things to be voiced that might otherwise be censored. Indeed, sometimes it is the seeming triviality of science fiction that allows a freer voice in such contexts. One of the most celebrated recent science fiction films, *Sleep Dealer* (Alex Rivera, 2008), powerfully demonstrates how familiar science fiction icons take on new meaning when located within a Latin American context and connected to ways that existing technologies facilitate relations of domination. The film draws from the science fiction subgenre cyberpunk, which is known for its hacker heroes and celebrations of disembodied, individual transcendence of the material world, and made famous by authors such as William Gibson, Rudy Rucker, and Pat Cadigan. However, *Sleep Dealer* transforms these icons by placing them in a Mexican context.

In Rivera's reinvention of the form, his hacker, Memo Cruz (Luis Fernando Peña), works with cobbled-together tech resembling the antiquated computers of the 1990s rather than the sleek futuristic "decks" made famous by Gibson. Memo directly links his interest in online connections to his desire to be a part of the urban globalized economy of Western capitalism, yet his hacking leads not to transcendence but to the destruction of his family home—and his father's death—when his signal is deemed terrorist by drone surveillance. Fictional and material worlds

collide in this remotely piloted military technology, one of the real-world legacies of the cyberpunk imagination. In the narrative that follows, Memo achieves his dream of getting "nodes" that allow him to interface directly with online technologies, but in his case they serve only to further bind him to global capital rather than allow him to transcend its vicissitudes (fig. 1). Memo goes to work in a futurized version of a *maquiladora* where his nodes are used to connect him to robot workers in the United States, which he pilots remotely from Mexico. This technology, his foreman bombastically proclaims, allows America to realize its dream of having all the labor without allowing any of the laborers to cross its border. Rivera thus skillfully uses a familiar science fiction scenario not only to comment on the reality of labor relations across the U.S.-Mexico border—including the ways surveillance and military drone technologies are central to these structures of exploitation—but also to demonstrate how these familiar plots must be remade to suit their Latin American context. Given his position within systems of global capital, Memo finds only an intensification of his precarious economic position through his fusion

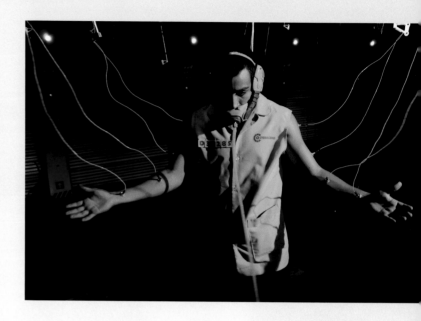

FIGURE 1
Still from *Sleep Dealer*
Director Alex Rivera, U.S. / Mexico
2008
© Alex Rivera

with the machine, not the power to take control of such systems imagined for cyberpunk protagonists in American fiction. Moreover, the film evades the urban setting of most cyberpunk and focuses instead on Memo's background as part of a farming community and on the struggle to control water resources essential to sustainable agriculture. High-tech and automated robot security aggressively rations what Mexicans can take from a reservoir, property of a foreign-owned corporation, and U.S. military drone pilots bomb "water terrorists" who seek to return this resource to the community nearby.

Another Mexican science fiction film, *2033* (Francisco Laresgoiti, 2008), similarly revises a familiar science fiction plot of a future dominated by corporate control—the best-known examples include the Tyrell Corporation of *Blade Runner* (Ridley Scott, 1982) or the Weyland-Yutani Corporation of the *Alien* franchise (1979–2014). *2033* projects a future Mexico taken over by military dictatorship following contested elections in 2013. The cityscape presented in the film is reimagined to more closely match the futuristic towers of cities such as London (fig. 2). Like similar dystopian science fiction of this type, what remains of the government serves elite economic interests and the film's future Mexico is sharply stratified between rich and poor: scenes show that the homeless cannot afford even water, a now-commodified resource, and various kinds of surveillance monitors and other checkpoints physically exclude them from much of the city. Some scenes show the privileged reacting violently to the mere presence of the poor, an extrapolation that seems exaggerated in

some scenes but which may reflect the status quo more closely than one would like to admit. It resembles the roughly contemporary non–science fiction film *La Zona* (Rodrigo Piá, 2007), which concludes with residents of a Mexican gated community beating a boy to death and attempting to hide his body from authorities because he broke into their enclave and they wrongly believe he was responsible for the death of a resident. Similarities between the two films point to how science fiction has become something of a popular vernacular for representing experiences within the technologized present moment of intensifying social stratification.

Although in many ways *2033* simply reiterates familiar science fiction–thriller scenarios, it also subtly shows how its Mexican setting requires shifts in this well-worn plot, thereby pointing to a way that the technologized imagination of mainstream science fiction reflects and is complicit in ideologies of American hegemony. The film is thus able to critique some elements of such Hollywood science fiction as it also revises the genre to speak to its Latin American context. The main product of the evil corporation is TECPANOL, a synthetic food substitute made from plankton that is offered as a frugal solution to "world hunger" but also contains

FIGURE 2
Still from *2033*
Director Francisco Laresgoiti, Mexico 2008
Produced by La Casa de Cine
© Francisco Laresgoiti / La Casa de Cine

pharmaceuticals that make those who consume it docile and compliant. TECPANOL thus reflects the inequalities between rich and poor, within Mexico and between Mexico and the Global North, and serves as a tool to perpetuate such structures. Importantly, in a scene in which a technician explains the product to a group of men in business attire, she speaks English to them but Spanish to the workers with whom she interacts, suggesting that the plutocracy serves a global economic order that sees Mexico only as a source of cheap labor. The film ends with the revolution only just "woken up"—from chemical dependence, from cryogenic stasis. However, the dramatic final battle shows their defeat at the hands of the better-equipped corporate forces, with only a few survivors escaping to continue their work. The Mexican revolutionaries fighting against the elites seem defeated, their leader presumed dead (but only, we learn, imprisoned in cryonic storage). *2033* thus resists the easy and emotionally satisfying victories over corporate forces that we see in Hollywood films such as *Elysium* (Neill Blomkamp, 2013), where economically marginalized hackers in Mexico are able to hijack a spaceship, crash into the orbiting gated community satellite of Elysium, and reprogram the computer so that all those without citizen rights—hence access to privileges such as health care—suddenly are recognized. *Elysium* was filmed in Mexico, largely on the site of an existing landfill that has its own nearby encamped communities living in a way not that different from what is projected into the dystopian future of Blomkamp's film. In contrast to the triumphant hack, *2033*

mobilizes affect in its viewers, focusing them on the longer and more difficult struggle toward economic and social justice. The major battle ends in defeat, but the revolution continues.

Post-dictatorship Argentina is perhaps the Latin American country that has most embraced the possibilities for science fiction cinema to articulate histories that cannot otherwise be voiced, a fact that is not surprising of the country that has given us the fiction of Jorge Luis Borges, one of the finest writers of speculative fiction. Examples of two such films are *La Sonámbula* (Fernando Spiner, 1998) and *La Antena* (Esteban Sapir, 2007). As Everett Hamner points out in his excellent article "Remembering the Disappeared," it was only in the 2000s that Argentine politicians were ready to "condemn the policies and crimes of their predecessor" because the immediate post-dictatorship government of Raúl Alfonsín conceded to military demands for amnesty from crimes committed during the country's Dirty War (a period of military dictatorship, roughly from 1974 to 1983, in which more than thirty thousand citizens labeled dissidents were taken from their homes, often tortured, and never seen again).[6] This regime, in which it was dangerous to voice certain opinions, was followed by a post-dictatorship period in which discussion of these crimes was actively discouraged: thus issues of memory and the refusal to let certain events be "disappeared" is central to Argentine culture, as Hamner's analysis explores. Both *La Sonámbula* and *La Antena* engage with this history, through distinct aesthetic strategies that reflect the approximately decade gap between them.

La Sonámbula uses two visual modes to distinguish between worlds seemingly set in two times: a harshly lit, futuristic Buenos Aires rendered as a black-and-white, even at times blue-and-white, cool landscape of technologized urban space (see fig. 3), and a bucolic and lush country house, surrounded by warmly lit fields of green in which a woman wakes from a dream and goes to the door (at times we see this same woman in loving embrace with an unknown man in a pastoral setting). It is never clear which world is the projection or memory and which is the "real" in the film: Is the rural landscape a dream of a now-lost past, or is the dystopian future merely a dream of another kind of world, as one character surmises? The future city is dominated by bureaucracy and totalitarian control: a plague has wiped everyone's memory and the government purports to be investigating in order to match people with the correct memories, yet there are hints that a more arbitrary or perhaps even

revisionist logic guides their insistence that citizens must accept as real the memories the government tells them they have. A militarized police force violently confronts those who resist their place in the new script of

PLATE 34

LA GRAVEDAD DE LOS ASUNTOS
(NAHUM AND ALE DE LA PUENTE)
With selected participants Tania Candi-
ani, Juan José Díaz Infante, Nahum, and
Ale de la Puente

Still from *Supernova*
2015

La Gravedad de los Asuntos (Matters of Gravity) is a collaborative project that explores the relationship between art and science via the concept of "gravity." A group of Mexican artists took a zero-gravity, parabolic flight with Russian cosmonauts in order to experience weightlessness together, generating a set of individual and collective artworks as well as a series of discussions, workshops, and a book.

The collective artwork *Supernova* (2015) is a short video that playfully explores the implications of gravity and human embodiment through the image of an exploding, star-shaped piñata. The candy disperses across the entire aircraft, inviting not only a reconsideration of the cultural history of national space programs but also a philosophical reflection on the physical forces and "matters" of the universe that make life possible.

Other projects made in response to the initiative include the experimental poetry of Juan José Díaz Infante, who considers how zero gravity changes our conception of poetry, expanding it to include physical forces and bodies in motion. Tania Candiani's work mines the history of science for forgotten and obsolete ideas to imagine alternative trajectories for technological thought experiments, like early flight machines. Nahum is interested in "humanizing" space and scientific discourse through art, emphasizing the importance of emotions in space travel. And Ale de la Puente's work explores how deeply gravity shapes our everyday experience of space and time.

RUDI KRAEHER

PLATE 35

GYULA KOSICE
Maqueta de la Ciudad Hidroespacial T
2007

Slovakian-Argentine artist Gyula Kosice (1924–2016) was one of the main proponents of kinetic and concrete art in midcentury Argentina, incorporating new materials like neon gas and water in his sculptural experiments with abstraction. His late work with "hydrospatial" sculptures reflects the artist's visionary, utopian thinking and emphasizes creativity in urban invention over the ideological, economic, and technological limits of "feasibility."

Kosice's *Hydrospatial City* project is a collection of multimedia works depicting floating disc- and dome-shaped models (*maquetas*) for alternative human habitats. Reminiscent of the architectural/science fiction concept of an "arcology"—Paolo Soleri's term for environmentally sustainable, densely populated communities—*Hydrospatial City* consists of Plexiglas and metal sculptures, drawings, descriptive schematics, theoretical writing, and a proposal that the artist sent to NASA. Responding to ecological concerns about environmental sustainability and population growth, the speculative qualities of *Hydrospatial City* question many assumptions about the form and function of our dwelling places and how powerfully they shape our understanding of "human" life on Earth.

The diagrams for his transparent dwelling bubbles, like *Maquette K* (1965–75), include fantastical designations (or speculative *provocations*) for the different living spaces: "A habitat full of unclassifiable words," or a place for "the operational lodgings of the soul." The short animated video *La ciudad hidroespacial* (2003) depicts Kosice's models flying over Buenos Aires, taking the viewer through an immersive journey into these imaginative structures.

RUDI KRAEHER

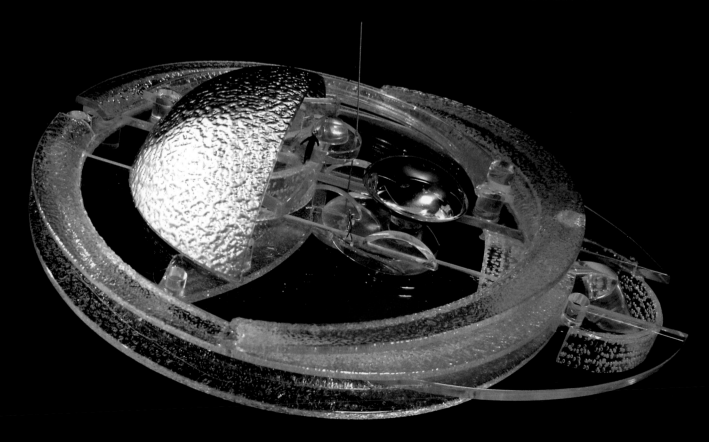

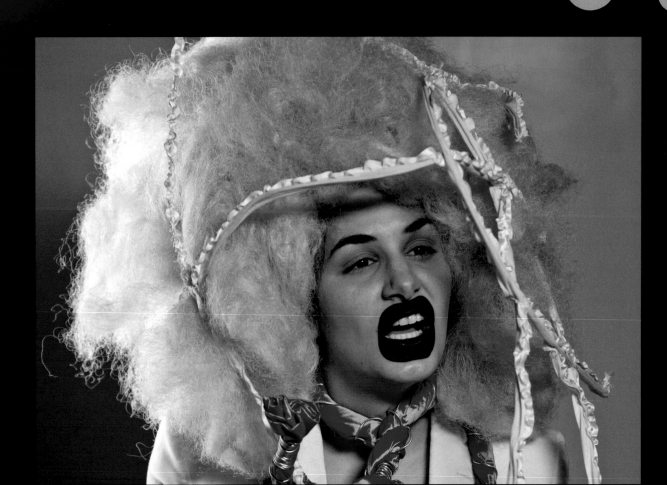

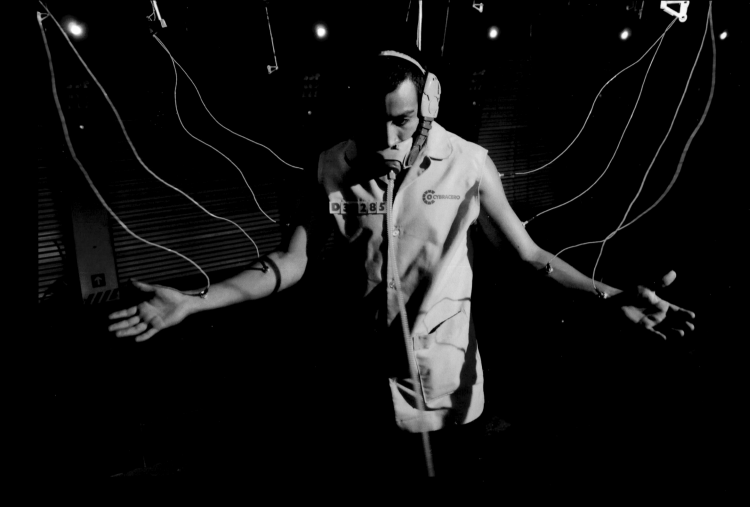

PLATE 37 ALEX RIVERA
Still from *Sleep Dealer*
Director Alex Rivera, U.S./Mexico
2008

Alex Rivera is a digital media artist and filmmaker who uses satire and wordplay to critically reflect on the implications of globalization on information technology and mass migration. Rivera's feature-length, science fiction film *Sleep Dealer* (2008) is set in the near future at the U.S.-Mexico border. It uses many of the motifs from the 1980s science fiction subgenre, cyberpunk, to build a dystopian world set in the borderlands. Visually arresting and disturbingly plausible, the film parodies corporate, techno-utopian rhetoric to portray a vision of the "new American dream: labor without the workers." *Sleep Dealer* extrapolates the concept of the "Bracero" guest worker program (1942–64) and digitizes it into "cybraceros."

Set in a futuristic Tijuana during an era of closed national borders and privatized water, laborers in the Global South "plug in" to their digital network terminals in *infomaquiladoras*—digital sweatshops—via implanted nodes in their bodies that enable them to remotely operate robots from the other side of the border. A provocative and ambitious work, the film insists on depicting the historical continuity between the colonial past and the late capitalist present, making a strong argument for the continued cultivation of transnational alliances that resist the destructive forces of global capitalism.

RUDI KRAEHER

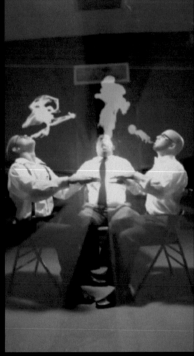

38 JOSÉ LUIS VARGAS
Stills from *El retorno de Albizu*
2009

José Luis Vargas is a painter, performance artist, and educator working in Santurce, Puerto Rico. His work mixes humor and the supernatural with popular culture and science fiction to speak to the formation of collective memory. Working in tension with museums as official institutions for the discursive construction of history and culture, Vargas co-founded the interactive, experimental exhibition project El Museo de Historia Sobrenatural. This art space/event functioned as a kind of collaborative laboratory for artists and community members to explore how the mythic, the heroic, and the supernatural operate within a collective Puerto Rican imaginary.

The oil painting on tarp *El Museo de Historia Sobrenatural* (2015) resembles a post-apocalyptic, circus-style adver-

tisement or a run-down, DIY performance backdrop. In the short video *El Retorno de Albizu* (2009), three men hold a séance to summon the spirit of Pedro Albizu Campos (1891–1965), a Puerto Rican nationalist hero. Both pieces use nineteenth-century sensationalist/paranormal motifs, like the "freak show" or ectoplasm (spirit) photography. Vargas's engagement with the supernatural brings together historical figures and popular culture through a critique of colonialism and a science fiction pedagogy that estranges everyday reality in order to better speak to the contradictory realities of Puerto Rican sovereignty and identity.

RUDI KRAEHER

SLIPSTREAM
ISLANDS

OF STRANGE
THINGS

TYLER STALLINGS

BUILDING *MUNDOS ALTERNOS* IN THE AMERICAS

World building is a major element of the science fiction genre. History, geography, economics, demographics, physics, cosmology, transportation, religion, technology, food, and the culture of an imaginary world are the elements to be considered by authors, filmmakers, and game makers. The test for a reader, viewer, or participant is to suspend their present-day logic so that they can feel present in a virtual future.

The challenge for the maker is to reconsider ongoing tropes, like anything called "Empire" being absolutely evil; an entire world being defined as if it had one purpose, such as the desert world of Arrakis in Frank Herbert's novel *Dune* (1965); and of course, the altogether prevalent, homogenous alien race that populates an entire planet or galaxy. In other words, the task is to bring diversity to one's imaginary world, which, one would assume, also reflects the author's take on diversity in the real world. Embracing diversity is, of course, a major underlying theme in *Mundos Alternos: Art and Science Fiction in the Americas*.

It is hard to say that the genre of science fiction fine art exists, at least within the context of the international, contemporary art world that the artists of *Mundos Alternos* inhabit. More familiar cover art, movie posters, comic books, and illustrated stories are a separate issue. Contemporary art making itself represents a kind of science-fictional process that results in a slipstream artifact, or strange thing.

SLIPSTREAM IMMIGRATION

Slipstream, a phrase coined by science fiction author Bruce Sterling and his colleague Richard Dorsett in 1989, is primarily applied to literature that includes elements of science fiction, also called speculative fiction, in order to create a sense of the uncanny, of weirdness in the world, and of dissonance between what one thinks is real and the feeling that other layers exist beyond the senses upon which we rely. More than twenty-five years ago, Sterling wrote, "It seems to me that the heart of slipstream is an attitude of peculiar aggression against 'reality.' These are fantasies of a

kind, but not fantasies which are 'futuristic' or 'beyond the fields we know.' These books tend to sarcastically tear at the structure of 'everyday life.'"[1]

A recent and notable Latin American slipstream example is the novel *The Brief Wondrous Life of Oscar Wao* (2007) by Junot Díaz. With settings ranging from New Jersey to the Dominican Republic, it features a science fiction–obsessed boy who eventually dies, though the reasons are ambiguous. His death is either the result of a *fukú* curse; the lingering vestiges of a corrupt society stemming from the rule of the Domincan Republic's former dictator, Rafael Trujillo; or, of course, an inseparable mixture of both family, political scourges, and colonialism as filtered through the allegory of the science fiction genre.

Commenting on his attraction to science fiction, Díaz said, "I fell for genre because I desperately needed it—in my personal mythology, genre helped me create an operational self. I suspect I resonated with the world-building in many of these texts because that's precisely what I was engaged in as a young immigrant." He added, "Alien invasions, natives, slavery, colonies, genocide, racial system, savages, technological superiority, forerunner races and the ruins they leave behind, travel between worlds, breeding programs, superpowered whites, mechanized regimes that work humans to death, human/alien hybrids, lost worlds—all have their roots in the traumas of colonialism."[2]

CONTEMPORARY ART AS SPECULATIVE TECHNOLOGY

For a visual artist, the magic of their own making occurs when a preconceived notion takes a different turn during the process, leading them down a road that they could not have expected without taking the first step of manipulating materials with their hand. It is a method that intertwines haptic, optic, and cognitive processes. This approach is probably the same for an author or filmmaker, who starts with an outline or script but allows his/her imagination to wander from the original path. With regard to contemporary visual art then, an artist's methodology of process and product are inseparable from one another, so they inherently slipstream.

The slipstream aspect in visual art is where the difference lies between it and writing or filmmaking. There is a physical manifestation of the artist's idea in the world; that is, it does not remain imaginary in a reader's mind nor an untouchable screen image. Rather, it is a physical object that rests in a world where viewers can interact with it through touch, smell, and sound, or perhaps walk back and forth from it, around it, or through it.

Art critic Jan Tumlir expressed a similar notion about the relationship between contemporary art and science fiction when he wrote about Orange County Museum of Art's 2007 California Biennial: "The young artists on the West Coast are operating in an idiom closely linked to science-fiction."[3] He goes on to list some of the science fiction tropes with which they are engaged: future and alien civilizations, time travel, colonization, "the redefinition of the idea of the human in response to the other, either alien or handmade," and so on. But more specifically he wrote that,

due to the materiality of visual art, "intensive concentration on these various artifacts is aimed at somehow 'breaking through.'" In other words, as Tumlir has suggested, these artworks were, for him, like gateways or portals to help a viewer's engaged mind consider other realities.

The emphasis on artist-made physical objects, or slipstream, science-fictional artifacts, is the major reason for the absence here of classic visual memorabilia that one associates with the science fiction genre: book cover art, comic books, and movie posters, just to name a few. In other words, these objects are produced ready for reproduction and absorption through other media such as magazines and computer screens, therefore to interact with them is simply to view them in their reproduced, mostly illustrative, sense. This is as opposed to the unique object generated by visual artists that can exist in only one location; thus, it requires a pilgrimage to the site, such as a gallery, museum, collector's home, public plaza, or artist's studio.

A turn toward re-engagement with materiality, and its place within an increasingly screen-based cultural environment, is underscored by a recent exhibition at the Leopold Museum in Vienna, Austria. *The Poetics of the Material* (2016) was a group exhibition in which "contemporary art, which can be regarded as being aligned with 'new materialism,' attempts to give expression to the interpenetration of material phenomena and immaterial aspects of reality. The latter reveal themselves in the meaning of language or in the influence of cultural narratives on the perception of reality."[4]

Throughout visits with artists for *Mundos Alternos*, I engaged in a type of "retro-labeling," as described by Rachel Haywood Ferreira in her seminal book, *The Emergence of Latin American Science Fiction* (2011). Ferreira outlined the process of defining science fiction in Latin American literature in light of the genre's already prescribed nature in the States and Europe: "Although the genealogy of science fiction has been actively traced in its countries of origin since the moment Gernsback formally baptized the genre, in Latin America this process did not get underway until the late 1960s and continues today."[5] Initially, her process identified late nineteenth- and twentieth-century Latin American texts, primarily from Argentina, Brazil, Chile, and Colombia (due to the strength of publishing in those countries) in which there were science fictional tendencies. The most immediate and prominent examples of retro-labeled works were the ubiquitous and highly marketed "magic realism" novels and short stories of Argentine Jorges Luis Borges's *A Universal History of Infamy* (1935), Colombian Gabriel García Márquez's *One Hundred Years of Solitude* (1967), and Chilean Isabel Allende's *The House of the Spirits* (1982).

In this regard, the curators of *Mundos Alternos* sought contemporary visual artists who employed science-fictional or slipstream thinking rather than literal science fiction elements. Driven by the theme of the show, these artists demonstrated a commitment to and influence from science fiction literature and film. The main theme that occupied them was a

consideration of the future, with a focus on post-colonization, labor, surveillance, environment, and hemispherical connections, viewed through the lens of art.

However, the biggest difference—and hopefully the contribution of this exhibition and book to the burgeoning scholarship around Latino and Latin American science fiction studies—is the effect of the material nature of visual art whose subject matter is science fictional. In other words, literature and film remain abstract and distant with less emphasis on the tactile, while the visual arts assert their objects into the world, as if building, literally, speculative technologies.

Visual art exists as a magical or yet-to-be speculative technology that has in fact manifested itself from the future into the present. These strange objects have ambiguous message(s). This requires work on the part of its viewer, who must be willing to engage with an object in order to receive its meaning. However, this does not suggest that there is a single, hidden meaning to be ascertained, but that an object's meaning is determined in part through a viewer's interaction with it, as if experiencing a close encounter of the third kind, in which contact is made with alien beings, whose language we do not yet know.

Meaning being determined in part by a book's reader, for example, is not an original notion, but a classically postmodern one that accounts for paradox, unreliable narrators, and undermining the authority of the writer through metafiction techniques. However, it is employed here in order to demonstrate that this postmodern methodology can be different when dealing with strange objects versus literature and film.

FIGHTING FOR THE FUTURE

The artistic inclination to pastiche disparate materials and ideas together generates uncanniness through its physical manifestation. This technique creates a slipstream or science-fictional effect of "cognitive estrangement," to borrow a phrase from notable sf theorist, Darko Suvin, in which the material and conceptual mash-ups provide a platform for viewers to look at their immediate society differently. Suvin might suggest that one's viewpoint could be shifted to the point that there is recognition of one's oppression and therefore, with a new view of the world, an individual begins to resist, which is the major subtext for *Mundos Alternos*.[6]

Or, to illustrate further, as Ernest Hogan, the U.S-born author of the seminal Chicano science fiction novel *High Aztech* (1992), wrote, "I've always been more interested in science fiction as a confrontation with changing reality rather than escapism. And as a Chicano, I'm plugged into cultural influences that most science fiction writers don't have access to."[7] Three years later, after participating in the "Day of Latino Science Fiction" symposium at University of California, Riverside, he wrote, "One difference between Anglo and Latino science fiction is that making it to the future is something that can't be ignored. The future isn't a given, it will have to be fought for. And if you don't fight for it, you might not get there."[8]

(fig. 1) Hogan's use of the phrase "plugged into" is embodied, literally, by *Mundos Alternos* artist Alex Rivera's film, *Sleep Dealer* (2008): nodes that are inserted in one's body allow Mexican workers to work in the United States virtually, thus, the States get their labor, but do not have to deal with the laborers' bodies.

Sherryl Vint, professor of English, science fiction studies scholar, and *Mundos Alternos* research team member and contributor, invited both Hogan and Rivera to UC Riverside's campus. As the organizer of "A Day of Latino Science Fiction," she said, "Our event will foster discussion of the specific ways Latino writers negotiate science fiction's relationship to the colonialist imagination, and its possibilities for imagining more ethnically inclusive futures."[9]

ACCESSING GATEWAYS OR *LAS PUERTAS*

For curators of the visual arts in general, it is necessary to travel in order see the work. This experience is different for film or literature where one can go to the local cinema or read in the comfort of a home. In the context of the works presented here, the materiality of a unique, strange object required one's presence. Footwork was involved, rather than being desk-bound or screenbound, in order to access gateways, or *las puertas,* to *mundos alternos.*

The proposition that one would need to travel to a physical location in order to experience art seems quaint in its seemingly romantic notion that values analog, handmade, and strange objects. This notion runs counter to today's prevailing narrative of connectedness through globalization and electronic social networks that allow one to remain local yet be aware and interact globally.

Following the notion of traveling to slipstream islands of artistic mate-riality, one of the more profound experiences during the research phase for *Mundos Alternos* was a trip to Cuba during the 12th Havana Biennial (2015). There, a major outdoor installation by Cuban-born artist Glexis Novoa, now based in Miami, encapsulated much of what was outlined in the preceding paragraphs.

In the installation *El vacío (Emptiness)* (2015), as in much of Novoa's work, including that produced in the studio, he conflates decaying archi-tecture with drawings of utopian, totalitarian-like architecture drawn pri-marily on marble, a material that is often used in government buildings worldwide. Novoa renders his buildings in miniature to diminish the authoritarian government that his imaginary, futuristic buildings are meant to evoke. He creates a looped, doubling, and time-travel effect as these totalitarian buildings of the future are inscribed on totalitarian-tinged frag-ments of marble from the present.

For *El vacío,* Novoa created a site-specific installation in which he positioned his drawings on the remaining concrete columns of a building beyond repair. He excavated the building in a semi-archaeological manner through the removal of dirt accumulated over decades. When you looked

out from the building, situated along the Malecón, the horizon lines of Novoa's imaginary, tiny cities lined up with the horizon of the Caribbean Sea, also known as the Straits of Florida (figs. 2–4).

For a viewer, the drawings of an imagined, authoritarian utopia were in the foreground of their vision, while they stood within one of the many ruins of a building unsustainable by a Communist government that began

FIGURE 2
View of deteriorated building in Havana containing Glexis Novoa installation
El vacío
2015
Courtesy of the artist
Photo by Tyler Stallings

FIGURE 3
View of miniature drawing of a stealth bomber drawn on plaster applied to the concrete column by the artist with the drawing's horizon lining up with the horizon line of the Caribbean Sea, looking toward the Malecón
Courtesy of the artist
Photo by Tyler Stallings

FIGURE 4
View of miniature drawing of city with totalitarian monuments, such as Vladimir Tatlin's proposed *Monument to the Third International* (1919–20) drawn by Glexis Novoa on plaster applied to a concrete column by the artist
Courtesy of the artist
Photo by Tyler Stallings

with utopian visions in the late 1950s. As time has progressed, the building and the political vision have deteriorated, mainly during the Special Period, or *Período especial*, a time of economic crisis that began in 1989 and extended into the late 1990s, primarily due to the scattering of the Soviet Union, which had been a major financial investor. The viewer was also looking to the real horizon line of the ocean, toward the States, a country of both refuge and exile, but also consternation, as it was in part its influence on Cuba up until the revolution that supported much of the inequality that Fidel Castro wanted to combat. In essence, estrangement and dissonance were created through the conflation of two realities—that of Cuba and the States—and of two imaginaries, one government claiming a history of spreading the wealth to the exploited and another purporting a history of providing access to wealth for its citizens.

When addressing how he conflates perspectives in his work, Novoa said, "My work repeatedly turns to the architecture of power and politics as its main subject. The collected images and information are ultimately used to demonstrate the eventual loss of significance of the very systems and archetypes they represent, and the disarticulation of discourses through pragmatic processes."[10]

Walking in the barely standing building, shuffling through the dirt, smelling the ocean air, and watching others interact with Novoa's drawing would have been impossible without travel to Cuba, a literal island. Once there, one entered Novoa's temporary and, again literal, portal. It collapsed

two geographical and political viewpoints on either side of an intangible horizon line, as if a wormhole where space and time fold so that you could easily traverse point A to a distant point Z without obstacles—whether the sea or an embargo.

Nearly thirty years later, after the Cuban Revolution (1953–59), a more recent revolution in Chiapas, Mexico, was explored by Portuguese-born, Los Angeles–based artist Rigo 23. For several years, he worked with indigenous groups in Chiapas that aim for equal rights or autonomy from the Mexican government. Rigo 23 chose to extend Subcomandante Marcos and the Zapatista Army of National Liberation's (EZLN) use of poetics through workshops with the Good Government Junta of Morelia, Chiapas. ("The Good Government Juntas represent both the poetic, populist and the practical nature of the Zapatista struggle to build workable alternatives of autonomy locally, link present politics to traditional ways of organising [sic] life in indigenous communities, and contrast with the 'bad government' of official representational politics in Mexico City."[11])

Through this art making with Rigo 23, they envisioned autonomy as having occurred already. They asked how they would then represent themselves beyond Earth, on an intergalactic level, emphasizing an indigenous, technoculture imaginary and calling their project the *Autonomous InterGalactic Space Program* (2012). In other words, Rigo 23 suggested that to imagine autonomy and to begin to materialize strange objects around this notion puts one on the path toward generating a new vocabulary in the present to be used in the future, such as negotiating between indigenous communities in Chiapas and the Mexican government.

In this context, Rigo 23's corn-husk spaceship from the project, which arose from southern Chiapas, was destined to become an interplanetary traveling vegetable that nurtured recognition of any being, whether on Earth, or elsewhere, as one who deserved freedom, justice, and equality. From an intergalactic sensibility, social justice for the indigenous in Chiapas translates to all Earthlings, who become indigenous collectively, in the context of encountering other beings beyond our blue dot in the solar system (fig. 5).

In an *ART21* interview, Rigo 23 recognized the value of traveling and through his presence becoming a wormhole in which he collapsed geopolitical events in order to generate kinship:

> I have come to realize that, often, the further one comes from an area of intense conflict, the more likely the locals are to give you the benefit of the doubt. So, as one talks about Leonard Peltier in East Jerusalem, or about going to Palestine in Wounded Knee, links and kinships that are invisible to most manifest themselves in wonderful and affirming ways. There is a mutual recognition that one is globalized in an entirely different way.[12]

In kinship with Rigo 23, Salvadoran-born, Los Angeles–based artist and professor of Central American studies Beatriz Cortez created several

FIGURE 5
Rigo 23
Autonomous InterGalactic
Space Program
2009–present
Installation view at REDCAT,
Los Angeles
Photo: Scott Groller

projects in which she aimed to enunciate a positive, future imaginary for an indigenous population. *La máquina de la fortuna* (2014; *The Fortune Teller Machine*) is an interactive sculpture, developed in collaboration with the Guatemalan Kaqchikel Maya collective Kaqjay Moloj, that prints fortune messages in Kaqchikel and in Spanish. When a viewer presses a button, a thermal printer ejects a message from their collective desires that were programmed into the fortune-teller machine. The messages are written in a future perfect verb tense, as if predicting what will become, hopefully, a reality soon. A sample list of possible, future-tense messages that a viewer may receive from this portal to the future include:

> Xtik'oje' jun raxnäq k'aslen.
> *Habrá justicia.*
> There will be justice.
>
> Xtiqetamaj achike ru ma xe kamisäx ri qawinaq.
> *Sabremos la verdad.*
> We will know the truth.
>
> Xtiqaya' ruq'ij ri kib'anob'al ri qatit qamama'.
> *Estaremos orgullosos de nuestro pasado.*
> We will be proud of our past.
>
> Xti ak'axäx ri k'ayewal qa chajin.
> *Nuestra voz será escuchada.*
> Our voice will be heard.
>
> Chiqonojel xtiqil ru b'eyal ri qak'aslen.

Tendremos oportunidades.
We will have opportunities.

Xtik'oje' jun qak'aslen ri man xkojyax ta pa k'ayewal.
Seremos libres.
We will be free.

Brought together under the *Mundos Alternos* moniker, these artists from Cuba, El Salvador, and Portugal demonstrate cross-cultural affinities with one another. They also currently live in the States but continue to have exchanges with their home countries in North and Central America, connecting the dots across the States, Mexico, the Caribbean, and Central America.

STRANGE OBJECTS IN ARGENTINA

Orienting toward Argentina in South America is the collaborative duo of Guillermo Faivovich and Nicolás Goldberg, otherwise known as Faivovich & Goldberg. Their project, *Meteorit "El Taco"* (2010), explored a north region of the country where four thousand years ago a meteor shower deposited several meteorites. *"El Taco"* was a fragment of an eight-hundred-ton iron mass, older than Earth itself, which came from the asteroid belt located between Mars and Jupiter. Discovered in 1962, the meteorite was retrieved by a joint scientific expedition between the United States and Argentina. It was shipped to the Max Planck Institute for Chemistry in Germany where it was divided into two halves. One part went to the Smithsonian Institution in the States, where it is kept at a distance from the public in a typical museum-display style, and the other half is at Buenos Aires's Galileo Galilei Planetarium, commonly known as Planetario, where it sits outside the entrance, barely protected, permitting patrons to touch this bit of our solar system in a most casual manner (fig. 6).

FIGURE 6

One-half of the meteorite at Buenos Aires's Galileo Galilei Planetarium, commonly known as Planetario, where it sits outside the entrance, barely protected, permitting patrons to touch this bit of our solar system in a most casual manner, 2016
Photo by Tyler Stallings

The artists were fascinated with the meteorite being an object older than our own world, but now here as an intergalactic immigrant. Truly a transcendent object, it existed before humans. As the artists said, it is a "cosmic readymade" that celebrates—at least provisionally—the possibility of reintegration when the two halves were brought together from two continents in the Americas for their project at Portikus in Germany.

Argentine artist Gyula Kosice looked to the clouds, too, but instead of engaging with ancient artifacts that fell from space, he conceived futuristic, floating cities. A Hungarian transplant, he took root in Buenos Aires, where he co-founded the Madí group in 1946, a proponent of Bauhaus ideas within Latin America. Interested in the intersection of art and technology, and how such work could be a platform for speculating on the future, Kosice often used neon in his sculptures and incorporated water in his works, not only as a kinetic feature but also as a way of considering his sculptures as architectural models, which led to his theoretical *Hydrospatial City*, begun in the 1970s (fig. 8).

The resulting works were both hanging, sculptural mobiles and Plexiglas maquettes of visionary architecture. Kosice conceived of them as living pods that would float in the sky, using water as the main source of energy to keep them aloft. His visionary speculations are akin to Paolo Soleri's concept for Arcosanti on the outskirts of Phoenix, Arizona, and Buckminster Fuller's conceptualization of "Spaceship Earth" and architectural designs like the geodesic dome. However, Kosice's designs were not built. They became conceptual platforms for discussion that exemplified nicely through the world-building aspect, inherent in the title, of *Mundos Alternos,* since they were intended as literal islands in the sky that function as testaments to the importance of far-reaching speculations arising from the intersection of science and imagination, that is, science-fictional thinking.

Kosice's futuristic poeticism is typified by some of the descriptive tags in his 1972 diagrams for a *Hydrospatial City*. In the one for *Maquette L,* Kosice indicated spaces designated for: "1) Place for tomorrow's art which is the oblivion of all the arts; 3) Place in which to record in writing—with ink from clouds—the enjoyable radication of all desires; 7) To be classified as unpredictable perpetuator. So that inexact science may become over-humanized; and 8) In the hydrocracy make public and republic that we are water. Recorded joy of the civilizations."[13] (fig. 9)

Kosice imagined his *Hydrospatial City* during the time of the Argentine military junta's seven-year Dirty War (1976–83). Conceivably, his off-planet, floating pods were imaginary places that, if built, could be literal islands to escape from dictatorship. The thoughts that he expressed in *La Ciudad Hidroespacial Manifesto* suggest how he saw his strange objects as sly and veiled reactions to an oppressive moment in history: "The centers of power and of economic and political decision-making can do no more than uselessly try to slow down this tendency which will transform man the moment his body and his mind begin to be concerned with universal projects and he comes thus more universal."[14]

It was also during this time that Argentine comic strip writer Héctor Germán Oesterheld and artist Francisco Solano López resurrected their science fiction comic, *El Eternauta*, after it was first published in the late 1950s. In the sequels, published in 1969 and 1975, the script became politicized in light of the military junta and neoliberalist policies. In brief, the story starts with a devastating snowfall that covers Buenos Aires, eradicating most life-forms in a short span of time. Juan Salvo and his friends and family survive. The environmental catastrophe was caused by an alien invasion of Earth, but Salvo and other survivors fight back. At one point, the aliens try to reel the survivors back in to "snow-free zones," but the ploy is discovered by Salvo's group. They escape in one of the alien's spaceships and activate a time-travel mechanism by mistake. The result is that Salvo escapes the aliens to some degree but now traverses different time periods in search of his friends in other time continuums, thus becoming an *Eternauta*, that is, traveling for eternity.

```
- Maquette L -

Places:

1) Place for tomorrow's art which is the oblivion of all the arts.

2) So as not to do political art. Place in which to do, politically,
   hydrocynetic art and to dissolve it in the hydrospatial
   habitat-revolutionary, liberating.

3) Place in which to record in writing -with ink from clouds- the
   enjoyable radication of all desires.

4) Recompense for premature ideas. Crash of sky against sky and
   splashings with approval.

5) Place of avenues of known waters. Inverted toboggan.

6) To be available in the expansive waves of hydroenergy. Laze with
   maximum danger in the cardiacal drop.

7) To be classified as unpredictable perpetuator. So that inexact
   science may become over-humanized.

8) In the hydrocracy make public and republic that we are water.
   Recorded joy of the civilizations.

9) Place undefined in the dot to graduate in what is to come.
```

In a sense, Oesterheld created Salvo as someone who disappeared and became a form of escape from the aliens but also became displaced from his home planet and time zone. The story's elements amounted to an allegory for the Dirty War, in which the aliens represented the military and also the influence of neoliberal policies from the States. In essence, Oesterheld found a way to provide a gateway for his readers in which he demonstrated, through a science fiction story in the form of a comic strip that tyranny could indeed be questioned.

"Profoundly disturbed by the Dirty War and the political repression, Oesterheld criticised [*sic*] the dictatorship in *El Eternauta II*. He introduced himself as a narrating character ('Germán') within the story and reflected deeply on survival in extreme conditions in a future inhospitable Argentina destroyed by invaders."[15] As a result, it was assumed that Oesterheld became one of the thirty thousand *desaparecidos* when he "disappeared" in 1977, as he was not seen or heard from after 1979.[16] Solano López fled to Spain.

On this note of science fiction as allegory during a time of Latin American dictatorships, J. Andrew Brown discussed cyborgs as an expression of the post-human in Latin American texts in his book *Cyborgs in Latin America* (2010). He wrote that in Latin America, "one increasingly finds cybernetic bodies and technological identity at the sociopolitical intersection of military dictatorship and neoliberal policy."[17] Brown further argued that the cyborg functions differently in Latin America than it does in North America or Europe, where theorists such as Donna Haraway have put forward the cyborg in a feminist context, for example, as a way of questioning patriarchal and heteronormative values due to its hybrid nature of being human and machine, thus transgressing the aforementioned categories for controlling bodies.

Brown exemplified his counter-narrative to the North American cyborg with an analysis of Manuel Puig's novel *Pubis angelical*, which was published in 1976, just two years after the oppressive Dirty War began to

FIGURE 9
Gyula Kosice
Maquette L
1965–75
Courtesy of the Kosice Museum, Buenos Aires. © Gyula Kosice.

take effect when the Perón government weakened. The story is about an Argentine woman who travels back and forth through time. "In all time periods and with each female character, the woman's body is presented as traumatized, ravaged by illness, by heartbreak, by surgery; all these traumas are represented symbolically in an artificial heart that ticks like a clock within her."[18] A 1982 film adaptation by Raúl de la Torre, which was produced toward the end of the Dirty War, provides a serendipitous bracketing of that time period with the same work in two different media. Brown writes, "The painful experiences that produced the figurative loss of her heart occasion, then, the need for an artificial replacement. What this establishes is the idea of the cybernetic body as an emblem of trauma; the prosthesis that the cyborg bears testimony of the violence that caused the need for its presence."[19]

In other words, for Brown, this representation of a cyborg is different from one in a North American context, which may represent a cyborg as the result of neoliberalist policies in which the body becomes a commodity, in the extreme, by merging with machine. Cyborgs become slaves of a privatized industry that has replaced services traditionally attached to government agencies, such as the slave androids in *Blade Runner* (1982), the privatized police cyborg in *RoboCop* (1987), or the police robot that gains human consciousness in *Chappie* (2015).

SCIENCE-FICTIONAL CONNECTEDNESS

From a curatorial perspective, the necessity of travel in cars, trains, planes, and by foot throughout the Americas became an experience in which the circulation of the kind of artwork that we sought became slipstream islands of materiality. Our radars were attuned to artists who viewed their art as platforms for investigating and questioning the immediate culture that surrounded them and the world at large, that is, embodying Suvin's aforementioned cognitive estrangement.

In this regard, our visits became ones in which citizens of alternative worlds found one another and cemented bonds through face-to-face meetings. We were surrounded by the artists' slipstream artwork in their studios or galleries, which became *las puertas*. It was by traveling through these wormholes, found throughout the Americas, to islands of materiality, as opposed to "islands in the net," to coin another phrase from Bruce Sterling's 1988 novel with the same title, that we found an overall utopian experience of connectedness through material presence, rather than a dystopian one of disembodied connection through the telepresence of texts and screens. In other words, we were in true locations of the future, rather than just sensing, at an untouchable distance, the things to come.

NOTES

1. Bruce Sterling, "Catscan 5: Slipstream," *sf Eye*, no. 5 (July 1989), accessed October 26, 2016, https://w2.eff.org/Misc/Publications/Bruce_Sterling/Catscan_columns/catscan.05.

2. Taryne Jade Taylor, "A Singular Dislocation: An Interview with Junot Díaz," *Paradoxa* 26 (2015): 97–110.

3. Jan Tumlir, "Sci-Fi Historicism, Part I: The Time Machine in Contemporary Los Angeles Art," *Flash Art* 40, no. 253 (March–April 2007): 102–5.

4. Leopold Museum, accessed October 26, 2016, http://www.leopoldmuseum.org/en/exhibitions/78/the-poetics-of-the-material.

5. Rachel Haywood-Ferreira, *The Emergence of Latin American Science Fiction* (Middletown, CT: Wesleyan University Press, 2011), p. 1.

6. Darko Suvin, "On the Poetics of the Science Fiction Genre," *College English* 34, no. 3 (December 1972): 372–82.

7. Ernest Hogan, "Chicanonautica: Prophesy, High Aztech, and Nerve Jelly," February 5, 2011, *La Bloga,* accessed October 24, 2016, http://labloga.blogspot.com/2011/02/chicanonautica-prophesy-high-aztech-and.html.

8. Ernest Hogan, "Chicanonautica: Voyage to a Day of Latino Science Fiction," *La Bloga,* May 15, 2014, accessed October 24, 2016, http://labloga.blogspot.com/2014/05/chicanonautica-voyage-to-day-of-latino.html.

9. "Latino Science Fiction Explored, UCR Science Fiction and Technoculture Studies Program Hosts April 30 Event," *UCR Today,* accessed October 24, 2016, https://ucrtoday.ucr.edu/21579.

10. "Statement," Glexisnovoa.com, accessed October 24, 2016, http://www.glexisnovoa.com/index.php/joomla-overview/statement.

11. Paul Chatterton, "The Zapatista Caracoles and Good Governments: The Long Walk to Autonomy," *State of Nature,* 2007, accessed October 24, 2016, http://www.stateofnature.org/?p=6119.

12. Thom Donovan, "5 Questions (for Contemporary Practice) with Rigo 23," *ART21 Magazine,* January 20, 2011, http://blog.art21.org/2011/01/20/5-questions-for-contemporary-practice-with-rigo-23/#.V-7HaDsR87Y.

13. Max Perez Fallik (Gyula Kosice's grandson), e-mail image to author, July 11, 2016.

14. Gyula Kosice, "La Ciudad Hidroespacial Manifesto," in *Kosice,* ed. Santiago Luján Gutiérrez (Buenos Aires: Ediciones de Arts Gaglianone, 2006), p. 122.

15. Carlos A. Scolari, "*El Eternauta:* Transmedia Expansions, Political Resistance and Popular Appropriations of a Human Hero," in *Transmedia Archaeology: Storytelling in the Borderlines of Science Fiction, Comic Books, and Pulp Magazines*, ed. Carlos Scolari, Paolo Bertetti, and Matthew Freeman (New York: Palgrave Macmillan, 2014), p. 55.

16. historietasargentinas.com, publisher of *El Eternauta* books, http://www.historietasargentinas.com/eternauta.html.

17. J. Andrew Brown, introduction to *Cyborgs in Latin America* (New York: Palgrave Macmillan, 2010), p. 2.

18. Brown, "Posthuman *Porteños*: Cyborg Survivors in Argentine Narrative and Film," in ibid., p. 10.

19. Ibid., p. 15.

ADÁL (b. 1948, Utuado, Puerto Rico) systematically explores identity issues to their ultimate consequences due to his complex view of double identity. From his suggestive, "surreal" photographic collages in the early 1970s to the ironic concreteness of his *Auto-Portraits* series, and, finally, the creation of an ethereal, ubiquitous country where he and his Out of Focus Nuyorican colleagues live, ADÁL collapses self-portraiture's allegedly self-referential quality. Indeed, a great deal of his work arises from the possibility of achieving an ultimate, definitive picture of one's self. ADÁL is represented in the permanent collections of the Museum of Modern Art, New York; San Francisco Museum of Modern Art; Museum of Fine Arts, Houston; the Metropolitan Museum of Art, New York; El Museo del Barrio, New York; Museé Modern de la Ville de Paris, France; Smithsonian American Art Museum, Washington, DC; and National Portrait Gallery, Washington, DC. His work is included in the traveling exhibition *Our America: The Latino Presence in American Art* at the Smithsonian American Art Museum. In 2016 he was awarded the Pollock-Krasner Fellowship and was a fellow at the Smithsonian National Air and Space Museum, Washington, DC.

AZTLAN Dance Company, originally founded in 1974, is directed by Roén R. Salinas (b. 1965, Austin, Texas). Salinas is a Tejano cultural artist, educator, and activist based in Austin, Texas. He earned his PhD (2015) and MFA (2006) from the University of Texas at Austin and is the principal of Austin's Santa Cruz Theater, where the AZTLAN Dance Company maintains permanent residence. Salinas's signature, contemporary, expressive Xicano/Latino choreography explores borderlands as an intersectional site to experience modern interpretations of the world. Works in this collection include *Xicano Super Heroes: The Rise of EloteMan* (2016), *The Aztlan Enchilada Western* (2011, revised in 2015), *Itzpapalotl: Obsidian Butterfly* (2014), *Loterialandia* (2013), *Sexto Sol: A Cumbia Cruiser's Guide to the Galaxy* (2012), and *SwitchBlade: An Eastside Story* (2012). Salinas's company has presented at the International Theater and Performing Arts Festival, Great Britain; Hong Kong Arts Festival; Austin Dance Festival; and DANZAS: Modern Movimientos, University of Texas. His work has been recognized by the Austin Critic's Roundtable for Performance Choreography and Lifetime Achievement, and the ESB-MACC Award for Excellence, among others. Salinas's collection of more than forty original choreographies revises myth, history, and popular culture into modern theatrical works that contribute to greater American social and political commentary.

Guillermo Bert (b. 1959, Santiago, Chile) is a Los Angeles–based, multimedia artist. Working with laser and digital technologies, his most recent series, *Encoded Textiles* and *Exodus Series*, combine traditional indigenous technologies of weaving and storytelling. Bert collaborated with Mapuche, Zapotec, Acoma, and others to create a bridge between intertwined worlds. His career as an artist and arts educator has taken many forms, from art director of the *Los Angeles Times* (1995–2000) to professor of mixed media at the Art Center School of Design, Pasadena (2000–5). Bert has had exhibition and film screenings at Museum of Latin American Art, Long Beach; Pasadena Museum of California Art; Museum of Art and Design, New York; and Albuquerque Museum of Art, among others. He has forthcoming projects at the Craft and Folk Art Museum, Los Angeles, and at Nevada Museum of Art, Reno. Bert's work has been supported by the California Community Foundation Fellowship, the Center for Cultural Innovation, and the National Association of Latino Arts and Culture.

Erica Bohm (b. 1976, Buenos Aires, Argentina) graduated from the National School of Fine Arts Prilidiano Pueyrredón in 2001. She went on to study photography with Gabriel Valansi and joined the Postgraduate Artists program and Film Laboratory at Universidad Torcuato Di Tella, Buenos Aires, in 2009 and 2012, respectively. Bohm participated in Antarctica Art Residence, Antarctica, Argentina (2015), and Mapping Exchange: Artists Residency Programs, Blanton Museum of Art, Austin, Texas (2009). She has had solo exhibitions of her work at THE MISSION, Houston and Chicago; Baró Galeria, São Paulo; and Centro Cultural Parque de España, Rosario, Argentina. Bohm's work has also been included in numerous group exhibitions at Museo de Arte Contemporáneo de Buenos Aires; Museo de Arte Contemporáneo de Bogotá, Colombia; Hyde Park Art Center, Chicago; Museum of Contemporary Art, Chicago; Museo Malvinas e Islas del Atlántico Sur, Buenos Aires; Museo de Arte Moderno, Buenos Aires; Museo de Arte Contemporáneo de Mar del Plata, Argentina; Fundación Proa, Buenos Aires; Universidad Torcuato Di Tella, Buenos Aires; Creative Research Lab, Austin; Ruth Benzacar Gallery, Buenos Aires; Nora Fisch Gallery, Buenos Aires; and Instituto Cervantes de São Paulo, among others.

Tania Candiani (b. 1974, Mexico City, Mexico) is currently based in Mexico City. Her work encompasses a variety of media in an exploration of notions of translation and antiquated technologies. Candiani's work has been exhibited in museums around the world, including Polytechnic Museum, Moscow; Boijmans Museum, Rotterdam; Museo de Arte Moderno, Mexico City; Museum of Contemporary Art San Diego; Rubin Center at the University of El Paso; Zacheta National Gallery of Art, Warsaw; and the Abrons Art Center, New York City. Alongside Luis Felipe Ortega, she represented her country in the 2015 Venice Biennale. Candiani was awarded a Guggenheim Fellowship in 2011 and the Award of Distinction by the Prix Arts Electronica in 2013, in the category of Hybrid Arts. Since 2012, she has been a member of Mexico's National System of Art Creators. Candiani has participated in several artist-in-residence programs in Poland, the United Kingdom, Austria, the United States, Colombia, Russia, Spain, Argentina, Slovenia, Japan, Egypt, and Lithuania. Her

work resides in private and public collections, including the Museum of Contemporary Art San Diego; San Diego Museum of Art; Museum of Latin American Art, Long Beach; Mexican Museum San Francisco; Deutsche Bank; and INBA Mexico.

Beatriz Cortez (b. 1970, San Salvador, El Salvador) is an artist and cultural critic who lives in Los Angeles. Cortez earned a PhD from Arizona State University (1999) and an MFA from the California Institute of the Arts (2015). Her work has been the subject of solo exhibitions at the Vincent Price Art Museum, Los Angeles; Cerritos College Art Galleries; Grand Central Arts Center, Santa Ana, California; Stamp Union Gallery at the University of Maryland, College Park; and Museo Municipal Tecleño, El Salvador, among others. Cortez has been included in exhibitions at Sala Nacional de Exposiciones Salarrué, El Salvador; Los Angeles Contemporary Exhibitions; Museo de Arte y Diseño Contemporáneo, San José, Costa Rica; and Orange County Museum of Art.

Claudio Dicochea (b. 1971, San Luis Rio Colorado, Mexico) is a visual artist and educator who lives in San Antonio. Dicochea earned a BFA from the University of Arizona (1995), a PBA from the San Francisco Art Institute (1999), and an MFA from Arizona State University (2009). His work has been included in exhibitions at Denver Art Museum; Snite Museum of Art, Notre Dame; National Museum of Mexican Art, Chicago; McNay Art Museum, San Antonio; El Paso Museum of Art; Phoenix Art Museum; Arizona State University Art Museum, Tempe; Museo de Arte de Ciudad Juárez, Chihuahua, Mexico; and the 17th Biennale of Sydney, *The Beauty of Distance—Songs of Survival in a Precarious Age*. Dicochea's work has been the subject of solo exhibitions at Lisa Sette Gallery, Phoenix, which represents him. His paintings are also included in the collection of Arizona State University Art Museum and El Paso Museum of Art.

Faivovich & Goldberg is composed of Guillermo Faivovich (b. 1977, Buenos Aires, Argentina) and Nicolás Goldberg (b. 1978, Paris, France), who live and work in Buenos Aires. Since 2006, they have been working on *A Guide to Campo del Cielo*, which revolves around the cultural impact of the Campo del Cielo meteorites in Chaco, Argentina. In 2012 an iteration of the project was central to the concept of *documenta*, a major exhibition of modern and contemporary art that takes place every five years in Kassel, Germany. Faivovich & Goldberg's work has also been featured as part of the Bienal do Mercosul, Porto Alegre, Brazil; the Gwangju Biennale, South Korea; Portikus, Frankfurt, Germany; and Fondazione Merz, Turin, Italy. Their work will be the subject of solo exhibitions at the Mistake Room, Los Angeles (2017), and Arizona State University Art Museum, Tempe (2018).

Sofía Gallisá Muriente (b. 1986, San Juan, Puerto Rico) is a visual artist who works mainly with video, photography, text, and installation. She earned a BFA from New York University (2008) and has participated in postgraduate experiments such as Anhoek School, Brooklyn, and La Práctica at Beta-Local. Muriente earned an Emerging Artist Grant from TEOR/éTica in Costa Rica, where she had a solo show in 2015. Her work has also been shown in the Bronx Latin American Art Biennial; San Juan Poly/Graphic Triennial; Los Angeles Contemporary Exhibitions; Latin American Art Museum of Buenos Aires; and the Walker Art Center, Minneapolis. She is currently one of the co-directors of Beta-Local, an organization dedicated to promoting critical and aesthetic thought and practices in Puerto Rico.

Guillermo Gómez-Peña (b. 1955, Mexico City, Mexico) is a performance artist, writer, activist, radical pedagogue, and artistic director of the performance troupe La Pocha Nostra. Born in Mexico City, he moved to the United States in 1978. Gómez-Peña's performance work and eleven books have contributed to debates on cultural and gender diversity, border culture, and U.S.-Mexico relations. His artwork has been presented at more than nine hundred venues across the United States, Canada, Latin America, Europe, Russia, South Africa, and Australia. Gómez-Peña has received a MacArthur Fellowship, Bessie Award, and American Book Award. He is a regular contributor to newspapers and magazines in the United States, Mexico, and Europe, and a contributing editor for the *Drama Review* (NYU-MIT). Gómez-Peña is a senior fellow at Hemispheric Institute of Performance and Politics, New York University, and a patron for Live Art Development Agency, London. In 2012 he was named Samuel Hoi Fellow by USA Artists.

> **La Pocha Nostra** is a transdisciplinary arts organization that provides a support network and forum for artists of various disciplines, generations, and ethnic backgrounds. It is devoted to erasing the borders between art and politics, art practice and theory, artist and spectator. Founded in 2001, La Pocha Nostra is intensely focused on the notion of collaboration across national borders, race, gender, and generations as an act of radical citizen diplomacy, and as a means for creating "ephemeral communities" of rebel artists.

La Gravedad de los Asuntos (Matters of Gravity) is an artist-driven project directed by Nahum and Ale de la Puente that explores the force of gravity, a mystery still remaining for science. Two years of reflection and a few seconds in zero gravity were the origins of a series of artists' works that were completed at the Yuri Gagarin Cosmonaut Training Centre in Star City, Russia. There, on board the iconic Ilyushin 76 MDK, nine artists and one scientist from Mexico were subjected to an environment of weightlessness. A few seconds were enough to experience eternity, tell a story, break a paradigm, liberate a molecule, have an illusion, experience movement without references,

create poetry out of falling bodies, make the useless become useful, and search for the impossible embrace. The participants of Matters of Gravity include Ale de la Puente, Arcángelo Constantini, Fabiola Torres-Alzaga, Gilberto Esparza, Iván Puig, Juan José Díaz Infante, Marcela Armas, Miguel Alcubierre, Nahum, and Tania Candiani. The project has been exhibited at Laboratorio Arte Alameda, Mexico City; Polytechnic Museum, Moscow Russia; KSEVT, Vitanje, Slovenia; Rubin Center, El Paso, Texas; and Museo de Arte de Zapopan, Jalisco, Mexico.

La Gravedad de los Asuntos: Ale de la Puente (b. 1968, Mexico City, Mexico) uses installations to explore notions of time through experiences in space, from a technological, scientific, philosophical, and even linguistic approach. In her work, De la Puente uses different media to explore the relationship between space time and our image of the world. She collaborates in projects that involve astronomy, nuclear sciences, navigation, and the different forms in which we perceive time because our image of the world and the way we live in it determines our perception of time. De la Puente studied at the Arques School of Traditional Boatbuilding, Sausalito, California (2000); Escola Massana, Barcelona (1994); and Universidad Iberoamericana, Mexico City (1991). Her solo exhibitions include *(Tres Puntos) . . . de Vista, Inés Barrenechea,* Madrid (2013); *. . . sobre los títulos,* Casa Vecina, Mexico City (2009); and *Textile Sculpture, Mosaicon Konserwacja Zabytkow,* Lodz, Poland (1994).

La Gravedad de los Asuntos: Juan José Díaz Infante (b. 1961, Mexico City, Mexico) is a photographer, poet, and transdisciplinary artist living in Mexico City. He graduated from Brooks Institute in 1982. Infante's work includes poetry, music, photography, video, transdisciplinary art, and space art. He is the director of the art-space mission *Ulises I,* a satellite art piece, and the founder of the Mexican Space Collective. Infante is also a curator and cultural activist. This year he is working on two major exhibitions of contemporary and modern architecture. Since 2014, Infante has been establishing a school of satellites as a cultural statement. His projects have been exhibited in the major museums of Mexico, and his work has been included in major international events like the Venice Biennial, the European Cultural Month, and Fotofest. Infante is the author of nine experimental videos, and he has published more than twenty-six books. His latest work is the radio transmission of the Quixote to the moon at the Cervantino Festival in Guanajuato.

La Gravedad de los Asuntos: Nahum (b. 1979, Mexico City, Mexico) is an artist and a musician currently based in Berlin. He earned his MA at Goldsmiths, University of London, and is also a graduate of International Space University. Nahum's space work examines the relationship between the universe and the human being, as well as the importance of the personal experience to generate feelings that connect us with the cosmos. He co-founded the musical ensemble Orchestra Elastique and organized the international festival KOSMICA, a series of gatherings about art, outer space, and culture. Nahum chairs the technical committee for the Cultural Utilizations of Space at the International Astronautical Federation (IAF) in Paris. In 2015 he was recognized as a Young Space Leader for his contributions to astronautics. Nahum has also been appointed curator for the digital arts biennial TransitioMx in Mexico City. His work has been shown in several venues in the United Kingdom, including Institute of Contemporary Arts, London; Southbank Centre, London; Battersea Arts Centre, London; The Place, London; and The Basement, Brighton. Nahum's work has also appeared at Laboratorio Arte Alameda, Mexico City; Fonoteca Nacional, Mexico City; and Visual Voice Gallery, Montreal.

La Gravedad de los Asuntos: Tania Candiani—*see individual listing*

Hector Hernandez (b. 1974, Laredo, Texas) is an artist and independent curator living in Austin, Texas. He earned his license as an importer/exporter in 2000, and has been active in the art community since the late 1990s. Hernandez has taken part in solo and group exhibitions at Kunsthaus Gallery, San Miguel de Allende; FotoFest, Houston; McNay Art Museum, San Antonio; MACLA/ Movimiento de Arte y Cultura Latino Americana, San Jose; and The Contemporary Austin, to name a few. In 2005 he co-founded Los Outsiders art collective. The *Austin Chronicle* awarded the collective the best gallery exhibition in 2012 and 2015. Hernandez, as part of the collective, is also a finalist for the SXSW Eco Award in Urban Strategy + Civic Engagement (2016).

Gyula Kosice (1924, Košice, Czechoslovakia–2016, Buenos Aires, Argentina) was an avant-garde artist, poet, and theoretician. Known for his luminic and hydrokinetic works, Kosice made the first interactive, articulated and mobile sculpture in the world, *Röyi* (1944). He was the founder of Madí Art (1946) and author of its manifesto, *Madí Manifest.* Kosice was the first artist in the world to use neon gas (1946) and water (1948) in his sculptures. He fathered *Hydrospatial City,* now housed at the Museum of Fine Arts, Houston, and erected monumental sculptures in Argentina, Slovakia, Uruguay, Korea, and Italy. Kosice had solo exhibitions at Galerie Denise René, Paris; Drian Gallery, London; Terry Dintenfass Gallery, New York; Instituto Di Tella, Buenos Aires; Espace Cardin, Paris; Hakone Open Air Museum, Tokyo; Museo Nacional de Bellas Artes, Buenos Aires; Centro Cultural Recoleta, Buenos Aires; and Centre Pompidou, Paris. His work is in the collections of the Museum of Fine Arts, Houston; Centre Pompidou, Paris; Colección Patricia Phelps de Cisneros, New York; and Museo Nacional de Bellas Artes, Buenos Aires.

LA DAVID (b. 1953, San Antonio, Texas), a.k.a. LA VATOCOSMICO c-s, attended San Antonio Community College in 1972, where he experimented with various styles and mediums that cultivated his knowledge of different artists and art movements, such as Impressionism, Cubism, Dada, and Pop art. His objective in regard to his "Mas Cosmico Arte" culture entails a social and political consciousness. LA David's art is eccentric satire with a mixture of cosmic fusion, resulting in profundity in dealing with his cosmic Chicano roots. He has been included in the International Latina/Latino Arts Festival at Arizona State University, Tempe; La Peña, Austin; Gallista Gallery, San Antonio, as part of MeChicano Alliance of Space Artisans (MASA); the Luminaria San Antonio Arts Festival; Henry B. Gonzales Convention Center, San Antonio; and San Antonio Educational and Cultural Arts Center, Texas A&M University, among others. LA David also took part in several annual *La Virgen de Guadalupe* exhibits sponsored by the Dallas Office of Cultural Affairs and the Texas Commission of Arts, Dallas.

Robert "Cyclona" Legorreta (b. 1952, El Paso, Texas) is a performance artist and self-described "political art piece" in Southern California, whose work challenges gender, race, and sexuality norms. He grew up in East Los Angeles's prevalent Mexican American community, where he was the subject of physical assault and police harassment, experiences that contributed to his confrontational art practice. Legorreta's Cyclona, the artist's performance persona, is based on the pseudonym for Pachuca Zoot-Suiters of the 1940s combined with the meteorological force of a storm. In 1969, Cyclona starred in *Caca-Roaches Have No Friends*, a definitive example of experimental performance art growing out of East Los Angeles—an environment shaped by the Chicano civil rights movement, antiwar movement, hippie counterculture, and lesbian and gay liberation. Legorreta is a consummate self-documentarian and collector of Latino-themed objects, such as LP records, toys, and ephemera. His archival art practice has been featured in shows like *Arte No Es Vida* (2008) at El Museo del Barrio in New York, *Asco: Elite of the Obscure* (2011) at Los Angeles County Museum of Art, and *California-Pacific Triennial* (2013) at the Orange County Museum of Art. Legorreta's collection can be found at the Chicano Studies Research Center at University of California, Los Angeles.

Chico MacMurtrie (b. 1961, Deming, New Mexico) has explored the intersection of robotic sculpture, media installation, and performance since the late 1980s. He received an MFA from the University of California, Los Angeles, in 1987. MacMurtrie and his interdisciplinary collective Amorphic Robot Works are dedicated to the study and creation of movement as it is expressed in anthropomorphic, organic, and abstract robotic forms. He has received numerous awards for his artworks, including grants from the National Endowment for the Arts, Andy Warhol Foundation, Rockefeller Foundation, VIDA Life 11.0, and Prix Ars Electronica. MacMurtrie was awarded a Guggenheim Fellowship in 2016, and his work has been the subject of solo exhibitions at Wood Street Gallery, Pittsburgh; Beall Center for Art + Technology, Irvine; Museum of Contemporary Art, Tuscon; and Pioneer Works, Brooklyn. In 2016, Muffatwerk, Munich, presented a ten-year traveling survey of MacMurtrie's Inflatable Architectural Bodies. His work has been included in exhibitions at the Hayward Gallery, London; Museo Nacional Centro de Arte Reina Sofía, Madrid; Espacio Fundación Telefónica, Madrid; Cité des Sciences et de l'Industrie, Paris; Museo Universitario Arte Contemporáneo, Mexico City; Shanghai Biennale; and the International Triennial of New Media Art, the National Art Museum of China, Beijing.

Marion Martinez (b. 1954, Española, New Mexico) is an artist of circuit-board art, which she refers to as "mixed tech media." Martinez's art displays the dichotomies of her life in a ranch and farmer family community adjacent to one of the leading technological research facilities in the nation. Her upbringing in the Hispanic tradition, combined with her exposure to Native American culture, contributes to her work. Martinez's art, composed of salvaged technology parts, features the interplay of symbols and images representing her culture. Her work is housed in several collections, such as the Hispanic Research Center at Arizona State University, Tempe; San Juan Community College, Farmington; Northern New Mexico Community College, Española; Museum of International Folk Art, Santa Fe; Nokia Corporation; and Fidelity Investments. Her work premiered at the juried exhibition *Something Wild!* in Las Vegas (1992), and was later exhibited on the New Mexico tree at the White House during the holiday season (1999).

MASA (MeChicano Alliance of Space Artists) is a collective annual exhibition featuring Latino artists. Co-founded by Luis Valderas and Paul Karam in 2004, the project focuses on Chicano identity and has commented on topics ranging from immigration to discrimination. MASA was a response to post-9/11 racism, as it exists in the reinforced militarization of the U.S.-Mexico border and in the rise of anti-immigration legislation. The group promotes multiple ways of seeing through the combination of past images, objects, and symbols with those of the present and future. Art shown through MASA highlights a reexamination of colonial divisions. *MASA Project I* was the inaugural exhibition held in 2005 at Gallista Gallery, San Antonio. It presented a survey examining the various space-strands used by Chicano artists to decolonize. *MASA Project II* was held in 2006 at Gallista Gallery and expanded on the first exhibition with a focus on gender roles. *MASA Project III* was held in 2007 at Centro Cultural Aztlan, San Antonio, and was sponsored by University of

Texas at San Antonio. Curated by Arturo Almeida in 2007, *MASA Project III* touched on the theme of Meso-American cultures in conversation with the modern space race.

MASA: Sam Coronado (1946, Ennis, Texas–2013, Fort Wayne, Indiana) began his artistic career in 1969 as a technical illustrator at Texas Instruments. He earned his BFA from the University of Texas at Austin in 1975. Coronado worked in a range of media, including oil and acrylic painting and printmaking. These artistic experiments led to a specialty in serigraphy. Venues that have exhibited Coronado's work include McNay Art Museum, San Antonio; Dallas Latino Cultural Center; Edgar Allan Poe Museum, Richmond; Ningxia Exhibition Center, Yinchuan, China; OSDE Art Space Foundation, Buenos Aires, Argentina; and International Center of Bethlehem, Palestine. Coronado was a co-founder of Mexic-Arte Museum, and he also established the nonprofit organization Serie Project, which aims to create and promote serigraph prints created by Latino artists and others. In conjunction with Coronado Studio, which creates screen prints exclusively, the Serie Project administers and produces fine art prints that are shown internationally. Coronado taught art and lectured on Chicano art in numerous museums, art schools, and universities throughout the United States. The Austin Visual Arts association awarded him a Lifetime Achievement Award in 2012.

MASA: Luis "Chispas" Guerrero (b. 1957, San Antonio, Texas) In 1996, after working for ten years as a welder, Luis Guerrero began to fuse and transform diesel engine parts and other metal junkyard scraps into sculptures. He is a member of Los Vatos Locos, a group of fourteen San Antonio–based artists. Guerrero is interested in "capturing the evolving Mexican American culture, its ongoing struggle, present day myths and musical legends." His studio, *Ay Chispas* (There are sparks) is named for the flickers of fire that shoot through the air when his welding tools are fusing metals together. Guerrero has exhibited throughout San Antonio and South Texas, and his work can be found in many public and private collections, including Arizona State University Art Museum, Tempe. He was one of seven artists featured in *Yo Soy/I Am*, a DVD produced by the Hispanic Research Center at Arizona State University. Additionally, his work has been published in *Chicano Art for Our Millennium: Collected Works from the Arizona State University Community* and *Triumph of Our Communities: Four Decades of Mexican American Art*.

MASA: Sergio Hernández (b. 1948, Los Angeles, California) is a painter and cartoonist living in Acton, California. Hernández earned his BA in Chicano studies with a minor in art in 1976 from California State University, Northridge. He has exhibited his work at the National Museum of Mexican Art, Chicago; Gallista Art Gallery, San Antonio; Oakland Museum of California; Vincent Price Art Museum, Monterey Park; Cornell University, Ithaca; Bilkent University, Ankara, Turkey; University of Wisconsin; The dA Center for the Arts, Pomona; ChimMaya Gallery, Los Angeles; Avenue 50 Studio, Inc., Los Angeles; Santa Paula Art Museum; California Oil Museum, Santa Paula, CA; California State University, Channel Islands; Arte Americas, Fresno; California State Capitol Building, Sacramento; The Latino Museum of History, Art and Culture, Los Angeles; and Lancaster Museum of Art and History. Hernández was selected as an artist-in-residence at Coronado Studios, Austin, and was one of the original staff of the historical socialpolitical magazine *Con Safos*. He created the *Arnie & Porfi* cartoon strip and publishes his cartoons in several periodicals and social media. In 2009, the National Newspaper Association's Better Newspapers Contest awarded him second place for Best Original Editorial Cartoons.

MASA: Debora Kuetzpal Vasquez (b. 1960, San Antonio, Texas) is a Chicana multimedia artist, educator, and activist. Observing the Chicana movement through the lens of a child has shaped her life, work, and the creation of her cartoon character, Citlali, La Chicana Super Hero. Citlali combats social and political issues pertaining to women, children, and animals. Vasquez received a BA from Texas Woman's University, Denton, and an MFA from the University of Wisconsin-Madison. She also received a certificate in traditional culture from Universidad Náhuatl de Ocotepec in Mexico. Vasquez is an assistant professor and the head of the Visual Arts Program at Our Lady of the Lake University, San Antonio. Her research examines artistic perception through three main foci: cultural hybridity in contemporary and global artistic approaches to indigenous and African spiritual healing; achieving ecological balance and community health by way of multigenerational relationships from a feminist perspective; and bringing attention to the lack of Chicana and women's representation in the arts and the education system. She recently opened Corazones on Fire: Painting with a Cultural Edge, a painting-as-entertainment studio that focuses on healing through culture.

MASA: Miguel Luciano (b. 1972, San Juan, Puerto Rico) is a visual artist based in New York City. Luciano earned a BFA from New World School of the Arts (1996) and an MFA from the University of Florida (2000). His work has been exhibited nationally and internationally, including in exhibitions at the Mercosul Bennial, Brazil; Grande halle de la Villette, Paris; Museo del Palacio de Bellas Artes, Mexico City; the Ljubljana Biennial, Slovenia; San Juan Poly/Graphic Triennial, Puerto Rico; Museo Nacional de Bellas Artes de la Habana, Cuba; and Smithsonian American Art Museum, Washington, DC. He is the recipient of numerous awards, including the Louis Comfort Tiffany Award Grant and the Joan Mitchell Foundation Painters and Sculptors

Award. Luciano was also a fellow of the smARTpower program, a community-based art initiative of the Bronx Museum of the Arts and the Bureau of Educational and Cultural Affairs at the U.S. Department of State. His work is featured in the permanent collections of Smithsonian American Art Museum, Washington, DC; Brooklyn Museum, New York; El Museo del Barrio, New York; Newark Museum; and the Museo de Arte de Puerto Rico.

MASA: Laura Molina (b. 1957, Los Angeles, California) is a visual and performing artist living in Los Angeles. Molina studied acting and stagecraft at the Inner City Cultural Center, Los Angeles, in 1979, and was accepted into the Character Animation Program at the California Institute of the Arts the same year. She was an artist-in-residence at Self Help Graphics & Art from 1993 to 1995, and participated in their Screen Print Atelier in 2003 and 2006. Molina has participated in several group shows at Galería de la Raza, San Francisco; Self Help Graphics & Art; Millard Sheets Art Center, Pomona, California; Mesa Southwest Museum (now Arizona Museum of Natural History); and National Museum of Mexican Art, Chicago. Her works can be both personal and political. In many of Molina's pieces, her own image is an important part of the subject matter.

MASA: Tony Ortega (b. 1958, Santa Fe, New Mexico) holds an MFA in drawing and painting from the University of Colorado at Boulder and is currently an associate professor at Regis University, Denver. He is the recipient of the coveted Governor's Award for Excellence in the Arts (1999) and the Mayor's Award for Excellence in the Arts (1998). Ortega has been a working artist and teacher for the past thirty years and is known for his vibrant, colorful artwork. His lifelong goal is to contribute to a better understanding of cultural diversity by addressing the culture, history, and experiences of Latinos through his art. Ortega's work can be found at Denver Art Museum; Los Angeles County Museum of Art; Colorado Springs Fine Art Center; and William Havu Gallery, Denver. He has exhibited in the United States, Latin America, and other parts of the world.

MASA: Raul Servin (b. 1946, Ixcapuzalco, Guerrero, Mexico) studied at the Instituto Nacional de Bellas Artes (INBA) in Acapulco under Master Genaro Bernal. Raul is a founding member of El Jardin del Arte de Acapulco. He started showing his work in 1965, and had his first solo show in 1967 at Galeria Edan, Acapulco. Servin's knowledge of pre-Colombian art was essential to the decorations he created for the stage of the Flying Indians at Hemisfair, San Antonio, in 1968. His art has been the subject of solo exhibitions at San Antonio Public Library (1980); Gallery 35, Lytle, Texas (1998); Gallista Gallery, San Antonio (2000 and 2008); Casa de la Cultura, Del Rio, Texas (2011); Centro Cultural Aztlan, San Antonio (2012); Guadalupe Cultural Arts Center, San Antonio (2015); and many others. Servin's work is in several permanent art collections, including the University of Texas at San Antonio and University of Notre Dame.

MASA: Luis Valderas—see individual listing

Jillian Mayer (b. 1984, Miami, Florida) makes work that explores how technology affects our identities, lives, and experiences. Through videos, online experiences, photography, telephone numbers, performance, paintings, sculpture, and installation, her work investigates the tension between physical and digital iterations of identity and existence. Mayer's video works and performances have premiered at galleries and museums internationally, including the Museum of Modern Art, New York; Museum of Contemporary Art, North Miami; Brevard Art Museum, Melbourne, Florida; Bass Museum of Art, Miami Beach; Musée d'art contemporain de Montréal; and Solomon R. Guggenheim Museum, New York. Her work has appeared at film festivals, including Sundance Film Festival, Utah; SXSW Film Festival, Austin; and New York Film Festival. She has been featured in *Art Papers*, *ArtNews,* and *ArtForum*. Mayer is a recipient of the Creative Capital Fellowship (2015); the South Florida Cultural Consortium Fellowship (2014 and 2011); the Sundance Institute New Frontier Story Lab Fellowship (2013); Zentrum Paul Klee Fellowship, Bern, Switzerland (2013); Cintas Foundation Fellowship (2012); and Harpo Foundation Grant (2012). Mayer was also named one of the "25 New Faces of Independent Film" by *Filmmaker Magazine* (2012). She often collaborates with filmmaker Lucas Leyva, and helps run the Borscht Corporation, a nonprofit film collaborative, production company, and film festival.

Edmundo "Mundo" Meza (1955, Tijuana, Mexico–1985, Los Angeles, California) was a painter, performance artist, and window dresser who grew up in Huntington Park, California. He was among a group of Chicano conceptualist artists in East Los Angeles, and organized performance activations with a queer art trifecta that included Gronk and Robert "Cyclona" Legorreta in the late 1960s–early 1970s. Meza was renowned for his large-scale, photo-realist acrylic paintings, surrealist drawings, and self-transformations that reformulated Chicano gender and sexual binaries. His burgeoning career in window-display installation in Melrose Avenue boutiques responded to social and political movements with salacious "frozen" vignettes. After Meza passed away from AIDS in 1985, much of his work remained inaccessible and fell outside of contemporary art theory and criticism until recently. Hints of his uncredited impact on Los Angeles's nascent art and fashion industry were retold in Simon Doonan's memoirs, *Confessions of a Window Dresser* (1998)

and *Beautiful People* (2005). Trace elements of Meza's works are found in the Robert Legorreta-Cyclona Collection at the UCLA Chicano Studies Research Center Library in Westwood, California.

Irvin Morazán (b. 1976, San Salvador, El Salvador) is a multidisciplinary artist born in El Salvador. He moved to the New York area in the 1980s as part of the Salvadoran Civil War diaspora. Morazán is currently an assistant professor at Virginia Commonwealth University, Sculpture + Extended Media. He utilizes performance, sculpture, and video to explore fictional and autobiographical rituals that are sparked by current events, migration, ancient medicine, indigenous cultures, and his autobiography. Morazán has performed and presented his work extensively throughout the past few years at venues such as El Museo del Barrio, New York; the Metropolitan Museum of Art, New York; Jersey City Museum; Masur Museum of Art, Monroe; Caribbean Museum, Colombia; Museo de Arte de El Salvador; Mercosul Biennial, Brazil; Central America Biennial X, Costa Rica; XI Nicaragua Biennial, Nicaragua; Performa 11; Performa 13; Sauf Haus, Berlin; and Exit Art, New York. Residencies include those at Lower Manhattan Cultural Council Workspace; SOMA, Mexico City; and Skowhegan School of Painting and Sculpture, New York. His work has been recognized by numerous awards and fellowships, including Creative Capital Grant; Joan Mitchell Emerging Artist Grant; the Virginia Commonwealth University Fountainhead Fellowship; Dedalus Foundation Fellowship; Art Matters Grant; Cisneros Foundation Grant; and the Robert Mapplethorpe Award for Photography.

Glexis Novoa (b. 1964, Holguin, Cuba) is a visual artist who lives in Miami, Florida, and Havana, Cuba. Novoa earned a degree in drawing and printmaking from the National School of Art in Havana (1984). His work has been the subject of solo exhibitions at the Museo Nacional de Bellas Artes de La Habana, Cuba; Lowe Art Museum, Coral Gables, Florida; Cheekwood Botanical Garden and Museum of Art, Nashville; and Worcester Art Museum, Worcester, Massachusetts, among others. Novoa's work has been included in exhibitions at Padiglione d'Arte Contemporanea, Milan; Museo Nacional Centro de Arte Reina Sofía, Madrid; Museo del Palacio de Bellas Artes, Mexico City; and Kunsthalle Düsseldorf, Germany.

Rubén Ortiz Torres (b. 1964, Mexico City, Mexico) is a photographer, painter, printmaker, curator, and professor of visual arts at University of California, San Diego. He earned his MFA from the California Institute of Arts in 1992. Ortiz Torres trained as a realist painter, but became known for his photographs and prints inspired by the punk scene in Mexico. He credits the rise of cars seen in his more recent work to his childhood admiration for car models and life in Los Angeles. Ortiz Torres is recognized as an innovator of Mexican postmodernism in the 1980s. His body of work includes readymades, photographs, photo collages, a feature film, video installations, paintings, sculptures, and performances. His art is housed in several public and private collections such as the Metropolitan Museum of Art, New York; Museum of Modern Art, New York; Museum of Contemporary Art, Los Angeles; and Museum of Contemporary Art, San Diego. Ortiz Torres has participated in twenty-five solo exhibitions, more than one hundred group exhibitions, and more than fifty film screenings. Recent exhibitions featuring his work include *Customizing Language* at Los Angeles Contemporary Exhibitions (LACE) in 2016 and *Portrait of an Artist as a Young Man* at the San Diego Museum of Art in 2011.

Rigo 23 (b. 1966, Madeira Island, Portugal) is an artist living in Los Angeles. He earned an MFA from Stanford University (1997) and a BFA from the San Francisco Art Institute (1991). Rigo's work has been the subject of solo exhibitions at the New Museum, New York; Artists Space, New York; REDCAT, Los Angeles; Fowler Museum, Los Angeles; and Museu de Arte Contemporânea de Niterói, Rio de Janeiro. His work has been included in Auckland Triennial, New Zealand (2014); Folkestone Triennial, United Kingdom (2012); Bi-City Biennial of Urbanism and Architecture, Shenzhen and Hong-Kong (2009); Aichi Triennale, Japan (2013); Kochi-Muziris Biennale, India (2010); Lyon Biennale, France (2009); Liverpool Biennial, United Kingdom (2006); and California Biennial (2004), among others. His work is in the collections of the Los Angeles County Museum of Art; San Francisco Museum of Modern Art; de Young Museum, San Francisco; Berkeley Art Museum; Museu Berardo, Lisbon; and CIDECI collection, Chiapas, Mexico.

Alex Rivera (b. 1973, New York, New York) is a filmmaker and digital artist currently based in Los Angeles. He earned his BA from Hampshire College in 1995. Rivera uses art to reexamine conventions about identity, race, immigration, and the global economy. Rivera's most recent projects describe the parallel realities of digital globalization and globalization through migration. His body of work includes political satire, documentary, and science fiction. Rivera's work veers toward considerations of political realities and Latino stories. His films have been featured at international venues, such as the Berlin International Film Festival; Museum of Modern Art, New York; Solomon R. Guggenheim Museum, New York; Lincoln Center for the Performing Arts, New York; and the J. Paul Getty Museum, Los Angeles, among others. He has garnered several awards from the Sundance Film Festival, is a Sundance and Rockefeller Fellow, and was listed as one of *Variety* magazine's "10 Directors to Watch."

Clarissa Tossin (b. 1973, Porto Alegre, Brazil) is an artist currently based in Los Angeles. Tossin earned a BFA from Fundação Armando Alvares Penteado (2000) and an MFA from California

Institute of the Arts (2009). She was awarded a residency fellowship at Fundação Joaquim Nabuco in Recife, Brazil (2015), and an emerging artist fellowship from the California Community Foundation (2014). Her work has been the subject of solo exhibitions at Museum of Latin American Art, Long Beach; Galeria Luisa Strina, São Paulo; Artpace, San Antonio; Samuel Freeman Gallery, Los Angeles; Blaffer Art Museum at the University of Houston; and Sicardi Gallery, Houston. Tossin's work was included in the *Made in L.A.* biennial exhibition at the Hammer Museum, Los Angeles (2014); *Unsettled Landscapes,* SITE Santa Fe Biennial (2014); *United States of Latin America*, Museum of Contemporary Art Detroit (2015); and *Bringing the World into the World*, Queens Museum, New York (2014). Her work resides in the public collections of the Museum of Fine Arts, Houston, and the Kadist, Paris.

Carmelita Tropicana (b. 1982, WOW Café Theater; a.k.a. Alina Troyano, b. 1951, Cuba) is an Obie award–winning performance artist and writer. Her works include *Schwanze-Beast* (2015), a performance commissioned by Vermont Performance Lab; *Recycling Atlantis*, a collaboration with Uzi Parnes and Ela Troyano (2014); a performance installation at the 80WSE Gallery, New York; *Post Plastica,* a collaboration with Ela Troyano (2012); and an installation/video and performance presented at El Museo del Barrio, New York. Tropicana's publications include *I, Carmelita Tropicana: Performing between Cultures* (2000) and *Memories of the Revolution: The First Ten Years of the Wow Café*, co-edited with Holly Hughes and Jill Dolan. She received a 2016 Creative Capital grant for her upcoming collaboration with Branden Jacobs Jenkins.

Luis Valderas (b. 1966, McAllen, Texas) received a BFA in secondary art education from the University of Texas-Pan American. Valderas co-founded *Project: MASA I, II, and III*, a national group exhibition featuring Latino artists and focusing on Chicano identities. Valderas is also the co-founder of 3rd Space Art Gallery, a space devoted to representing current trends in the San Antonio visual arts scene, and A3—Agents of Change LLC, a public art community engagement project. He has shown his work locally, nationally, and internationally. Valderas's work was exhibited at OSDE Espacio de Arte, Buenos Aires, Argentina, and the Medellín Museum of Modern Art, Colombia. His work has been featured in *Chicano Art for Our Millennium*; *Our Communities: Four Decades of Mexican American Art*; *Aztlán: A Journal of Chicano Studies*; and *Altermundos: Latin@ Speculative Literature, Film and Popular Culture*. Valderas's work is part of several private and public collections, including South Texas Blood & Tissue Center, San Antonio; University of Texas at San Antonio; Arizona State University, Tempe; International Museum of Art and Science, McAllen; Mexic-Arte Museum, Austin; Art Museum of South Texas, Corpus Christi; and San Antonio Museum of Art.

Ricardo Valverde (1946, Phoenix, Arizona–1998, Los Angeles, California) was an artist and photographer who documented the lives of diverse communities in Los Angeles and Mexico for more than three decades. He received his MFA from the University of California, Los Angeles, in 1976. Notable exhibitions include *Asco: Elite of the Obscure, a Retrospective, 1972–1987*, Los Angeles County Museum of Art, Williams College Museum of Art, and *Museo Universitario de Arte Contemporáneo* (MUAC), Mexico City; *MEX/LA: Mexican Modernisms in Los Angeles, 1930–1985*, Museum of Latin American Art, Long Beach; and *ASCO and Friends: Exiled Portraits*, Cartel Triangle, Marseille, France. A retrospective of his work was exhibited at Vincent Price Art Museum, Monterey Park. The University of California, Los Angeles, Chicano Studies Research Center Press published *Ricardo Valverde* as part of their *A Ver: Revisioning Art History* series. Valverde's works are in the collections of the Center for Creative Photography, Tucson; Smithsonian Institution, Washington, DC; and the J. Paul Getty Museum, Los Angeles.

José Luis Vargas (b. 1965, Santurce, Puerto Rico) is a visual artist and educator who lives in San Juan. Vargas earned an MFA from the Royal College of Art in London (1994) and a BFA from the Pratt Institute in New York (1988). His work has been exhibited at EXPO CHICAGO; ARCOmadrid; Material Art Fair, Mexico City; New Art Dealers Aliance (NADA), New York and Miami; and the Roberto Paradise Gallery, Puerto Rico. The Institute of Puerto Rican Culture organized a retrospective exhibition of Vargas's work in 2014. He was selected as a prizewinner at John Moore's Exhibition in Liverpool, England, in 1994.

Simón Vega (b. 1972, El Salvador) creates drawings, objects, sculptural installations, and happenings inspired by the self-made informal architecture, local market stands, and vendor carts found on the streets and beaches of Central America. These works, assembled with wood, cardboard, plastic, metal, and found materials, include transmutable elements, colored lights, and live plants. They parody Mayan pyramids, modernism's iconic buildings, and contemporary surveillance systems, creating an ironic and humorous fusion between first and third worlds. Vega graduated in fine arts at the University of Veracruz in Mexico (2000), and received an MA in contemporary arts from the Complutense University of Madrid (2006). His work has been exhibited in Europe, the United States, and Latin America, including at the Pérez Art Museum of Miami (PAMM); the 55th Venice Biennale, Italy; the IX Havana Bienal; Museo del Barrio's Bienal: *The S-Files*, New York; and *HilgerBROTKunsthalle*, Vienna. Vega's work is included in important public and private collections such as the Pérez Art Museum of Miami; the Sanziany Collection at Palais Rasumofsky, Vienna; and El Museo del Barrio, New York. He lives in La Libertad, El Salvador.

SELECTED BIBLIOGRAPHY

Adams, Beverly, and Vanessa K. Davidson, eds. *Order, Chaos, and the Space Between: Contemporary Latin American Art from the Diane and Bruce Halle Collection*. New York: Artbook/DAP, 2013.

Anzaldúa, Gloria. *Borderlands/La Frontera: The New Mestiza*. 3rd ed. San Francisco: Aunt Lute, 2007.

Armstrong, Elizabeth. *Ultra Baroque: Aspects of Post Latin American Art*. La Jolla, CA: Museum of Contemporary Art, San Diego, 2000.

Atencio, Tomas. "El Oro del Barrio in the Cyber Age: Leapfrogging the Industrial Revolution." In *Resolana: Emerging Chicano Dialogues on Community and Globalization*, edited by E. A. Mares and Miguel Montiel, pp. 9–68. Arizona: University of Arizona Press, 2009.

Baddeley, Oriana. *Drawing the Line: Art and Cultural Identity in Contemporary Latin America*. London and New York: Verso, 1989.

Bell, Andrea L., and Yolanda Molina-Gavilán, eds. and trans. *Cosmos Latinos: An Anthology of Science Fiction from Latin America and Spain*. Middletown, CT: Wesleyan University Press, 2003.

Bernard, Goorden, ed. *SF Latino-Américaine: Anthologie*. Brussels: Editions Recto-Verso, 1984.

Botey, Mariana, et al. *MEX/LA: Mexican Modernism(s) in Los Angeles 1930–1985*. Ostfildern: Hatje Cantz Publishing, 2011.

Brown, J. Andrew. *Cyborgs in Latin America*. New York: Palgrave Macmillan, 2010.

———. *Test-Tube Envy: Science and Power in Argentinian Narrative*. Lewisburg, PA: Bucknell University Press, 2005.

Carmichael, Matt. "The Agile City: Making Many Small Plans." *Livability: America's Best Places to Live and Visit*, June 10, 2013. http://www.livability.com/blog/community/agile-city-making-many-small-plans.

Carvajal, Rina, et al. *The Experimental Exercise of Freedom: Lygia Clark, Gego, Mathias Goeritz, Helio Oiticica, Mira Schendel*. Los Angeles: Museum of Contemporary Art, 1999.

Chavoya, C. Ondine. "Customized Hybrids: The Art of Ruben Ortiz Torres and Lowriding in Southern California." *CR: The New Centennial Review* 4, no. 2 (Fall 2004): 141–84.

Chavoya, C. Ondine, and Rita Gonzalez, eds. *ASCO: Elite of the Obscure, a Retrospective, 1972–1987*. Los Angeles: Los Angeles County Museum of Art, 2011.

Cockcroft, Eva Sperling, and Holly Barnet-Sanchez. *Signs from the Heart: California Chicano Murals*. New Mexico: University of New Mexico Press, 1993.

"Control Major to Juan, 2006." YouTube video, 1:58. Posted August 15, 2011. https://www.youtube.com/watch?v=__nxQixGWdk.

Del George, Dana. *The Supernatural in Short Fiction of the Americas: The Other World in the New World*. Westport, CT: Greenwood Press, 2001.

"The Enchanted Environment." *Blogger*. http://kidordinfrenchcesar.blogspot.com/2010/09/enacted-environment-streets-and-yards.html.

Ferrer, Elizabeth. *Modern and Contemporary Art of the Dominican Republic*. Edited by Suzzane Stratton. Seattle: University of Washington Press, 1996.

Fishburn, Evelyn, and Eduardo L. Ortiz, eds. *Science and the Creative Imagination in Latin America*. London: Institute for the Study of the America, 2005.

Foster, Thomas. "Cyber-Aztecs and Cholo-Punks: Guillermo Gómez-Peña's Five-Worlds Theory." *PMLA* 117, no. 1 (2002): 43–67.

Ginway, M. Elizabeth. "Teaching Latin American Science Fiction: A Case Study." In *Teaching Science Fiction*. Edited by Peter Wright and Andy Sawyer, pp. 179–201. England: Palgrave McMillan, 2011.

Ginway, M. Elizabeth, and J. Andrew Brown, eds. *Latin American Science Fiction: Theory and Practice*. New York: Palgrave Macmillan, 2012.

Gómez-Peña, Guillermo. *Dangerous Border Crossers: The Artist Talks Back*. New York: Routledge, 2000.

Gómez-Peña, Guillermo. *The New World Border: Prophecies, Poems, & Loqueras for the End of the Century*. San Francisco: City Lights, 1996.

Gonzalez, Rita, Howard N. Fox, and Chon A. Noriega, eds. *Phantom Sightings: Art after the Chicano Movement*. Los Angeles: Los Angeles County Museum of Art; Berkeley and Los Angeles: University of California Press, 2008.

Gonzalez-Day, Ken. "Choloborg: The Disappearance of the Latino Body." *Art Journal* 60, no. 1 (2001): 23–26.

Goodwin, Matthew David, ed. *Latin@ Rising: An Anthology of Latin@ Science Fiction and Fantasy*. San Antonio: Wings Press, forthcoming.

Hanor, Stephanie. *TRANSactions: Contemporary Latin American and Latino Art*. New York: DAP, 2006.

Harris, Jonathan, ed. *Identity Theft: The Cultural Colonization of Contemporary Art*. Liverpool: Liverpool University Press, 2008.

Hassler, Donald M., and Clyde Wilcox, eds. *Political Science Fiction*. Columbia: University of South Carolina Press, 1997.

Haywood-Ferreira, Rachel. "Back to the Future: The Expanding Field of Latin-American Science Fiction." *Hispania* 91, no. 2 (2008): 352–62.

———. *The Emergence of Latin American Science Fiction*. Middletown, CT: Wesleyan University Press, 2011.

Hoeg, Jerry. *Science, Technology, and Latin American Narrative in the Twentieth Century and Beyond*. Bethlehem, PA: Lehigh University Press; London: Associated University Press, 2000.

Hopkinson, Nalo, and Uppinder Mehan, eds. *So Long Been Dreaming: Postcolonial Science Fiction & Fantasy*. Vancouver: Arsenal Pulp Press, 2004.

Kaup, Monika. *Neobaroque in the Americas: Alternative Modernities in Literature, Visual Art, and Film*. Charlottesville and London: University of Virginia Press, 2012.

"Latin American Science Fiction." University of South Florida Libraries. http://www.lib.usf.edu/special-collections/science-fiction-fantasy/latin-american-science-fiction/.

"Latino Urban Forum's James Rojas Supports Permitting L.A.'s Street Vendors." *The Planning Report*, June 2, 2008. http://www.planningreport.com/2008/06/02/latino-urban-forums-james-rojas-supports-permitting-las-street-vendors.

"Latinopia." *Latinopia*. http://latinopia.com/.

Ledesma, Eduardo. "Close Readings of the Historic and Digital Avant-Gardes: An Archeology of Hispanic Kinetic Poetry." *Hispanic Issues On Line* 9 (Spring 2012): 237–62.

Lobos, Rodrigo. "Terrain Series." http://rodrigolobos.cl/terrains-series.php.

Lockhart, Darrell B., ed. *Latin America Science Fiction Writers: An A-to-Z Guide*. Westport, CT: Greenwood Press, 2004.

Londero, Rodolfo Rorato. *Futuro Esquecido —A Recepção da Ficção Cyberpunk na América Latina*. Rio de Janeiro: Rizoma, 2013.

Lozano-Hemmer, Rafael. "Surface Tension." http://www.lozano-hemmer.com/surface_tension.php.

Luciano's, Miguel. "Pimp My Piragua." http://www.miguelluciano.com/pmp.html.

Marciano, Eric. *Latin American Women Artists: 1915–1995*. Princeton: Films for the Humanities and Sciences, 2005.

Martín-Cabrera, Luis. "The Potentiality of the Commons: A Materialist Critique of Cognitive Capitalism from the Cyberbracer@s to the Ley Sinde." *Hispanic Review* 80, no. 4 (Fall 2012): 583–605.

McKone, Jonna. "Cities in Flux: Latino New Urbanism." *The City Fix,* November 2, 2010. http://thecityfix.com/blog/cities-in-flux-latino-new-urbanism/.

Merla-Watson, Cathryn Josefina, and Olguín, B. V., eds. *Altermundos: Latin@ Speculative Literature, Film, and Popular Culture*. Los Angeles: UCLA Chicano Studies Research Center Press, forthcoming.

"Molina Speaks-Xicano Futurist." Bronze Future Part 8 of 8. YouTube video, 5:07. Posted by "Molina Speaks." February 6, 2012. https://www.youtube.com/watch?v=C4IFYAIZalo.

Molina-Gavilán, Yolanda, et al. "Chronology of Latin American Science Fiction, 1775–2005." *Science Fiction Studies* 34, no. 3 (2007): 369–431.

Montross, Sarah J., ed. *Past Futures: Science Fiction, Space Travel, and Postwar Art of the Americas*. Brunswick, ME: Bowdoin College Museum of Art; Cambridge, MA: MIT Press, 2015.

Morales, Arnaldo. Arnaldo Morales Studio. http://www.arnaldomorales.com/studio.html.

Mosquera, Gerardo. *Beyond the Fantastic: Contemporary Art Criticism from Latin America*. Cambridge: MIT Press, 1996.

Muñoz, José Esteban. *Cruising Utopia: The Then and There of Queer Futurity*. New York: New York University Press, 2009.

Nelson, Diane M. "Maya Hackers and the Cyberspatialized Nation-State: Modernity, Ethnostalgia, and a Lizard Queen in Guatemala." *Cultural Anthropology* 11, no. 3 (1996): 287–308.

Noriega, Chon A. "Sacred Contingencies: The Digital Deconstructions of Raphael Montañez Ortiz." *Art Journal* 54, no. 4 (1995): 36–40.

Noriega, Chon A., Terezita Romo, and Pilar Tompkins Rivas, eds. *L.A. Xicano*. Los Angeles: UCLA Chicano Studies Research Center Press, 2011.

"NYC's Daily News: A Curator's Mission with El Museo del Barrio's Rocio Aranda-Alvarado." *Art. Recognition. Culture.*, March 26, 2012. http://arcthemagazine.com/arc/2012/03/a-curators-mission-with-el-museo-del-barrios-rocio-aranda-alvarado/.

Olalquiaga, Celeste. *Megalopolis: Contemporary Cultural Sensibilities*. Minneapolis: University of Minnesota Press, 1992.

Raimundi-Ortiz, Wanda. "Wepa Woman: Exile Series-Lamento de La Llorona (La Llorona's Lament)." http://wandaraimundi-ortiz.com/artwork/1429488_Wepa_Woman_Exile_Series_Lamento_de_La.html.

Ramírez, Catherine S. "Afrofuturism/Chicanafuturism: Fictive Kin." *Aztlán: A Journal of Chicano Studies*, 33, no. 1 (Spring 2008): 185–94.

———. "Cyborg Feminism: The Science Fiction of Octavia E. Butler and Gloria Anzaldúa." In *Reload: Rethinking Women + Cyberculture*, edited by Mary Flanagan and Austin Booth, pp. 374–402. Cambridge: MIT Press, 2002.

Ramirez-Dhoore, Dora. "The Cyborderland: Surfing the Web for Xicanidad." *Chicana Latina Studies* 5, no. 1 (2005): 10–47.

Rebchook, John. "Health in the City: Denver's Westwood." *Urban Land Magazine*, August 12, 2013. http://urbanland.uli.org/sustainability/health-in-the-city-denver-s-westwood/#.UgmzHaVFv2E.facebook.

Rivera, Lysa. "Future Histories and Cyborg Labor: Reading Borderlands Science Fiction After NAFTA." *Science Fiction Studies* 39, no. 3 (November 2012): 415–36.

———. "Los Atravesados: Guillermo Gomez-Pena's Ethno-Cyborgs." *Atzlan: The Journal of Chicano Studies* 35 (2010): 103–33.

Roberts, Brady M. *2001 Phoenix Triennial: Phoenix Art Museum*. Phoenix: Phoenix Art Museum, 2001.

Robinett, Jane. *This Rough Magic: Technology in Latin American Fiction*. New York: P. Lang, 1994.

Rogriguez, Bélguca, Edward J. Sullivan, and Marina Pérez de Mendiola. *Latin American Women Artists—Artistas Latinoamericanas: 1915–1995*. Milwaukee: Milwaukee Art Museum, 1995.

Rojas, James. "Latino Urbanism: Transforming the Suburbs." *Buildipedia*, July 15, 2013. http://buildipedia.com/aec-pros/urban-planning/latino-urbanism-transforming-the-suburbs.

———. "The Path of Most Resistance: Latino Pedestrian Safety." *MIT CoLab Radio*, July 12, 2011. http://colabradio.mit.edu/the-path-of-most-resistance-latino-pedestrian-safety/.

Ruiz, Alma. *Poetics of the Handmade*. Los Angeles: Museum of Contemporary Art, 2007.

Schwaller, Ellen. "Community Space to Cultural Space: Latino Urbanism and the Transformation of the Built Environment." *Global Site Plans: Branding for Environmental Design*, July 27, 2012. http://www.globalsiteplans.com/environmental-design/architecture-environmental-design/community-space-to-cultural-space-latino-urbanism-and-the-transformation-of-the-built-environment/.

"Sighting Technology in Modern and Contemporary Latin American Art 2011 Annual Conference." *Institute for Comparative Modernities*. http://www.icm.arts.cornell.edu/conference_2011/participants.html.

Stephens, Josh. "Out of the Enclave: Latinos Adapt, and Adapt to, the American City." *Planetizen*, September 22, 2008. http://www.planetizen.com/node/35091.

Suarez, Rafael Vargas. "Vargas-Suarez Universal." http://www.vargassuarezuniversal.com/.

Sullivan, Edward J., ed. *Brazil: Body and Soul*. New York: Guggenheim Museum, 2001.

———. *The Language of Objects in the Art of the Americas*. New Haven: Yale University Press, 2007.

———. *Latin American Art in the Twentieth Century*. London: Phaidon Press, 1996.

Suppia, Alfredo Luiz. "'Breathe, baby, breathe!': Ecodystopia in Brazilian Science Fiction Film." *Practicing Science Fiction: Critical Essays on Writing, Reading and Teaching the Genre*, edited by Karen Hellekson, et al., pp. 130–45. Jefferson: McFarland & Company Publishers, 2009.

Tewksbury, Drew. "Date Farmers: Desert Detritus Becomes Chicano Pop Art." *KCET*, May 7, 2012. https://www.kcet.org/shows/artbound/date-farmers-desert-detritus-becomes-chicano-pop-art.

Toledano Redondo, Juan C. "From Socialist Realism to Anarchist Capitalism: Cuban Cyberpunk." *Science Fiction Studies* 32, no. 3 (2005): 442–66.

Ugalde, Gus. "High School Students in Boyle Heights become urban planners for a day." *Boyle Heights Beat*, February 25, 2013. http://www.boyleheightsbeat.com/high-school-students-in-boyle-heights-become-urban-planners-for-a-day-2152.

University of South Florida Tampa Library. *Alambique*. http://scholarcommons.usf.edu/alambique/.

Vargas, George. *Contemporary Chican@ Art: Color and Culture for a New America*. Austin: University of Texas Press, 2010

Vargas, Kathy. *Intimate Lives: Work by Ten Contemporary Latina Artists*. Austin: Women and Their Work, 1993.

Wagley, Catherine. "Do the Mexican Rebel Zapatistas Have a Space Program? A New Exhibit Imagines One." *LA Weekly*, May 7, 2012. http://blogs.laweekly.com/arts/2012/05/redcat_rigo_23_zapatista.php.

Zamora, Lois Parkinson, and Monika Kaup, eds. *Baroque New Worlds: Representation, Transculturation, Counterconquest*. Durham: Duke University Press, 2010.

CONTRIBUTORS

Kency Cornejo is assistant professor of modern and contemporary Latin American art with a concentration on Central American art at the University of New Mexico. Specializing in the intersections of race, gender, and coloniality, her current book project expands on her dissertation and is titled *Visual Disobedience: Art and Decoloniality in Central America*. Cornejo's publications include "The Question of Central American–Americans in Latino Art and Pedagogy," in *Aztlán: A Journal of Chicano Studies;* "No Text without Context: Habacuc Guillermo Vargas's *Exposition #1*," in *Art and Documentation/Sztuka i Dokumentacja*; and "Indigeneity and Decolonial Seeing in Contemporary Art of Guatemala," in *FUSE Magazine*. A recipient of the Fulbright-Hays DDRA and the Ford Dissertation Fellowship, Cornejo received her PhD from Duke University.

Robb Hernández is assistant professor of Latina/o literary and cultural studies in the Department of English at the University of California, Riverside. His current book project, *Finding AIDS: Archival Body/Archival Space and the Chicano Avant-garde*, constructs a queer genealogy of Latino artist communities through the alternative archives, records, and custodial practices produced during the AIDS crisis. Hernández has published in such journals as Radical History Review, *MELUS: The Society for the Study of the Multi-Ethnic Literature of the United States*, and *Aztlán: A Journal of Chicano Studies*. He is a recipient of grants from the Getty, Ford, and Hellman Foundations; National Association of Chicana/o Studies; and Dartmouth College, among others. Hernández holds a PhD from the University of Maryland, College Park.

Rudi Kraeher is a PhD student in the English Department at the University of California, Riverside. He earned his BA in English and Spanish from Temple University, and his MA in English from University of California, Riverside. His research focuses on conceptual artwork that theorizes alternative forms of visuality, vision, and the visible, especially in relation to histories of racialized and gendered violence. Kraeher's dissertation project investigates the speculative implications of a politics of obscurity and opacity in contemporary visual culture.

Kathryn Poindexter is curatorial assistant at the California Museum of Photography, *Mundos Alternos* project coordinator, and this volume's managing editor. She previously held positions at the Riverside Art Museum and the UC Irvine Beall Center for Art + Technology, and works as chief assistant to artist David Rabinowitch. Her curated and co-curated exhibitions at the CMP include *Jennah Ward Bentley: Teviot 10* (2016), *Myth and Majesty: Photographs Picturing the American Southwest* (2016), *Aaron Siskind: Pleasures and Terrors* (2015–16), and *Penelope Umbrico: Master, Mountain, Range (and Rangers)* (2015). Curated exhibitions at Riverside Art Museum include *Eretai: John Beech, Lael Marshall, David Rabinowitch, Michael Voss*; *Julie Torres: Close Encounters*; *David Leapman: The Tumbling Surveyors Pursuit*; and *SKY BLUE SKY: Print Media by Matthew Tyson*. Poindexter earned her BA in studio art in 2008 from University of California, Irvine, and studied at the University of British Columbia from 2006 to 2007.

Itala Schmelz is director of Centro de la Imagen in Mexico City. In 2013, Schmelz was selected as the curator of the Mexico pavilion at the 55th Annual Venice Biennale, where she organized the multimedia installation *Cordiox* by artist Ariel Guzik. As the director of Sala de Arte Público Siqueiros (SAPS) from 2001 to 2007 and the Museo de Arte Carrillo Gil (MACG) from 2007 to 2011, she designed multiple programs to support, conceptualize, and promote contemporary art in Mexico. She has also curated important exhibitions around the legacy of the Mexican painter and muralist David Alfaro Siqueiros. *El futuro más acá*, which Schmelz organized in 2003, was the first ever festival of Mexican science fiction films. Schmelz studied philosophy at Universidad Nacional Autónoma de México.

Tyler Stallings has been the Artist Director at UCR ARTSblock's Barbara and Art Culver Center of the Arts since 2010. He was chief curator at Laguna Art Museum prior to his arrival at UCR in 2006. He received an MFA from California Institute of the Arts. Stallings's curatorial projects focus on contemporary art, with a special emphasis on the exploration of identity, technology, photo-based work, and urban culture. His curated and co-curated exhibitions include *Mundos Alternos: Art & Science Fiction in the Americas* (2017), *Free Enterprise: The Art of Citizen Space Exploration* (2013), *Lewis deSoto & Erin Neff: Tahquitz* (2012), *The Great Picture: The World's Largest Photograph & the Legacy Project* (2011), *Margarita Cabrera: Puslo y Martillo (Pulse and Hammer)* (2011), *Mapping the Desert/Deserting the Map: An Interdisciplinary Response* (2009), *Intelligent Design: Interspecies Art* (2009), *Your Donations Do Our Work: Andrea Bowers and Suzanne Lacy* (2009), *Absurd Recreation: Contemporary Art from China* (2008), *Truthiness: Photography as Sculpture* (2008), *The Signs Pile Up: Paintings by Pedro Álvarez* (2007), *CLASS: C Presents Ruben Ochoa and Marco Rios: Rigor Motors* (2004), *Whiteness, A Wayward Construction* (2003), *Surf Culture: The Art History of Surfing* (2001), *Desmothernismo: Ruben Ortiz Torres* (1998),

and *Kara Walker: African't* (1997). Stallings's most recent book is *Aridtopia: Essays on Art & Culture from Deserts in the Southwest United States* (2014).

Alfredo Luiz Suppia is professor of cinema studies at the Universidade Estadual de Campinas (Unicamp) and has published extensively on science fiction film from Latin America. Suppia is the author of *Rarefied Atmosphere: Science Fiction in Brazilian Cinema* and *The Replicant Metropolis: Constructing a Dialogue between Metropolis and Blade Runner*. He co-edited the volume *Red Alert: Marxist Approaches to Science Fiction Cinema*, published in 2016 by Wayne State University Press. Suppia's writing has been published in the Palgrave Macmillan volume *Latin American Science Fiction: Theory and Practice* in 2012 and the journal *SFRA Review* in 2011, among others. He received his PhD in film studies from University of Campinas in Brazil.

Joanna Szupinska-Myers is curator of exhibitions at the California Museum of Photography (CMP) at the University of California, Riverside. As a curator and writer, she is immersed in contemporary art, the history of exhibitions, and the nature of collections. She has curated exhibitions of work by Marie Bovo, Zoe Crosher, Phil Chang, Gordon Matta-Clark, and Penelope Umbrico, among others, and curated and co-curated the group exhibitions *Mundos Alternos: Art and Science Fiction in the Americas* (2017–18), *Reproduction, Reproduction* (2015–16), and *Trouble with the Index* (2014) at the CMP, and *Skyscraper: Art and Architecture Against Gravity* (2012) and *First 50* (2012) at the Museum of Contemporary Art Chicago. Together with Julian Myers-Szupinska, she also works on various projects under the joint title *grupa o.k.*, whose practice includes research, writing, and editing. Joanna earned her MA in curatorial practice from the California College of the Arts, San Francisco, and her BA in art from the University of California, Los Angeles.

Sherryl Vint is a professor in the Media & Cultural Studies Department at the University of California, Riverside, specializing in the areas of science fiction, biopolitics, and science studies. Vint's book-length publications include *Bodies of Tomorrow: Technology, Subjectivity, and Science Fiction* (2007) and *Animal Alterity: Science Fiction and the Question of the Animal* (2010). Her writing has appeared in the journals Australian Literary Studies, *Science Fiction Film and Television* and *Extrapolation*. Vint has also edited volumes related to science fiction, including *The Routledge Companion to Science Fiction* (2009) and *Science Fiction and Cultural Theory: A Reader* (2016). She also serves as the editor of the journals *Science Fiction Studies* and *Science Fiction Film and Television*. Vint received her PhD from the University of Alberta.

The exhibition and book *Mundos Alternos: Art and Science Fiction in the Americas* have been made possible with major support from The Getty Foundation through the Pacific Standard Time: LA/LA initiative. We are grateful for the Getty's provocative prompt that led to the conceptualization of this project, and to the extension of the Foundation's generosity throughout Southern California.

A great deal of support came from the talented and dedicated staff at the University of California, Riverside's ARTSblock. We are incredibly grateful, in alphabetical order, to Trudy Cohen, Management Services Officer; Katherine Porter Dorff, Events Manager; Jennifer Frias, Associate Curator; Leigh Gleason, Curator of Collections; Timothy LeBlanc, Preparator; Nikolay Maslov, Curator of Film; Cody Norris, Senior Preparator; Emily Papavero, Director of Administration and Operations; and Danielle Peltakian, Administrative Assistant. Special thanks go to Kathryn Poindexter, CMP Curatorial Assistant, *Mundos Alternos* project coordinator, and this book's managing editor, who touched nearly every aspect of planning the exhibition, from coordinating travel to overseeing the publication's complex editorial activities; and Zaid Yousef, Exhibition Designer, whose keen eye and rapport with artists were invaluable during the planning and execution of the installation. We also wish to thank our curatorial interns Stephanie Boyer, Hugo Cervantes, Kelly Filreis, Nena Kellar, Karlyn Olvido, Jamison Pollock, and Jake Williams, who assisted with research, communication, organization, and preparing copy. The scholarly contributions and acumen of UCR Department of English PhD candidate Rudi Kraeher were critical to the completion of this book, and we are deeply indebted to him.

We are most grateful for our current and former colleagues at University of California, Riverside, including JJ Jacobson, Jay Kay and Doris Klein Librarian for Science Fiction at the UCR Libraries; Aleca Le Blanc, Assistant Professor in the History of Art Department; faculty in the Department of English, most especially Deborah Willis, George Haggerty, Stephen Hong Sohn, Jennifer Doyle, and Jim Tobias; and Richard Rycraw, Liability Program Manager.

We thank curator Sarah J. Montross for her generosity in sharing research while working on her exhibition *Past Futures: Science Fiction, Space Travel, and Postwar Art of the Americas* as the Andrew W. Mellon Post-doctorial Curatorial Fellow at Bowdoin College Museum of Art.

During the research phase of the project, numerous institutions, foundations, galleries, and colleagues offered their recommendations and assisted with accommodations, both within the United States and abroad. Research trips in the states included Arizona, California, Florida, Illinois, New Hampshire, New Mexico, New York, Puerto Rico, Texas, and Washington, DC.

In Arizona, we are indebted to Sara Cochran at Scottsdale Museum of Contemporary Art; Heather Lineberry, Julio Cesar Morales, and Greg Esser at Arizona State University Art Museum; Vanessa Davidson at the Phoenix Art Museum; Ashley Rice at Lise Sette Gallery; Jocko Weyland at the Museum of Contemporary Art Tucson; and the tour guides at Arcosanti and Biosphere II.

Those in California include Florencia Bazzano-Nelson, Cantor Center; Catherine Clark Gallery; Charles Desmarais, formerly of San Francisco Art Institute; Jill Dawsey, Museum of Contemporary Art San Diego; Curtis Marez, professor in the Ethnic Studies Department, Ricardo Dominguez, professor in the Art Department, and Sheldon Brown, Director of the Arthur C. Clarke Center for Human Imagination, all at University of California, San Diego; Alessandra Moctezuma at Mesa College Art Gallery, San Diego; Tarek El Haik formerly of San Francisco State University, and Fiamma Montezemolo, artist and scholar; Guillermo Galindo, artist and musician; Cathy Kimball at San Jose Institute for Contemporary Art; Julie Perlin Lee, formerly of Bowers Museum; Rory Padeken of the San Jose Museum of Art; the late, great Paule Anglim of Gallery Paule Anglim; Karen Rapp, formerly of Vincent Price Art Museum; Joey Reyes and Vanessa Nava of the Movimiento de Arte y Cultura Latino Americana; Betti Sue-Hertz, formerly of Yerba Buena Center for the Arts; Pam Winfrey, Exploratorium; Suzanne Walsh at Salt Fine Art; Laurie Steelink and Sean Meredith at Track 16 Gallery; Alma Ruiz, independent curator; Harry Gamboa Jr. at California Institute of the Arts, and Chon A. Noriega, Director of the UCLA Chicano Studies Research Center and professor in the Department of Film, Television, and Digital Media.

In Florida we met with Chana Budgazad Sheldon of Locust Projects; Gean Moreno, formerly of Cannonball; and Diana Nawi, Pérez Art Museum Miami, and we thank them for their generosity. For their assistance with research and coordination in New Mexico we thank Tey Marianna Nunn and David Gabel of the National Hispanic Cultural Center. In New York, we were grateful for the insights of research team member Rocío Aranda-Alvarado of El Museo del Barrio; Gabriel Perez-Barreiro, Director at Colección Patricia Phelps de Cisneros; Jens Hoffmann of the Jewish Museum, Andy Rebatta of the Museum of Chinese in America, and artist Miguel Luciano. In Washington DC, Joanne Flores, E. Carmen Ramos, Taina Caragol, and Ranald Woodaman at the Smithsonian Institution were tremendous resources. In New Hampshire, Mary Coffey was a treasure trove of insights and all things Orozco.

For their direction and support in Puerto Rico, we thank research team member Rebeca Noriega Costas for going above and beyond the line of duty; Walter Otero Gallery; Francisco "Tito" Rovira Rullán at Roberto Paradise Gallery; Michy Marxuach, Pablo Guardiola, and Sofía Gallisá Muriente at Beta-Local in San Juan; and our fellow travel companions in search of alien

life, ADÁL, José Luis Vargas, Frances Gallardo, Matt Goodwin, and Aidan Lopez Linehan, who were indispensible to this leg of fieldwork.

In Texas, many contributed to our research, including Arturo Almeida, University of Texas at San Antonio Art Collection; Joe Lopez at Gallista Gallery; David Rubin, independent curator and art critic; Rene Paul Barilleaux, McNay Art Museum; Gabriel Perez Barreiro (formerly), Meredith Sutton, Cassandra Smith, and Beth Shook (formerly) of Blanton Museum of Art; Dean Daderko and Valerie Cassel Oliver of the Contemporary Art Museum Houston; Michael Wellen, formerly of the Museum of Fine Arts Houston; Adriana Gallego, National Association of Latino Arts and Cultures; Mary Heathcott and Jacqueline McGilvray of Blue Star Contemporary Art Museum; Kerry Inman of Inman Gallery; Toby Kamps, The Menil Collection; Heather Pesanti, The Contemporary Austin; Riley Robinson, Artpace San Antonio; Paul Del Bosque, AZTLAN Dance Company; Dr. Tatiana Reinoza from University of Texas at Austin, Professor George Flaherty, University of Texas at Austin; Claudia Schmuckli, formerly of Blaffer Art Museum; David Shelton Gallery; Professor Roberto Tejada, and Lisa Cruces, Hispanic Collections Archivist and Librarian, both at University of Houston; and Luis Valderas and Kim Bishop, artists and curators.

For our travels in Cuba, we thank the Jorge Fernandez Torres, Director of the Havana Biennial; DeWitt Godfrey of the College Art Association; artist Felipe Dulzaides; Adolfo Nodal of Cuba Tours and Travel; Marilyn Zeitlin; and Johanna Felder. During the research trip in Mexico City we met with many who received us warmly, including our gracious host Miguel Ángel Fernández Delgado; curator Regina Tattersfield; Blanca Estela Rodriguez Mandujano, Centro Multimedia; Claudia Zapata, formerly of Mexic-Arte; and film director Trisha Ziff.

In Argentina, we thank for their generosity scholar and curator Rodrigo Alonso; science fiction scholar M. Elizabeth Ginway of University of Florida, Gainesville; and Max Perez Fallik of the Kosice Museum. In Brazil, we are indebted to Maria Quiroga and Alessandra Terpins, Galeria Luisa Strina; Adriano Pedrosa, Museu de Arte de São Paulo Assis Chateaubriand; Tobi Maier, curator and critic; Fernando Mota, Casa Triângulo gallery; curator Ana Paula Cohen; and Eduardo Basualdo, among others. Research team member Alfredo Luiz Suppia served as a superior guide while in São Paulo. In Chile, we were grateful for the help of Patricia Ready of Galeria Patricia Ready; and Milka Marinov Vlahovic and Lautaro Veloso of Museo Nacional de Historia Natural.

Our travel companions Naida Osline, Julian Myers-Szupinska, and Judith Rodenbeck were keen conversationalists during our travels in Cuba and South America, and contributed valuable insights during the curatorial process.

At Lucia|Marquand, in addition to partners Ed Marquand and Adrian Lucia, it was a pleasure to work with Tom Eykemans, Design Director; Melissa Duffes, Managing Editor; Zach Hooker, Designer; Rebecca Schomer, Accounting Manager; Kestrel Rundle, Editorial Assistant; and Meghann Ney, Image Manager and Production Assistant. Phillip Pennix-Tasden provided professional and timely translation of the Spanish essay. Gina Broze provided expertise in procuring many of the image licenses and files. We also express immense gratitude to Mariah Keller, a patient and competent editor, who facilitated many aspects of the publishing process.

We are profoundly grateful for the partnership of the various lenders who made the exhibition a reality. We extend our thanks to each of the artists involved as well as the lending galleries, institutions, and collectors: David Castillo Gallery, Miami; Jef Huereque, Los Angeles; Kosice Museum, Buenos Aires; Lisa Sette Gallery, Phoenix; Galeria Luisa Strina, São Paulo; THE MISSION, Chicago; Liza and Dr. Arturo Mosquera, Coral Gables, FL; Mike Moreno, Belen, NM; National Museum of Mexican Art, Chicago; National Hispanic Cultural Center, Albuquerque; Tey Marianna Nunn; Tom Patchett, Los Angeles; Pérez Art Museum Miami; Roberto Paradise gallery, San Juan; and Esperanza and Christopher L. Valverde, Los Angeles.

Finally, a very big thanks goes to all the artists who, unfortunately, we were unable to include in the exhibition. We wish that we had twice the gallery space to better demonstrate the magnitude of science fictional thinking that permeates the Americas. We are grateful for the insightful conversations and warm invitations to your studios. Your voices are part of the expanding universe in which *Mundos Alternos* is, at most, only a single galaxy.

Robb Hernández, Tyler Stallings, and Joanna Szupinska-Myers
CURATORS

Page 2: Claudio Dicochea, *Diseño de ChichiMeco (Design of ChichiMeco)* (detail), 2010. Acrylic, graphite, charcoal, and transfer on wood, 48 × 36 inches (121.92 × 91.44 cm). Courtesy of the artist and Lisa Sette gallery, Phoenix.

Page 8: Carmelita Tropicana. Photo by Carlos David, courtesy of Carmelita Tropicana.

Page 20: Beatriz Cortez, *Los Angeles Vernacular: Space Capsule Interior*, 2016. Installation view, Monte Vista Projects, Los Angeles, 2016. Courtesy of the artist.

Page 32, Plate 1: Tania Candiani, *Engraving Sound*, 2015. Mixed-media sound installation, dimensions variable; made in collaboration with Jadir Zárate (sound synthesis), Juan Flores (mechanical and electronic engineering), Tigre Ediciones (engraving), and RC Design (industrial design and production). Courtesy of the artist.

Page 33, Plate 2: Beatriz Cortez, *Los Angeles Vernacular: Space Capsule Interior* (detail), 2016. Installation view, Monte Vista Projects, Los Angeles, 2016. Courtesy of the artist.

Page 34, Plate 3: Faivovich & Goldberg, *A Guide to Campo del Cielo* (detail), 2006–present. Courtesy of the artists.

Page 35, Plate 4: Clarissa Tossin, *Transplanted (VW Brasilia)*, 2011. Natural latex, 105 × 108 × 7 inches (266.7 × 274.3 × 17.8 cm). Photo by Edouard Fraipont, courtesy of the artist and Luisa Strina gallery, São Paulo.

Page 36: AZTLAN Dance Company, *Sexto Sol: A Cumbia Cruiser's Guide to the Galaxy*, 2012. Performance with performer Paul del Bosque, directed by Roén Salinas. Photo by Nora Salinas, courtesy of Nora Salinas and AZTLAN Dance Company.

Page 52, Plate 5: AZTLAN Dance Company, *Sexto Sol: A Cumbia Cruiser's Guide to the Galaxy*, 2012. Performance with performer Paul del Bosque, directed by Roén Salinas. Photo by Nora Salinas, courtesy of Nora Salinas and AZTLAN Dance Company.

Page 53, Plate 6: Robert "Cyclona" Legorreta, 1989. Performance at "Transcend," Los Angeles, 1989. The Fire of Life: The Robert Legorreta–Cyclona Collection 1962–2002, CSRC.0500, courtesy of the UCLA Chicano Studies Research Center.

Page 54, Plate 7: Claudio Dicochea, *de la Gobernatura Suprema y Jefe Saddle Blazing, se convierte en Marciano (of Supreme Governance and Chief Saddle Blazing, it turned into a Martian)*, 2010. Acrylic, graphite, charcoal, and transfer on wood, 48 × 36 inches (121.92 × 91.44 cm). Courtesy of the artist and Lisa Sette gallery, Phoenix.

Page 55, Plate 8: Guillermo Gómez-Peña and Saul Garcia Lopez, *Robo-Proletarian Warriors*, 2012. Photo by Wolfgang Silveri, Steirischer Herbst Festival, Austria, 2012, courtesy of La Pocha Nostra Archives.

Page 56, Plate 9: Hector Hernandez, *Bulca*, 2015. Photograph, 20 × 30 inches (50.8 × 76.2 cm). Courtesy of the artist. (front cover image)

Page 57, Plate 10: LA VATOCOSMICO c-s, The artist in his studio, 2016, with various works, 2008–16. Courtesy of the artist.

Page 58, Plate 11: Irvin Morazán, *Border Headdress*, 2016. Mixed-media sculpture with soil from the U.S./Mexican border, 84 × 59 × 63 inches (213.36 × 149.86 × 160.02 cm). Courtesy of the artist.

Page 59, Plate 12: *Mundo Meza and Jef Huereque, Halloween Party*, 1983. Photo by Simon Doonan, courtesy of Jef Huereque and Simon Doonan.

Page 60, Plate 13: *Schwanze-Beast*, 2015. Performance written and performed by Carmelita Tropicana, directed by Ela Troyano, and featuring Carmelita Tropicana and Erin Markey; costumes by Yali Romagoza. Commissioned by the Vermont Performance Lab and presented in 2015 as part of VPL's Progressive Performance Festival. Photo by Kelly Fletcher, courtesy of Vermont Performance Lab.

Page 61, Plate 14: Paul Karam and Luis Valderas, *Masa Mission 2.5*, 2007. Performance. Image courtesy of Luis Valderas.

Page 63, Plate 15: Ricardo Valverde, *Armando y Consuelo—Two Alienz Muertos*, 1983–91. Hand-painted gelatin silver print, 12 × 9.5 inches (30.5 × 24.1 cm). Collection of Esperanza Valverde & Christopher J. Valverde. Image courtesy of Esperanza Valverde & Christopher J. Valverde and UCLA Chicano Studies Research Center. (back cover image)

Page 64: Chico MacMurtrie/Amorphic Robot Works, *Organic Arches*, 2014. Installation view, SESC Santana, São Paulo, Brazil. Co-produced with SESC SP, Automatica and Molior in 2014. Photo by ARW, courtesy of Chico MacMurtrie/ARW.

Page 72, Plate 16: Chico MacMurtrie/Amorphic Robot Works, *Organic Arches*,